GLITTERING IMAGES

GLITTERING IMAGES

A Journey Through Art
from Egypt to *Star Wars*

CAMILLE PAGLIA

PANTHEON BOOKS, NEW YORK

Pantheon Books and colophon are registered trademarks of Random House, Inc.

Library of Congress Cataloging-in-Publication Data
Paglia, Camille, [date]
Glittering Images : a journey through art from Egypt to Star Wars /
Camille Paglia
pages cm
ISBN 978-0-375-42460-1
1. Art—History. 2. Art and society—History—21st century. I. Title.
N5303.P29 2012 709—dc23 2012005220

www.pantheonbooks.com

Jacket illustration and design by Peter Mendelsund

Printed in Great Britain
First Edition
2 4 6 8 9 7 5 3 1

Contents

Contents

Introduction

Modern life is a sea of images. Our eyes are flooded by bright pictures and clusters of text flashing at us from every direction. The brain, overstimulated, must rapidly adapt to process this swirling barrage of disconnected data. Culture in the developed world is now largely defined by all-pervasive mass media and slavishly monitored personal electronic devices. The exhilarating expansion of instant global communication has liberated a host of individual voices but paradoxically threatened to overwhelm individuality itself.

How to survive in this age of vertigo? We must relearn how to see. Amid so much jittery visual clutter, it is crucial to find *focus*, the basis of stability, identity, and life direction. Children above all deserve rescue from the torrential stream of flickering images, which addict them to seductive distractions and make social reality, with its duties and ethical concerns, seem dull and futile. The only way to teach focus is to present the eye with opportunities for steady perception—best supplied by the contemplation of art. Looking at art requires stillness and receptivity, which realign our senses and produce a magical tranquillity.

Members of the art world and residents of metropolitan regions with major museums suffer from a tragic complacency about the current status and prestige of art. The fine arts are shrinking and receding everywhere in the world. Video games, digitally animated movies, and televised sports have far more energy and variety as well as manifest impact on younger generations. The arts are fighting a rearguard action, their very survival at stake. Museums have embraced publicity and marketing techniques invented by Hollywood to attract large crowds to blockbuster shows, but the big draws remain Old Master or Impressionist painting, not contemporary art. No galvanizing new style has emerged since Pop Art, which killed the avant-garde by embracing commercial culture. Art makes news today only when a painting is stolen or auctioned at a record price. Furthermore, with the heady proliferation of

mediums available to artists, the genre of painting has lost its primacy and authority. Yet for five hundred years after the dawn of the Renaissance, the most complex and personally expressive works of art ever produced in the world were executed in paint—from tempera and oil to acrylics. The decline of painting has cut aspiring artists off from their noblest lineage.

In most leading countries, art is regarded as central to national history and identity and is routinely funded by ministries of culture. Art is omnipresent in Europe, which is littered with three millennia of monuments and ruins. European museums are treasure troves of cultural patrimony—works commissioned by church and state and later amassed by royal collectors, whose estates became public property after the rise of democracy. In the still relatively young United States, a practical nation founded by Puritans, the arts have never taken deep root. Much of the general public has fitfully regarded the fine arts as elitist or alien and chronically begrudged them government funding, which remains minuscule and is recurrently threatened with extinction.

Because the American political experiment was launched in the late eighteenth century, the age of European neoclassicism, government and bank buildings, as well as private dwellings, often resemble Greek or Roman temples. Public art in the United States throughout the nineteenth century usually took neoclassic form in county courthouses, graveyards, and war memorials, with which the United States overflows. Both neoclassic and Victorian-era art were strongly content-driven, full of uplifting messages about virtue, piety, patriotism, and duty—a moral view of art still maintained among many conservatives. Only a minority in the largely agrarian United States had any exposure to the arts, except at fairs and expositions. The central institution of America's small towns was the church, plain and unadorned in the Protestant style. Bible study and hymn singing were the central cultural activities, amplified by poetry, both read and recited.

After the Civil War, businessmen who had made huge fortunes in oil, steel, railroads, or high finance helped build museums, opera houses, libraries, and universities, partly to assert their own power against an old social establishment but also to vie with Europe, which still overshadowed American culture. Middle-class women were often arts boosters, giving an aura of high-toned gentility to arts appreciation, which sometimes repelled their husbands. In America, where masculinity was identified with the hardy frontier spirit, the arts have often suffered from a reputation for urban effeteness.

While the crafts always flourished in America, from pewter and silver to furniture and glass, painting remained conventional, focusing on portraiture, history, or landscape. The three thousand miles of the North Atlantic crossing were no impediment to a brisk book trade, but traffic in radical new paintings was quite another matter. The United States was isolated from the turmoil and scandal accompanying rapid changes in artistic style that began in 1819 with the lurid Romanticism of Géricault's *Raft of the Medusa* and continued to the early twentieth century with the brash colors and spatial distortions of Fauvism and Cubism. Aspiring American artists needed independent wealth or outside support to travel to Europe to see the latest trends. Hence the general public was woefully unprepared for the shock of the International Exhibition of Modern Art, held in 1913 in a National Guard armory in New York, where over a thousand works by three hundred avant-garde artists triggered a storm of incredulity and ridicule from the press.

With the founding of New York's Museum of Modern Art in 1929, avant-garde art gained a major beachhead in the United States, helped along by an influx of refugee artists such as Mondrian and George Grosz, who were fleeing the advance of Nazism. Steadily, the tenets of modernist art became basic cultural assumptions for Americans oriented toward the humanities. But the general public has never completely accepted abstract art, especially in heartland towns lacking the oversized, abstract steel sculptures common in plazas of so many large cities, including Chicago. For two decades after World War II, American movies and TV shows portrayed the abstract artist as a weirdo, criminal, or psychotic. Like the Beats, the artist was perceived as a slacker, roué, and Communist sympathizer. A suspicion that the art world is anti-American lingers today, exacerbated by a series of bitter controversies over sacrilegious art in the late 1980s and 1990s that nearly led to termination of the National Endowment for the Arts by the U.S. Congress.

This book was inspired by my dismay at the open animosity toward art and artists that I have heard on American AM talk radio over the past two decades. As a lifelong radio fan, I listen with great enjoyment around the clock to political and sports shows, whose call-in format provides a lively forum for scathingly direct working-class and lower-middle-class voices heard nowhere else in American culture. The arts are sheltered on FM radio, home to National Public Radio and the BBC World Service, with their measured pace and plummy tones, but even there, classical music stations are vanishing.

On populist AM radio, particularly on conservative shows, the ruling view among both hosts and callers is that the art world is a sterile dead zone of elitist snobs and that artists are pretentious parasites and con men.

It is alarmingly obvious that American public schools have done a poor job of educating students about art. From preschool on, art is treated as therapeutic praxis—do-it-yourself projects with construction paper and finger paints to unleash children's hidden creativity. But what is far more needed is a historical framework of objective knowledge about art. The odd class field trip to a museum, even if one is within reach, is inadequate. Art history courses should be built into the curriculum at the primary-, middle-, and high-school levels—a basic introduction to great art and its styles and symbols. The movement toward multiculturalism following the 1960s offered a tremendous opportunity to expand our knowledge of world art, but multicultural approaches have too often sacrificed scholarship and chronology for sentimental cheerleading and rote grievances.

Colleges awarding liberal arts degrees might be expected to stress arts education, but that is not the case. The current cafeteria-style curriculum makes art history courses available but not required. With rare exception, colleges have abandoned any notion of a core body of learning. Humanities departments offer a hodgepodge of courses tailored to professors' research interests. There has been a gradual phasing out in the United States of the art history survey course, which moved magisterially over two semesters from cave art to modernism. Despite their popularity with students, who remember them as crowning college experiences, survey courses are increasingly regarded as too cumbersome, superficial, or Eurocentric—and there is no institutional will to extend them to world art. Junior faculty teethed on post-structuralism, with its mechanical suspicion of culture, regard themselves as specialists rather than generalists and have not been trained to think over such vast trajectories. The end result is that many humanities majors graduate with little sense of chronology or the gorgeous procession of styles that constitutes Western art.

The most important question about art is: what lasts, and why? Definitions of beauty and standards of taste are constantly changing, but persistent patterns obtain. I subscribe to a cyclic view of culture: styles grow, peak, and decay but flower again through periodic revival. The line of artistic influence can clearly be seen in Western culture, with various breaks and recoveries, from ancient Egypt to today—a five-thousand-year saga that is not (as academic jargon would have it) an arbitrary, imperialistic "narrative." A host of

stubbornly concrete objects—not just waveringly subjective "texts"—survives from antiquity and from the societies that it shaped.

Civilization is defined by law and art. Laws govern our external behavior, while art expresses our soul. Sometimes art glorifies law, as in Egypt; sometimes art challenges law, as in Romanticism. The problem with the Marxist approaches that now permeate academe (via post-structuralism and the Frankfurt school) is that Marxism sees nothing beyond society. Marxism lacks a metaphysics—that is, an investigation of man's relationship to the universe, including nature. Marxism also lacks a psychology: it believes that human beings are motivated only by material needs and desires. Marxism cannot account for the infinite refractions of human consciousness, aspirations, and achievement. Because it does not perceive the spiritual dimension of life, Marxism reflexively reduces art to ideology, as if the art object has no other purpose or meaning beyond the economic or political. Students are now taught to look skeptically at art for its flaws, biases, omissions, and covert power plays. To admire and honor art, except when it conveys politically correct messages, is regarded as naive and reactionary. Only one Marxist scholar, Arnold Hauser in his epic 1951 study, *The Social History of Art,* has succeeded in applying Marxist analysis without losing the magic and mystery of art. And Hauser (an early influence on my work) was building on the great tradition of German philology, animated by an ethic of massive erudition that is now lost.

Art is a marriage of the ideal and the real. Art making is a branch of artisanship. Artists are craftsmen, closer to carpenters and welders than they are to intellectuals and academics, with their inflated, self-referential rhetoric. Art uses and speaks to the senses. It is grounded in the tangible physical world. Post-structuralism, with its French linguistic origins, is obsessed with words and is thus incompetent to illuminate any art form outside of literature. Commentary on art must approach and describe it in its own terms. A delicate balance must be struck between the visible and the invisible worlds. Those who subordinate art to a contemporary political agenda are as guilty of rigid literalism and propaganda as any Victorian preacher or Stalinist bureaucrat.

One reason for the marginalization of the fine arts today is that artists are too often addressing other artists and the in-group of hip cognoscenti. They have lost touch with the general public, whose taste and values they caricature and scorn. A majority of American artists, like a majority of American professors, are liberals who have little or no contact with those of oppos-

ing views. But the firebrand, antiestablishment, free-speech liberalism of the 1960s (with which I strongly identify) has evolved into a utopian dreamworld of the comfortable professional class, with its vague philanthropic impulses and strange passivity toward a bloated, authoritarian government. A monolithic orthodoxy has marooned artists in a ghetto of received opinion and cut them off from fresh ideas. Nothing is more hackneyed than the liberal dogma that shock value confers automatic importance on an artwork. The last time this was true was probably the late 1970s, exemplified by Robert Mapplethorpe's homoerotic, sadomasochistic photographs (which I admire and have defended). But culture has moved on. In the twenty-first century, we are looking for meaning, not subverting it. The art world, mesmerized by the heroic annals of the old avant-garde, is living in the past.

But conservatives are equally guilty of sins against culture. Despite their trumpet call for a return of education to the Western canon, they have behaved like provincial philistines when it comes to the visual arts. While there are several sophisticated art critics among urban conservatives, the momentum of the American conservative movement has been principally powered from outside the Northeast in agrarian regions where evangelical Christianity thrives. Protestantism has a history of iconoclasm: during the northern European Reformation, church statues and stained-glass windows were systematically destroyed as idolatrous. Compared with art-laden Roman Catholicism, mainstream American Protestantism is visually impoverished. Its images of Jesus as the Good Shepherd are often artistically so weak that they approach kitsch. Most conservatives operate in a climate that is either indifferent or hostile to art. The leading conservative writers and commentators seem blind to the intricate interconnection of art and politics in ancient Greece, which invented democracy. The nude, based on scientific study of anatomy, was the great symbol of Western individualism bequeathed to us by the Greeks, but Christian conservatives would never permit the erotic nudes of Western art to be shown in public schools. American Puritanism lingers in conservative suspicions about the sorcery of beauty.

On the other hand, a tremendous amount of major Western art has been intensely religious, and liberals, who have hounded Christmas crèches out of public squares, would similarly object to the doctrinal instruction necessary to present Christian iconography in the public classroom. Thus arts education is stymied in the United States—a victim of political cross fire. Although I am an atheist, I respect all religions and take them seriously as vast symbol systems

containing deep truth about human existence. While evil has sometimes been done in its name, religion has been an enormously civilizing force in world history. Sneering at religion is juvenile, symptomatic of a stunted imagination. Yet that cynical posture has become de rigueur in the art world—simply another reason for the shallow derivativeness of so much contemporary art, which has no big ideas left.

Given their ignorance and neglect of art, the series of public crises whipped up by right-wing politicians over offensive art in the late 1980s and 1990s was shot through with hypocrisy. But the instigators, including fundamentalist ministers, were absolutely correct that no genuinely avant-garde artist should be asking the government for support. There is no constitutional right to a government grant or to exhibition space in publicly funded institutions. Only one famous artist that I am aware of—the Beat poet Lawrence Ferlinghetti—had the perspicacity and courage to exhort the arts community to renounce its infantilizing dependence on the government dole.

Amid the controversies over sacrilege, the art world made a terrible strategic error in elevating partisan loyalties over the welfare of American art. In automatically rushing to the defense of third-rate works like Andres Serrano's *Piss Christ* (1987) and Chris Ofili's *The Holy Virgin Mary* (1996), it allowed itself to be defined in the public eye as an arrogant, insular fraternity with frivolous tastes and debased standards. There have been great works of sacrilegious art: my favorite is Salvador Dalí's parody of the Annunciation, *Young Virgin Auto-Sodomized by the Horns of Her Own Chastity* (1954), where a bored Mary, clad only in seamed nylons and loafers, leans over a balcony while casually exposing her bare buttocks to a descending flock of fat, phallic tubers, surreally suggesting angels' horns, holy doves, jostling sperm, and missile nose cones.

The mediocre Serrano and Ofili works did not deserve their fame. *Piss Christ,* whose conceptual muddle was worsened by Serrano's shaky self-defense, was a large-format photograph of a plastic crucifix mistily submerged in a glass beaker of the artist's urine. The multimedia Ofili work, mounted by the Brooklyn Museum of Art in its 1999 show *Sensation,* a Charles Saatchi enterprise imported from London, was equally confused. The British-Nigerian Ofili surrounded a cartoonish African Madonna with a collage of glued-on butterflies consisting of cutouts of female buttocks and genitalia from pornographic magazines; one breast, as well as the two stumpy pedestals, was sculpted of real elephant dung from the London Zoo. Whatever context might have been

helpfully supplied by curatorial support (such as references to African fertility cults) was completely missing.

There was a predictable explosion over the Ofili Madonna from the tabloid press and from spokesmen for New York's immense population of ethnic Catholics. The Republican mayor of New York, Rudolph Giuliani, gratuitously inserted himself into the furor by his dictatorial grandstanding in threatening to cancel the city funding of the Brooklyn Museum and evict it from its lease. The arts community, exhilarated at this new opportunity to wave the tattered avant-garde banner, leaped into groupthink mode. As with the prior flap over Mapplethorpe's photographs, there were demagogic attempts by supporters to blame the protests on racism, which had nothing to do with either controversy. Any acknowledgment of the pornographic cutouts was dishonestly suppressed in descriptions of the Ofili work by the liberal major media.

Though commercially successful for the Brooklyn Museum, *Sensation* was a public relations disaster for the reputation of art and artists in the United States. After several changes of leadership at the National Endowment for the Arts, the wounds had been slowly healing from the art battles of a decade earlier, and there was reason for cautious optimism about increases in federal arts funding. *Sensation* stopped that process cold. Conservative talk radio, now a nationally syndicated force, unsparingly informed its vast audience of the latest outrage. My own warnings to the arts community in my Salon.com column fell on deaf ears. But my fears have been realized: as the economy worsened over the intervening years, school and civic arts programs, whose rationale is not understood by many among the general public, have been drastically curtailed or eliminated altogether by strapped municipalities nationwide. American schoolchildren are paying the price for the art world's delusional sense of entitlement.

This book is an attempt to reach a general audience for whom art is not a daily presence. I have tried to chart the history and styles of Western art as succinctly and accessibly as possible. The format of the book is based on Catholic breviaries of devotional images, like Mass cards of the saints. The reader is invited to contemplate the work, to see it as a whole, and then to scrutinize its fine details. All parents who can afford it should have at least one art book lying around the house for children to encounter on their own. My young parents had E. H. Gombrich's *Story of Art* (1950), which they probably got from the Book-of-the-Month Club and which fascinated me despite its

fuzzy black-and-white pictures. Even more influential was the curator René Huyghe's *Art Treasures of the Louvre,* a 1951 collection of a hundred large, lavish color plates that my father brought home from Paris, where he had studied Romance languages for a year at the Sorbonne (1952–53) on the GI Bill. Those two books formed my sensibility by the time I had gotten to grade school. Children, as well as general readers, need handy, manageable books. Too many art books are victims of the coffee-table syndrome—big, unwieldy, glossily packaged showpieces. H. W. Janson's nine-hundred-page *History of Art,* which became an academic staple after its publication in 1962, is a beautiful but intimidating object, weighing seven and a half pounds. Janson's text is superbly erudite but moves so numbingly fast that discussion of individual works is scanted.

Each chapter here begins with a specific period or style and then moves to a representative artist and work. For the sake of readability, there are no footnotes. Outside artworks occasionally referred to (such as Sir Henry Raeburn's wonderful portrait of Eleanor Urquhart) may be easily found on the Web. I have supplied an index but no bibliography, which would take another volume. The foundation for these chapters was more than two centuries of scholarship in art history. Although my doctorate from Yale University was in English literature, my work, starting with my dissertation, has been interdisciplinary. I have incorporated the visual arts in my classes throughout my teaching career, which has been spent almost entirely at art schools—in the 1970s at Bennington College, my first job out of graduate school, and since 1984 at the University of the Arts in Philadelphia. Over the past two decades, I also developed my technique of image analysis through marathon slide lectures (up to eighty images) at public venues in the United States and abroad.

My thinking about art was impacted by an early attraction to archaeology, which confers historical perspective. The first art criticism I read (which I stumbled on in high school) was by Walter Pater and Oscar Wilde, apostles of aestheticism. They and their mentors Théophile Gautier and Charles Baudelaire remain my lodestars in approaching art in a reverential and even ecstatic way. Among art historians, my main influences have been two other products of German philology: Heinrich Wölfflin, with his critique of evolving phases of style; and Erwin Panofsky, whose theory of iconology requires layered attentiveness to idea, form, and social context. Lucidly written books by Rhys Carpenter, Sir Kenneth Clark, and Wylie Sypher broadened my understanding of art. In my upstate New York childhood, my immigrant family, with

their meticulous virtuosity in the crafts of sewing, tailoring, barbering, carpentry, masonry, metalwork, basketry, and leather working, also conveyed the age-old Italian philosophy of admiration of beauty and veneration for art and artists.

The artworks in this book were chosen to avoid overlap with those in my first book, *Sexual Personae* (1990), which highlighted Stone Age, Egyptian, and Greek sculpture, as well as Renaissance, Romantic, Pre-Raphaelite, and Symbolist painting. (I call for insurrection against the fast-moving Marxist academic trend to drop "Renaissance" for the turgid term "Early Modern," based on economics rather than art.) Scholarship has been copious on famous works like the Laocoön, the Book of Kells, and David's *The Death of Marat*, but little has been said about Bronzino's *Andrea Doria*, Friedrich's *The Sea of Ice*, Manet's *At the Café*, or Tamara de Lempicka's *Doctor Boucard*. Grosz's harrowing drawing *Life Makes You Happy!* seems virtually unknown, at least in the United States. Picasso's *Les Demoiselles d'Avignon*, the most important painting in any American museum, has drawn an enormous body of commentary, but I believe I have noticed and interpreted details that others have missed.

John Wesley Hardrick's vivacious portrait of Xenia Goodloe has been reproduced only once before, in the catalog for a 1996 exhibition at the Indianapolis Museum of Art, *A Shared Heritage: Art by Four African Americans*. I first saw Eleanor Antin's postcards for *100 Boots* reprinted in *The Village Voice* while I was in graduate school, and I never forgot them. Renée Cox's *Chillin' with Liberty* was published in the catalog for a 2001 exhibition at the Brooklyn Museum of Art, *Committed to the Image: Contemporary Black Photographers*. The thesis of my final chapter—that film director and digital pioneer George Lucas is the world's greatest living artist—emerged over the five-year process of writing this book. Nothing I saw in the visual arts of the past thirty years was as daring, beautiful, and emotionally compelling as the spectacular volcano-planet climax of Lucas's *Revenge of the Sith* (2005).

The creative energy of our era is flowing away from the fine arts and into new technology. Over the past century, industrial design, from streamlined automobiles and sleek home appliances to today's intricately customized personal gadgets, has supplied aesthetic satisfactions once mainly derived from painting and sculpture. In my experience as a teacher, industrial design students have acute powers of social observation and futuristic intuition, as well as independent and speculative minds, rarely found among today's overly

ideological intellectuals. The industrial designer recognizes that commerce, for good or ill, has shaped modern culture, whose cardinal feature is not economic inequity but egalitarian mass communication. Indeed, American genius has always excelled in frankly commercial forms like advertising, modern architecture, Hollywood movies, jazz, and rock music.

But mass media are a bewitching wilderness in which it is easy to get lost. My postwar generation could play with pop because we had a solid primary-school education, geared to the fundamentals of history and humanities. The young now deftly negotiate a dense whirl of relativism and synchronicity: self-cannibalizing pop, with its signature sampling and retro fads, has become a stupendous superabundance, impossible to absorb and often distanced through a protective pose of nervous irony. The rise of social media has blurred the borderline between private and public and filled the air with telegraphic trivialities, crowding out sequential discourse that invites rereading.

Our visual environment is highly kinetic but unstable. In the digital age, images even on news sites can be so skillfully manipulated that everything has become slippery and evanescent. Famous faces are dropped into compromising scenarios, while women's bodies are fashionably slimmed, smoothed, and lightened. Photographs of celebrities at industry galas may be instantly scrubbed before online release to the once unimpeachable wire services. TV editing has ruthlessly sped up. The dazzling fast cuts invented by New Wave director Jean-Luc Godard and popularized for music videos by Richard Lester's Beatles movies have become a stilted cliché to gin up false excitement. Movies, TV, and the Web over-rely on a constant flashing or strobing that fatigues the eye and may impede small children's cognitive development. Few young people, including college students, have patience now for the long, hypnotic takes and elegant pictorial composition of the European art films that Godard was merrily satirizing.

As digital photography has supplanted film over the past two decades (to the grief and indignation of many of my photography majors), the general public has gradually lost contact with the refinements of old-fashioned film developing. Striking, high-quality photographs of people and current events once filled the rotogravure sections of city newspapers and glossy, large-format magazines such as *Life* and *Look*, whose fraying issues have become collectors' items. Digital images are sharp and clean but lack the atmospheric shading that cues our sense of contour and depth. Digital color is supersaturated and garish, even cartoonlike, without the subtleties and fine gradations of

blended color, used in oil painting since the Renaissance. Digital photographs can seem like unnerving glimpses into the pretty but frozen world of a doll-house. Digital TVs, set at splashy wide-screen option, spread and stretch the image, imposing distortion on viewers as standard practice. Animated graphics in video games, electronic billboards, and sports telecasting create dizzily swooping compressions and tunnel-like warpings of space. The eye is assaulted, coerced, desensitized.

The only road to freedom is self-education in art. Art is not a luxury for any advanced civilization; it is a necessity, without which creative intelligence will wither and die. Even in economically troubled times, support for the arts should be a national imperative. Dance, for example, requires funding not only to secure safe, roomy rehearsal space but to preserve the indispensable continuity of the teacher-student link. American culture has become unbalanced by its obsession with the blood sport of politics, a voracious vortex consuming everything in its path. History shows that, for both individuals and nations, political power is transient. America's true legacy is its ideal of liberty, which has inspired insurgencies around the world. Politicians and partisans of both the Right and the Left must recognize that art too is a voice of liberty, requiring nurture without intrusion. Art unites the spiritual and material realms. In an age of alluring, magical machines, a society that forgets art risks losing its soul.

GLITTERING IMAGES

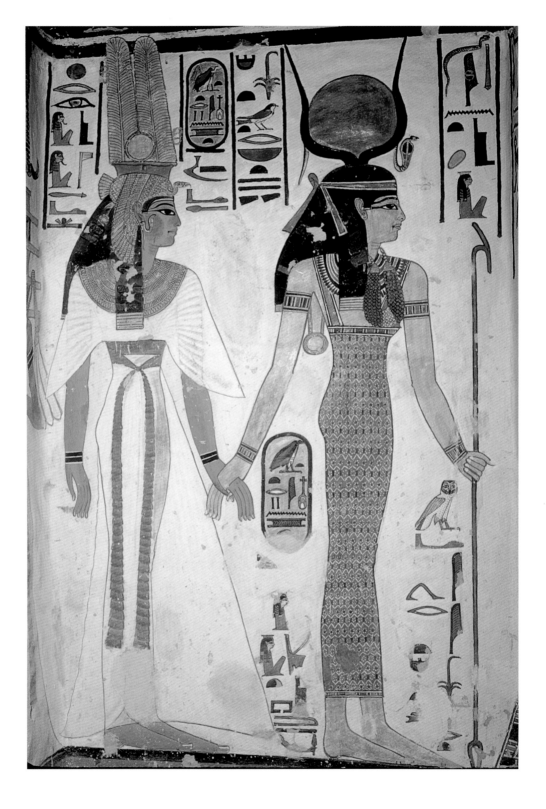

RESURRECTION
Queen Nefertari

Ghosts carved out of time. Egyptian art is a vast ruin of messages from the dead. Clean and simple in form, Egyptian painted figures float in an abstract space that is neither here nor there. The background is coolly blank. Everything is flattened into the foreground, an eternal present where serenely smiling pharaohs offer incense and spools of flax to the gods or drive their chariot wheels over fallen foes. Hieroglyphics hang in midair, clusters of sharp pictograms of a rope, reed, bun, viper, owl, human leg, or mystic eye.

Resurrection was the master value of a civilization that dreamed of conquering the terrors of death. At the heart of Egyptian religion was a corpse—the mummy of the great god Osiris, swaddled in linen strips. Osiris was murdered and dismembered by his evil brother, Set, who scattered his fourteen body parts throughout Egypt. Isis, Osiris's sister and devoted wife, collected and reassembled them—except for the missing penis, which she fabricated in wood or clay. As Osiris's embalmer and enhancer, therefore, Isis acted as a resourceful proto-artist, assembling materials and molding a work of mummiform sculpture that would be reproduced in Egyptian art and cult for three thousand years.

Passage to the afterlife meant a descent to the underworld. Souls hoping for rebirth invoked Osiris and literally became him. Despite its preoccupation with death, Egyptian art is rarely claustrophobic. The beyond was no spectral twilight but a lively zone of physical needs and pleasures. Warehousing stools, chairs, tables, chests, clothing, perfumes, ointments, jewelry, games, daggers, boomerangs, chariots, and jars of extracted viscera, the tomb was a distillation of real life. The urbane aristocrats promenading across the walls are wide-eyed and cheerful as they face the great unknown. Their majestically enthroned guardian gods often seem

Queen Nefertari and the Goddess Isis. The tomb of Nefertari, ca. 1290–1224 B.C. Valley of the Queens, Luxor, Egypt.

3

faintly comic, with the large heads of birds, beetles, or hippopotamuses, vestiges of primitive animism.

Resurrection also symbolizes our modern recovery of Egypt. For a millennium after the fall of Rome, Egypt was wrapped in a haze of occult legend. After Islam's arrival, it became a closed world whose pagan remains were ignored and neglected. Napoleon's 1798 invasion helped start Egyptology: a French officer's discovery of the Rosetta Stone led to the decipherment of hieroglyphics, while the immense, multivolumed report by Napoleon's team of surveyors and scientists set off a craze for Egyptian style that swept European architecture and decor and would even produce America's Washington Monument. Over the next century, thanks to photography, knowledge of Egypt was gradually spread throughout the world. The ancient Egyptians have finally achieved their immortality.

From earliest times through the Middle Kingdom, the rulers of Egypt were buried in sprawling necropolises at the desert's edge near the Delta, as the Nile fans out toward the sea. The principal sacred districts were at Saqqara and Giza, where the Great Sphinx, hacked out of bedrock, still guards Chephren's mammoth pyramid. After a devastating Syrian invasion, the capital of Egypt was moved four hundred miles south to Thebes. There the upstart warrior pharaohs of the New Kingdom created their own cemetery facing toward the setting sun across the Nile—the Valley of the Kings, scarcely more than a dry gulch behind the high, horned escarpment of the Libyan Plateau. Pyramids or telltale markers of any kind were prudently avoided. The coffins were buried deep in the rock and the entryways heaped with rubble. Nevertheless, most tombs in the Valley of the Kings were looted within two centuries. One that escaped detection belonged to a minor king, Tutankhamen, who died young. When his tomb was found and opened in 1922, the staggering treasures, such as his solid-gold mummy case, gave tantalizing hints of what the grave goods of a star pharaoh must have been.

Royal wives and children were buried in the nearby Valley of the Queens, where eighty tombs (called "Houses of Eternity") have been found. The most lavish one belonged to Nefertari, first and favorite wife of the imperialistic Rameses II, who sired at least forty-five sons from eight wives and who ruled for more than sixty years during the thirteenth century B.C. Nefertari's unusual status was signaled by her figure being made the same size as the king's at her shrine at Abu Simbel, where four seated colossi of Rameses were cut from a Nubian cliff on the Nile. Nefertari (her name means "the Most Beautiful of

Them All") was of noble but not royal blood. She may have been a cousin or even a younger sister of Nefertiti, charismatic queen of the rebel monotheist ruler Akhenaten. Nefertari bore Rameses's firstborn son, who died tragically young, perhaps inspiring the story in Exodus of God's curse upon Pharaoh. (In Cecil B. DeMille's epic movie *The Ten Commandments*, Anne Baxter plays a seductive Nefretiri to Yul Brynner's arrogant Rameses.) Nefertari had at least five more children, but the robust Rameses (whose well-preserved mummy survives in the Cairo Museum) outlived them all. Hence his successor, Merneptah, was the son of a lesser, rival queen.

Nefertari's tomb was discovered in 1904 by Ernesto Schiaparelli, an Italian scholar and museum director. Sunk forty feet into the bedrock, it has a twofold axis aligned to the compass points and consists of two large ceremonial

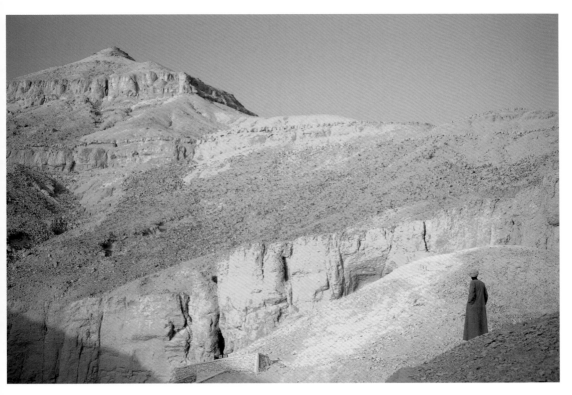

VALLEY OF THE KINGS, LUXOR, EGYPT *Pyramid-shaped mountain across the Nile from Thebes. Now called al-Qurn (the Horn). Ancient name:* ta dehent *(the peak). Sacred home of Meretseger (She Who Loves Silence), cobra goddess and vengeful guardian of the Theban necropolis.*

chambers, annexed by side chapels and niches and connected by a staircase. All that remains of the queen's pink granite sarcophagus is a smashed lid. The tomb's ceilings were painted midnight blue and spangled with gold stars to represent the heavens, while the walls and square columns were adorned with religious scenes and symbols. The raw limestone surfaces were first coated with a rough plaster of Nile mud, which was sculpted in low relief. A thin layer of fine plaster was then applied, upon which the designs were painted in tempera—always mineral pigments mixed with an unknown binder, perhaps a gum from the acacia trees of Thebes. A sparkling egg glaze was used as a sealant. Nefertari's tomb would suffer damage from an earthquake and serious deterioration from rock-salt crystals slowly deposited behind the plaster by seeping rainwater. Thanks to a major rescue project by the Getty Conservation Institute in collaboration with the Egyptian Antiquities Organization (1986–92), the tomb has been repaired, stabilized, and reopened to the public. The conservators' meticulous cleaning and consolidation (with no new paint whatever) have revealed the murals' still brilliant color.

The paintings are a narrative of Nefertari's journey toward the afterlife. She is presented as a pilgrim soul seeking justification and resurrection. There are oddly few references in the tomb to her husband and none to her children or life story. Everything is focused on Nefertari's spiritual quest. Respectful yet confident of her worthiness, she is a plucky, solitary wayfarer confronting the awesome powers and mysteries of the cosmos. Demons wait to pounce at each of five gates (out of a traditional twelve) leading to Duat, the netherworld. But Nefertari knows the sacred formulas, passes her test, and wins resurrection, proved by her being repeatedly called "the Osiris."

At a key point in her travels, Nefertari is welcomed by Isis, who takes her affectionately by the hand and leads her eastward toward the next chamber. The goddess speaks, promising salvation: "Come, King's great wife, Nefertari, beloved of Mut. I give to thee a place in the Sacred Land." The queen's name hovers in two golden cartouches (heraldic ringed medallions). Now she must meet the scrutiny and challenges of the other leading gods, including the sun god Re, the scorpion goddess Serquet, and ibis-headed Thoth. She will make offerings, appeal for aid, and play a chess-like table game (senet) with an invisible opponent, Fate.

The figures of Isis and Nefertari illustrate the strict conventions of Egyptian art, which remained virtually unchanged (except for Akhenaten's brief experiment in naturalism) for three millennia. Postures are formal and frozen and

contours firmly outlined. In Egyptian painting or relief sculpture, the head, nose, hips, and feet are shown in profile, while the eye, shoulders, and chest are seen from the front—an arresting but anatomically impossible hybrid. While wigs or fabrics may be finely patterned, draftsmanship is usually broad and cartoonlike. The palette is limited: pigment was applied in even swatches of five primary colors without shading. Egyptian paintings were made like jewelry in glittering, juxtaposed parts.

Everywhere in the tomb, Nefertari is presented as a paragon of grace and beauty, epitomizing the lofty standards of the Egyptian elite. A woman of high rank was nearly always depicted as slim, lithe, and small breasted—even if the mature reality was far from that. Nefertari wears a stylish ensemble of translucent linen: a crisply pleated cape-shawl knotted over a tight, high-waisted, ankle-length dress (*kalasiris*), smartly double-wrapped with a dangling, textured belt. Isis, in contrast, along with all of the tomb's other goddesses, wears a svelte, opaque, breast-baring sheath with shoulder straps—a design that had first appeared in Egyptian art a thousand years before and that never changed, symbolizing the gods' timeless power.

Over Nefertari's long black wig rests a magnificent golden vulture cap representing Mut, the hermaphroditic vulture goddess who was patron of Thebes. Its beak juts fiercely from the queen's brow, while its wings protectively embrace her head. A double vulture plume nesting a solar disk rises from the crown. The queen's jewelry consists of banded bracelets; a flat, broad gold collar (*wesekh*); and a rearing cobra (the royal uraeus of Lower Egypt) coiled through her earlobe. Isis's wig is wrapped by a ribbon and topped by the sky goddess Hathor's solar disk and cow horns, from which protrudes another cobra. Isis's green staff is the *was* scepter of authority; draped around her neck over her rainbow collar is a beaded necklace with two tubers (*menat*), Hathor's emblem of fertility. Its heavy gold counterpoise hangs behind Isis's right shoulder. The women's eyes (like men's eyes too in Egypt) are rimmed and extended by kohl, a sooty mascara that reflected and cooled the sunlight.

The queen's skin is red, close to burnt umber—a striking departure from the yellow tones normally given Egyptian women aristocrats. Her skin surprisingly matches that of the gods and not the goddesses in her tomb. Skin color in Egyptian art was generally a signifier of class rather than race: noblewomen neither worked in the hot sun like peasants nor exercised and waged war in the open like men. Nefertari's dark skin may refer to her unspecified activity in the public realm, also suggested by her state title, "Mistress of Upper and

Lower Egypt." As a masculine motif, her skin color would therefore parallel the pharaoh's kilt, head cloth, and ceremonial beard appropriated by the formidable Queen Hatshepsut in the prior dynasty. It is also at least theoretically possible that Nefertari, as a daughter of the south, was using mahogany skin tones to claim and promote a Nubian ancestry.

Egypt was a conservative society whose authoritarianism was bred by the harsh desert environment. Complex organization over huge distances was required for construction, irrigation, trade, and governance. Order, inextricable from truth and justice (*ma'at*), was seen as both beautiful and necessary. Hence the suave sophistication projected by gods and royals in Egyptian art had a larger ideal meaning. Artists were merely anonymous craftsmen in Egypt, but they were faithful messengers of the cultural code, generating for era after era these elegant apparitions who still haunt us.

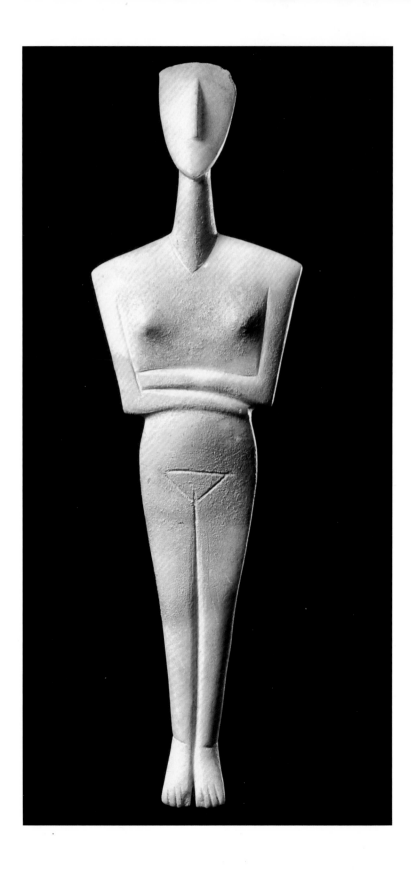

2

MYSTIC VISION
Idols of the Cyclades

What if an entire civilization disappeared and left only hidden hoards of stone dolls? That in effect is the story to date of the Cycladic idols, which have been dug out of cemeteries and ritual pits in the Cyclades, a chain of 220 arid, rocky islands in the Aegean Sea between southern Greece and Turkey. The purpose of these mysterious objects, carved from fine white marble during the early Bronze Age (3500–2300 B.C.), remains unknown. But their discovery in the late nineteenth century deeply influenced modern abstract art.

Although a few Cycladic figurines are male (in occupations such as lyre player, warrior, or hunter), the overwhelming majority are female and thus probably played some role in a regional fertility cult. Are they goddesses whose blessing is being invoked or human women praying for safe pregnancies? Artistically, they are remote descendants of the Stone Age statuettes of earth mothers that have been found throughout Europe. The most famous example, plucked from a riverbank in Austria, is the tiny Venus of Willendorf, with her pendulous breasts and bulging belly. Over a period of twenty thousand years, that corpulent design was refined and stylized, eventually producing the streamlined Venus of Lespugue (from the French Pyrenees), whose head has become a small, polished knob and whose torso is a smooth stalk rising from her bubbling hips.

The trim Cycladic idols represent a final stage in this long development. They have completely shed the ballooning silhouette of Stone Age mothers, who embodied the teeming, untidy organic principle. Classic Cycladic style is linear and coolly geometric, with smooth planes and sharp angles. It seems to be a unique fusion of the islands' earliest extant images—enthroned obese mother goddesses and flat, enigmatic violin-shaped totems. The figurines sport pert, maidenly breasts (rather than

Cycladic figurine. Early Cycladic II, ca. 2800–2300 B.C. Marble. 1 ft. 3½ in. Dokathismata type. The Museum of Cycladic Art, Athens, Greece.

11

droopy udders) as well as surprisingly long legs. Another novelty is that they have feet, unlike Stone Age statuettes, whose feet may have been ritually broken off to capture and detain the earth mother with her magical fertility. As with the latter figures, the pubis is emphatically marked by an inverted delta, an archaic symbol around the world for procreative female power. On the flat Cycladic surface, the delta has become more abstract and may be notched (extending the leg line) to suggest a vulval groove. But this is no map for male penetration: the female triangle, protected by stiffly locked legs, is stubbornly sealed.

In our figurine, Cycladic linearity is illustrated in the strangely elongated neck, a sturdy pylon supporting the ovoid head like a triangular plate or shield. It's as if a woman were becoming a praying mantis, an insect linked with prophecy in ancient Greece. She has a spiky, rudder-like nose but no eyes or mouth. Were they once painted on? Traces of color do cling to some idols. But that the face was not incised or sculpted (as Cycladic ears often were) may indicate it was thought to be of secondary importance. The Venuses of Willendorf and Lespugue are also both faceless: that absence of identity, in modern terms, is accentuated by their lowered heads, which convey an indifference to the outside world as they monitor the all-important womb. This Cycladic figurine, in contrast, has an alert aplomb, perhaps reflecting a less uncertain and more advanced society. Although lacking hands, her bony folded arms (always left above right) certainly seem more willed and potent than the feeble stumps resting on inflated breasts in Stone Age figures. She is barricaded, embracing only herself.

But the poise of the Cycladic idols may be a mirage arising from their shift in context. Photographed and displayed in museums, the figurines are positioned vertically, as if standing up. Like the Venus of Willendorf, however, they may have been originally intended to recline like sleepers or the dead laid out for immolation or burial. Ritual objects were often held in the hand like talismans. Indeed, one source of Cycladic streamlining may have been that surface detail was worn off through frequent handling over time—analogous to the weathering of white beach pebbles that may have partly inspired the statuettes in that marble-rich region. Now erect with upturned face, the idol seems attuned to higher realities, like a modern antenna picking up radio signals from the atmosphere. Her blank head appears almost helmetlike, while her body, with its wide, square, rather masculine shoulders (a feature of the Dokathismata type of idol from Amorgos), seems gloved in a filmy casing,

like a wet suit. Her springy legs and toes give her the look of a high diver or soaring space traveler.

Like the weathered colossi of Easter Island in the South Pacific, the sleek Cycladic idols are patient watchers and mystic seekers, tapping into elemental forces. The prominent head may suggest that a sense of consciousness was emerging in Aegean culture. Mind had not yet been dualistically severed from body, nor had the concept of an eternal soul been born. But progress is detectable out of humanity's early state of fearful passivity toward nature and matter. These cryptic figurines are daring explorations of form and structure, with the body represented as a skeletal frame and not simply as a heaving mass of fluid flesh.

The history of the Cycladic idols demonstrates how works of art change in meaning over time. We may never know what the figurines meant to their fabricators. But to many important modern artists—Pablo Picasso, Constantin Brancusi, André Derain, Jacob Epstein, Amedeo Modigliani, Jean Arp, Jacques Lipchitz, Alexander Archipenko, Henry Moore, Barbara Hepworth, and Alberto Giacometti—these sculptures were paradigms of a radical new simplification, breaking with the ponderousness and clutter of the Victorian period and Belle Époque. Like African and Polynesian tribal masks, the Cycladic figures became totems of exotic "primitivism" before and after World War I. Amid a revival of world mythology that was revolutionizing psychology and anthropology, they seemed to embody universal archetypes rather than the neurotic individualism of decadent Europe.

Although modernism as a movement may be nearly exhausted, the clarity and grace of these objects remain. Perhaps their spirituality can be even better appreciated now. Propped upright, the Cycladic idols are those who stand and wait—human beings battered by time and fate but still hoping for a revelation from beyond. Messages are no longer sought in the labyrinthine bowels of mother earth. The crisply carved Cycladic idols, appealing to the eye, carry an invigorating sense of the future. Even in their rightful positions on their backs, they are gazing skyward toward some other order—not necessarily a supreme deity but the shifting pattern of bright stars.

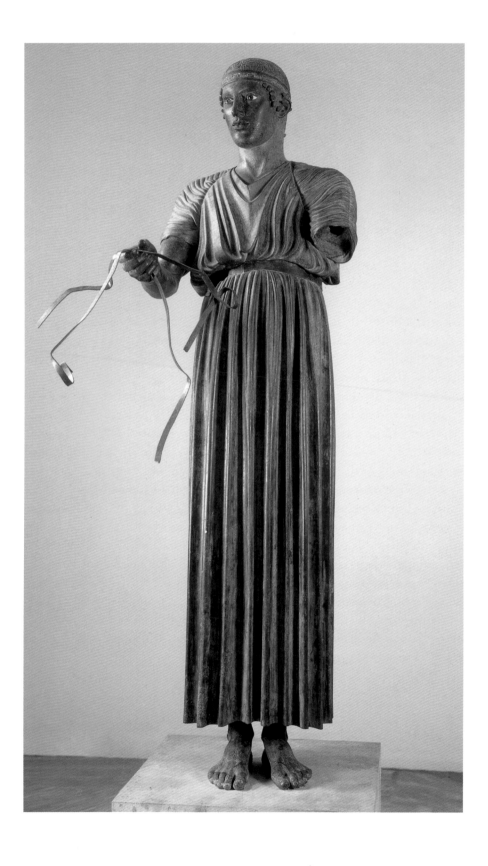

3

THE RACE
Charioteer of Delphi

The athlete was a prince in ancient Greece. In the prestige system of competitive sport invented by the Greeks, a superbly conditioned young man who triumphed over all others was a favorite of the gods. Poets composed odes to him, and sculptors memorialized his beauty. His gifts gave him charisma, an aura of divine light.

The Charioteer of Delphi is a rare example of a life-size bronze sculpture surviving from classical antiquity. We know most Greek bronzes from lackluster Roman marble copies. As police power waned during the decline of imperial Rome, metal was too valuable to be left unmolested. Tens of thousands of bronze statues were hacked to pieces and melted down by bandits or impoverished peasants. The bronzes in today's museums were recovered by luck or accident—such as when fishermen's nets entangled the silty cargo of ancient shipwrecks.

The Charioteer was found in 1896 by a team of French archaeologists excavating near the ruined Temple of Apollo at Delphi, a mountain shrine that was the most sacred spot in Greece. Pilgrims and ambassadors came to Delphi from all over the known world to consult the oracle, priestess of the sun god Apollo, who replied through her voice in riddling poetry. Kings, assemblies, generals, and tycoons built statues, altars, and treasuries at the sanctuary, neutral territory where warring city-states met in truce. Every four years, the Pythian Games were held at Delphi. Chariot racing, descended from military exercises as depicted in Homer, was staged in a hippodrome far below on the plain of Krisa, near the sea.

The Charioteer, dating from 475 B.C., was originally part of a large sculpture group consisting of four horses, a two-wheeled chariot, and one or more grooms. An inscription on the limestone pedestal identified it as a gift dedicated to Apollo by the team's sponsor, Polyzalos of Syracuse, a wealthy

Charioteer of Delphi. Ca. 475 B.C. Bronze. 5 ft. 11 in. Archaeological Museum, Delphi, Greece.

15

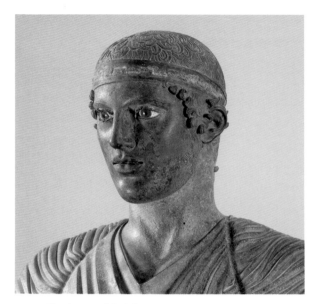

Charioteer of Delphi (detail of image on page 14)

Greek colony in Sicily. The work may have stood for barely a century: it was destroyed in a landslide, probably caused by the earthquake of 373 B.C., which dismembered the Charioteer but also buried and hid it from robbers for two millennia. The figure was found scattered in three sections (its components as cast in the foundry); only small pieces of the rest were unearthed, including a chariot pole, two horse's legs, a hoof, and a tail. We can glimpse what those horses might have looked like in the magnificent Greco-Roman quadriga long atop Saint Mark's Basilica in Venice—four gilt-copper racehorses that were looted by the Crusaders during the sack of Constantinople in A.D. 1204.

Despite missing its left arm, the Charioteer is otherwise in remarkably good condition and demonstrates the stunning quality of Greek sculpture at its height. It was created by the lost wax method: the features were molded in wax and then covered in clay; when heated, the wax ran off and left a clay mold for the liquid metal. The hardened bronze was originally gleaming gold, which oxidized to reddish brown and then the present moody green. Very few classical bronzes still retain their inlaid eyes: the Charioteer's luminous eyes are onyx set in white enamel. He has bronze eyelashes, gilt-copper lips, and

silver teeth. The ribbon headband, prettily tied in back, is patterned with a traditional Greek meander, showing traces of silver.

The Charioteer of Delphi is sculpted in the so-called Severe style, a brief interlude between the Archaic and the classical phases of Greek art that was characterized by a sophisticated formality and introspective reserve. It inherited a cardinal Archaic theme, the kouros (youth), a muscular athlete or warrior. Though no more than a fresh-faced teenager, the Charioteer is grave and dignified. Head and shoulders turned slightly to one side, he is shown riding his chariot during the victory lap, as his team of horses is led at a slow walk around the track past the cheering crowd. But he himself displays no exuberance or excessive pride (hubris). Holding the reins lightly in his extended hands, he is sober and self-controlled, mastering his emotions as he mastered the horses—a symbolic scenario in Greek myth of passions and impulses disciplined by the rational Apollonian mind. In modern sports terminology, the Charioteer has his "game face" on, impassive and distanced. He is "in the zone," described by athletes as a meditative state that blocks out distractions and inexplicably slows down time. Chariot racing, an expensive sport that required rich patrons, was notoriously difficult and dangerous: both drivers and horses could be killed, particularly in the turns, where chariots spilled or collided. Hence the Charioteer's steady stare might also be registering shock and awe at a near-death experience.

Greek athletes were not specialists but talented amateurs who trained for many events. Unlike runners or wrestlers, however, charioteers did not compete in the nude. Their ankle-length tunic (the *xystis*), originally a shield against dust and debris, was oddly the same one worn by Greek musicians. The Charioteer's tunic, exposing only his muscular arms and strong bare feet with tendons and veins realistically rendered, is a pleated chiton in the Ionian style. It is itself a work of art: the seamed sleeves ripple and eddy like a mountain stream, and the skirt falls in fluted grooves like an Ionic column. None of the folds in this garment are exactly the same—which is partly why the statue seems so alive. The high belt joins a yoke that crisscrosses in back to prevent the tunic from filling and dragging like a sail in the wind. If the Charioteer's legs seem overlong, it's because, elevated on his pedestal, he was seen from below, where the view would have been partially blocked by his low chariot.

The Charioteer's ephebic face is uniquely Greek, a look that would become canonical for gods and heroes in the classical tradition. His brow is high and

wide, and his nose straight and narrow, with an unbroken bridge. His mouth and beardless cheeks are full, with a short upper lip and a prominent, fleshy chin. His crown of hair is treated schematically, as if matted with sweat, but his sideburns and escaping curls have a playful, even flirtatious expressiveness. Greek homosexual idealism glamorized young male beauty without necessarily (as we see in Plato) seeking physical contact. The Charioteer's intricate, body-shrouding garment symbolizes his remoteness and chastity: most Archaic male statues had been boldly nude. His spiritual balance can also be felt in the even, forthright distribution of weight between his feet. As he gazes to his right, his eye line cuts at an angle across the tunic's folds, creating complex visual interest and reinforcing a sense of his collected composure.

The Charioteer of Delphi represents a stillness of perception, a peak moment where an exceptional person has become a work of art, the focus of all eyes, human and divine. He embodies the Greek principle of *kalokagathia,* "the beautiful and the good," which saw virtue and physical beauty as inseparably intertwined. The Greeks defined existence as a struggle or contest (agon) that tested and built character. To strive to be the best was a moral duty. Life was a perpetual game or race, with little hope of rest. The mad motion on the dirt track may be forgotten for an hour, as the winner humbly accepts his tributes. But victory is as transient as a young man's perfect beauty, which the Greeks described as a flower that blooms and vanishes.

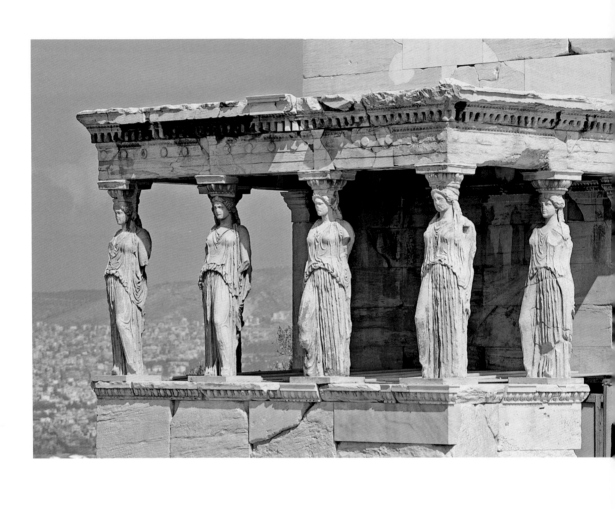

4

ROOF OF AIR
Porch of the Maidens

When is the burden of the gods lighter than air? Six stately young women stand like sentinels on a marble parapet atop the Athenian Acropolis. They are gazing at the Parthenon, the great temple of Athena that, even in its present ruin, is one of the marvels of the world. Casual and relaxed, the women are balancing a heavy stone roof on their heads. It is a remarkable display of female power: voluptuous curves combined with massive, muscular strength.

Since the Roman era, columns shaped like women have been called caryatids. The word comes from the Spartan city of Caryae, where young women did a ring dance around an open-air statue of the goddess Artemis, locally identified with a walnut tree. Antiquity's most famous caryatids were these six of the Acropolis. The Athenians, however, called them korai (maidens), their term for votive images that were female counterparts to the athletic kouros statues of Archaic art. Each Acropolis caryatid may once have held an offering plate or vessel in her outstretched hand (none of the fragile forearms survive). The young women are dressed in a fine peplos, a tunic doubled back at the bodice in a bottom-heavy arc and pinned at the shoulders with a brooch. Their long hair, falling in a loose braid down the back, presumably signals their unmarried status, since contemporary Greek matrons wore a chignon. The caryatids' fleshy physique is distinctly revealed by their "wet look" robes (also worn by goddesses on a Parthenon pediment). These pensive girls with their broad, ripe, thrusting breasts seem eagerly poised for marriage.

The Porch of the Maidens, as it came to be called, was a closed side chapel of the Erechtheum, a jammed, multilevel amalgam of three small temples named for Erechtheus, an early king of Athens. The inaccessibility of the porch may have symbolized the maidens' protected virginity. With pointed emphasis, the porch rests on stepped platform blocks of the old temple of Athena, which

Porch of the Maidens. 421–05 B.C. Pentelic marble. The Erechtheum, Acropolis, Athens, Greece.

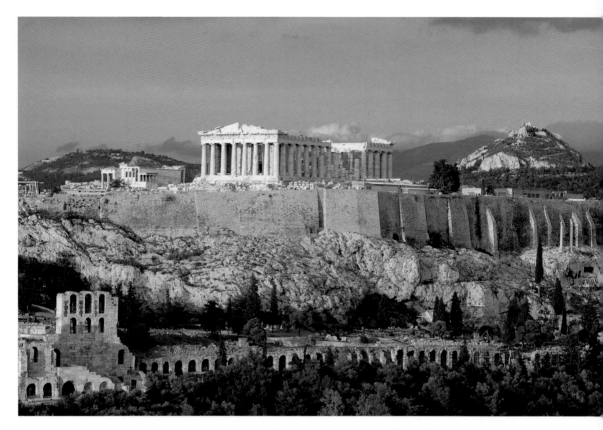

ACROPOLIS, ATHENS, GREECE *The caryatids of the small Porch of the Maidens on the Erechtheum (left center) gaze at the Parthenon (center), the great temple of Athena. At far right is the rock peak of the Areopagus, associated with ancient law courts and justice.*

was destroyed by the invading Persians in 480 B.C. Stored in the Erechtheum was Athens's most sacred object, the Palladium, a primitive, life-size wooden statue of Athena Polias, protector of the city. Also inside was a rock cleft said to have been made by the trident of the sea god Poseidon when he fought Athena for ownership of the new city. A hole in the roof marked where his trident had shot to earth and created a salt spring; when the wind was right, the cistern roared like the surf. The caryatids overlooked a walled garden harboring an ancient olive tree, Athena's gift to the city when it was named in her honor. Burned by the Persians, the tree miraculously sprouted again and reportedly lived for centuries. Off the garden lay a den for snakes, honored as guardian spirits of the hill.

The caryatids face the Parthenon, dedicated to Athena Parthenos ("the Virgin") during the high-classic era dominated by the cultivated statesman Pericles. Every year the great Panathenaic procession passed by on its path to the outdoor altar of Athena Polias, just beyond the Parthenon. Its purpose was to bring a new peplos, woven by the women of Athens, to adorn the old statue of Athena Polias in the Erechtheum. Displayed on a cart drawn through the city from the Dipylon Gate, the garment was hung on a mast like a sail on a ship. Thus the caryatids seemed to join the procession as it neared its goal.

The six living pillars of the Porch of the Maidens recall the distant organic origin of all architectural columns—bundled reeds or tree trunks. The women resemble a grove of trees, with the stone roof as their shady canopy. The sculptors (possibly Alkamenes and Agorakritos, students of Pheidias) have given the caryatids a dynamic contrapposto stance—one leg engaged and the other free, so that a draped thigh juts provocatively forward. Vertical folds of fabric carry visual energy up like a fountain to the women's faces, where it spills back down their bodies. The capital, where each statue's head meets the block, consists of a cushioned crown sculpted with an egg-and-dart pattern, its fat ovals bulging from the imagined pressure. These crowns may in fact be baskets, such as those filled with barley and sacrificial ribbons and carried by young noblewomen in the Panathenaic procession. Women also bore baskets on their heads during secret rites of the mother goddess Demeter at her shrine in Eleusis, near Athens. The Eleusinian baskets contained mysterious ritual objects, possibly including phallic fetishes. In a parallel ceremony on the Acropolis, two young girls with covered baskets on their heads descended through a secret rock staircase near the Erechtheum to the Gardens of Aphrodite below: the baskets held holy objects known only to the priestess of Athena.

Both the Parthenon and the Erechtheum remained relatively well preserved for a thousand years until they were caught up in war. Under the Ottoman Empire, the Parthenon became a mosque and the Acropolis a fortress torn by gun battles between the Turks and the invading Venetians. Munitions stored in the Parthenon blew up in 1687, severely damaging the temple and sending debris flying against the Erechtheum. After more violence during the Greek war of independence in the early nineteenth century, the Erechtheum collapsed, leaving the Porch of the Maidens standing. Travelers reported flecks of dazzling white marble exposed where bullets had hit the caryatids and chipped off their patina. One of the statues was among the Acropolis sculp-

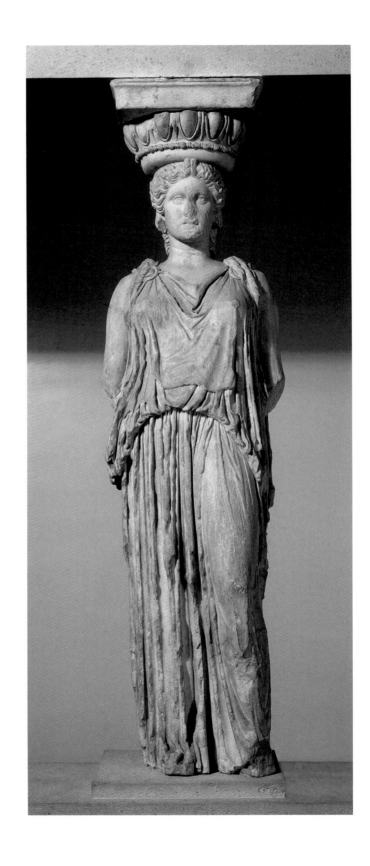

tures removed by Lord Elgin, the British ambassador to Constantinople. Now in the British Museum, along with the other "Elgin Marbles" whose return has been demanded by Greek patriots, that caryatid is in better condition than its five companions, who were eroded by acid pollution in modern Athens. In 1979, they were moved to the Acropolis Museum, with fiberglass replicas put in their place.

In his famous manifesto on architecture, the Roman writer Vitruvius propagated an error about the Acropolis caryatids: they depict, he claimed, the humiliated and enslaved matrons of Caryae, punished by fellow Greeks because of its treacherous defection to the Persians. But it is unlikely that the Athenians would have devoted such a monumental and sensitively placed statement to that remote event. Furthermore, the entire power of the caryatids comes from our sense that the women's subordination is not imposed but freely chosen. Spaced at a generous distance, they seem like confidently complete individuals who belong to a dedicated cohort. They are a sisterhood with one thing weighing on their minds—service to the gods. The air around them is transparent yet highly charged with religious feeling.

By one of those optical illusions for which the architects of the restored Acropolis were renowned, the two central statues (their knees in mirror-image reversal) seem to carry the brunt of the roof. Its rectangular corners fall over the weight-bearing but recessive legs of their outlying sisters. Hence the roof seems to float, as if the women were supporting it by thought alone. Their dignity shows how the Greeks honored their gods—not through genuflection or self-abuse but through assertions of human value and pride.

Caryatid from Porch of the Maidens.
Pentelic marble. 7 ft. 7 in. Removed by
Lord Elgin from the Acropolis in Athens
and now in the British Museum in London.

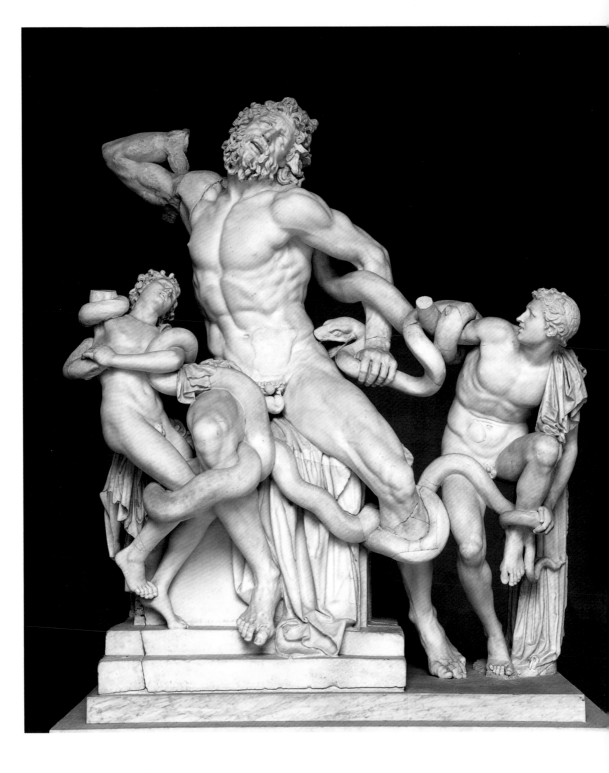

5

GOD'S SNARE
Laocoön

An altar on the shore beneath the high walls of Troy. A priest, the prince Laocoön, is sacrificing a bull in thanks for the Trojans' defeat of the Greeks, who had besieged the city for a decade. Suddenly two huge serpents shoot from the sea to attack him and his sons. We are witnessing their death throes: Laocoön and his younger son are bitten by the venomous serpents and wrapped in their coils. Will the elder boy, more lightly snared, escape?

The horrific tale of Laocoön, which does not appear in Homer, was well known in ancient literature and art. Sophocles, for example, wrote a lost play called *Laocoön*. But it was Vergil's lurid treatment of the episode in the *Aeneid* that became canonical. In earlier versions, Laocoön (Aeneas's uncle) was a priest of Apollo who violated his vow of chastity by marrying or by having sex in the sanctuary. In the *Aeneid*, however, Laocoön offends the warrior goddess Minerva, a fierce Greek partisan, when he warns the Trojans against a giant wooden horse consecrated to her by the Greeks before they sailed away. He hurls a spear at it, and its hollow belly, packed with Greek commandos, echoes ominously. Vengeful Minerva sends the serpents, who swim from an island where the Greek army is secretly camped.

The deepest theme of the Laocoön legend is theodicy: God's justice, a conundrum facing every religion. Are the gods' codes and demands fair or arbitrary? What constitutes an appropriate or excessive penalty for human transgression? The gods can seem tyrannical or cruelly indifferent. Why, for instance, should one bite of an apple condemn Adam and Eve and all future humanity to hard labor and death? Why were terrible sufferings heaped on pious Job merely for God's idle wager? Laocoön's grisly fate was a prelude to the destruction of a civilization. After the duped Trojans dragged the wooden horse through their gates, the Greeks jumped out, torched the city, and massacred or

Laocoön and His Sons. Ca. first century B.C. Parian marble. 6 ft. 10 in. × 5 ft. 4 in. Belvedere Courtyard, Pio-Clementino Museum, Vatican City.

enslaved its people. So Laocoön had spoken the truth ("Beware of Greeks bearing gifts"), for which he was strangely punished by the gods.

A bronze Laocoön with two figures may have been made in the second century B.C. on or near the Greek island of Rhodes, famous for its bronze colossus in the harbor, one of the wonders of the ancient world. It was an anxious period of political instability: Rhodes was under the sway of Pergamon, the commercial and cultural capital of the eastern Mediterranean, then losing power to rising Rome. A century later, a marble copy of the statue (perhaps encountered on Rhodes by the visiting emperor Tiberius) was evidently commissioned in Rome because of the fame of Vergil's epic. The Roman writer Pliny the Elder (who died in the eruption of Mount Vesuvius) saw it in the palace of his friend and future emperor, Titus, the brutal conqueror of Judaea. Pliny attributed it to three Rhodian sculptors, Agesander, Polydorus, and Athenodorus, and called it the most magnificent work of art that painting or sculpture had ever produced. The statue may have formerly been on display in Nero's sprawling Golden House nearby.

The Laocoön now standing in the Belvedere Courtyard of the Vatican was found in pieces in 1506 by Felice de Freddis, the owner of a vineyard who was apparently digging the foundations for his still-extant house on the Oppian Hill near the ruins of Titus's imperial baths. After a sad decline in the late Middle Ages, Rome was being revived and expanded by ambitious popes. The ancient artifacts turning up at construction sites were of keen interest to the new Renaissance humanists and artists. Pope Julius II, an avid patron of the arts, ordered an immediate inspection of the partially excavated statue by the architect Giuliano da Sangallo, who was accompanied by his friend and fellow Florentine Michelangelo Buonarroti, then working in Rome. Michelangelo's convenient arrival on the scene has inspired an intriguing theory that the Laocoön may be a forgery by Michelangelo himself, who had counterfeited at least one early piece for the lucrative antiquities market. The assumption remains, however, that the statue is genuine and that it survived the fall of Rome because it had been boarded up in an empty cistern (a reservoir for the baths) to hide it from marauding Vandals. The pope was certainly convinced: he quickly bought it for his private collection and had it transported in a procession hailed by church bells through the streets, where it was showered with rose petals and welcomed to the Vatican by the chapel choir.

Whatever its provenance, the Laocoön is an undeniable masterpiece that made an enormous impact at its discovery and has heavily influenced theo-

ries of Western art. The cultivated eighteenth-century German writer Johann Joachim Winckelmann, a foundational figure for both art history and archaeology, praised the Laocoön as a supreme expression of the "noble simplicity and quiet grandeur" of Greek classicism. In a treatise on aesthetics called Laocoön, the philosopher Gotthold Ephraim Lessing challenged Winckelmann from a literary perspective. Modern art historians, also diverging from Winckelmann, see the Laocoön as a work not of serene high classicism but of a later, international stage of Greek art that they call Hellenistic, characterized by heightened emotion, restless design, and a harsh realism or sensationalism.

Indeed, the Laocoön seems at first to be a chaotic welter. Especially without the original paint, it is difficult to decipher how many snakes there are and what they are doing. (They have been identified as reticulated Asiatic pythons.) Consisting of seven separate pieces, the Laocoön, like many Hellenistic works, was designed like a theater set for frontal viewing. From an angle, it degenerates into an undulating mass of limbs and coils. The serpent's bite makes Laocoön's torso flinch and bend like a bow; his chest expands, and his abdomen contracts, while his sinewy legs and feet go slack, already sapped by venom. His painfully strained shoulders, biceps, and rib cage seem ready to burst.

Should both sons die (Vergil's serpents devour them), it would mean the end of Laocoön's line. But he seems to ignore his imperiled sons, so caught up is he in his private drama, his shock at the gods' betrayal. The boys' slim figures make their burly father seem disproportionately large, as if he has gained semidivine stature through the intensity of his protest and resistance. The despairing gesture of hand to head, made by both Laocoön and his younger son, signifies expiring and death. (This correct position was restored when Laocoön's missing right arm was found in a Roman stonecutter's shop in 1905.) It is actually a feminine formula, borrowed from classical Dying Amazon statues. Given Laocoön's heavy muscularity and tendon-popping extremity, the overall effect is an unsettling combination of hypermasculine assertion with melting female passivity.

Typical of Hellenistic art here is the struggle against shadowy, indefinable forces. Man is no longer in command of his fate. Patriarchy, represented by the mature virility of the bearded priest, is helpless. Despite his imposing bulk, Laocoön cannot even stand on his own two feet: he has staggered backward onto the altar and been stripped of his robes. The perfection of the ideal male form, celebrated by Greek art, is violated and profaned. Nudity now signifies

not strength but vulnerability. In the hypothetical Renaissance restoration of the statue, there is even a hint of rape and castration in the writhing serpent's fanged assault on Laocoön's hip.

Laocoön's blank, tormented face seems to ask whether an ethical standard exists in the universe or whether the gods too are subject to impulse and caprice. It prefigures the agonized expression of the crucified Christ in medieval art, when he asks why God has forsaken him. The juxtaposition of beauty and horror in the Laocoön is close to decadent. It forces a mixed response of attraction and repulsion on the viewer. In late phases of culture, basic survival needs have been met, but the spiritual life is in disorder. The Laocoön represented a time very much like our own, when civic and religious traditions were breaking down and when nations felt they were in bondage to a host of intractable problems, slithering and ungraspable.

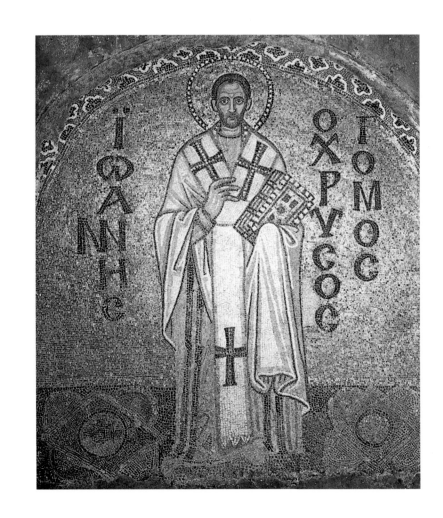

6

SKY OF GOLD
Saint John Chrysostom

In the Middle Ages, the chronicles of the Christian saints supplanted the hero legends of antiquity. Early saints were generally church leaders or martyrs, including many courageous women of the patrician class. They were shown in sacred art as strong, defiant personalities whose lives followed a mythic pattern of quest and struggle.

Saint John Chrysostom (ca. 347–407), a doctor and patriarch of the church, was a major player in the seething controversies of his time, when Christian theology was still in flux. *Chrysostomos* is a Greek honorific meaning "Golden Mouth," a tribute to John's spellbinding eloquence as a preacher. He was born and bred in the sophisticated commercial city of Antioch, in the southern region of modern Turkey. From his start as a priest, he was drawn to extreme asceticism, a regime of self-discipline that seriously damaged his health. His diet was so frugal that he is sometimes cited as a pioneer of vegetarianism. John's sermons became renowned; indeed, divinity schools still study his Easter Address as a model of oratory. In his long war against heresy, however, John drew so firm a line between Christianity and Judaism that modern historians would indict him as an early source of European anti-Semitism.

John was appointed bishop of Antioch and then archbishop of the great capital city of Constantinople, where he clashed with the luxurious and sybaritic imperial court. He bitterly feuded with the headstrong empress Eudoxia, who may have been wielding near-monarchic power due to the illness or incompetence of her husband. From the pulpit of the basilica of Hagia Sophia, John invoked the Bible to denounce Eudoxia as a faithless Jezebel and corrupt Herodias, charges that nearly cost him his head—the fate of Herodias's antagonist John the Baptist. But the palace merely deposed and banished the archbishop twice. After his second demotion, John's sup-

Saint John Chrysostom. Ninth century. Mosaic. Hagia Sophia Museum, Istanbul, Turkey.

33

HAGIA SOPHIA, ISTANBUL, TURKEY *A Christian basilica built in the sixth century. Minarets for the call to prayer were sporadically added after its conversion to a mosque in the fifteenth century. It is now a national museum.*

porters rioted and set fire to the basilica, wrecking its roof. Old and ailing, John would soon die on a forced march through the countryside.

Hagia Sophia (the name refers to Christ as God's "holy wisdom") has been ruined and rebuilt several times after earthquakes or civil disorder. The present immense building in Istanbul dates from the sixth century A.D. Filled with radiant light from the forty windows of its great dome, it is a masterpiece of the ornate Byzantine style. That word is derived from the city's original name, Byzantium, which was founded by Byzos, a Greek colonist. In the fourth century A.D., the city was renamed Constantinople in honor of the Roman emperor Constantine, who had converted to Christianity. When the city was conquered by the Ottoman Turks, Hagia Sophia was turned into a mosque. Four tall minarets were eventually added and all Christian symbols removed or whitewashed.

Over the centuries, Hagia Sophia suffered serious deterioration. A restoration was ordered by Sultan Abdul Medjid in 1846. During the project, led by two Swiss architects, the lavish medieval mosaics were exposed and recorded but then plastered over again. The drawings made at that time are all that remain of many mosaics, which later collapsed during an earthquake. When the Turkish Republic was established after World War I, its first president, Kemal Atatürk, severed civil government from Islamic law. One of his boldest moves was to turn the mosque of Hagia Sophia into a national museum. In 1932, the mosaics were uncovered again by the Byzantine Institute of America.

The life-size image of Saint John Chrysostom in Hagia Sophia is located forty feet up the northern wall of the nave below the dome. There were once three strips (registers) of mosaics on the facing walls, depicting angels, prophets, and bishops, but they are gone. Of the fourteen bishops, for example, only three survive. Mosaic, a jigsaw of colored glass or tile, is normally very durable because it is bonded to wall, ceiling, or floor and becomes part of the architecture. In Hagia Sophia, the prophets and patriarchs are shown as literally foundational to the church that they helped create: stern and vigilant, they invest the very structure with their spiritual energy and fortitude. John makes a gesture of blessing (the Sign of the Cross) with his right hand, while he cradles the Holy Scripture in his other arm. His left hand is respectfully shrouded in his robe, as if the book, bound in gold and studded with huge emeralds and pearls, were burning with the truth and too hot to touch.

The mosaics of Hagia Sophia are icons, sacred images that functioned as protectors of people and cities. In portable wooden form, icons were carried by armies into battle. Icons continue to be revered in the massive icon screens standing before the altars of Greek and Russian Orthodox churches. During the early Middle Ages, Constantinople was torn by street violence over icons, which were condemned on biblical grounds as idolatrous. Iconoclasm—vandalism and outright destruction of sacred images—was approved and sometimes instigated by the emperor or the pope. Iconodules (defenders of icons) were often women, commoners as well as aristocrats.

Saint John Chrysostom's image displays the principal features of Byzantine style. The composition is shallow; that is, the picture lacks depth, and everything is packed into the foreground. The figure is sharply outlined, as if carved, and observes strict frontality: John faces squarely forward and stands stiffly with equal weight on each foot. There is dual perspective: John is seen from the front, but the brightly patterned floor is seen from the ceiling, so

INTERIOR OF HAGIA SOPHIA, ISTANBUL, TURKEY *Northern tympanum below the dome and above the second-floor stone gallery. Mosaic of Saint John Chrysostom is in fourth niche from left (where black railings are removed). Mosaics of four other saints, as well as all seven figures in the facing southern tympanum, were destroyed by earthquakes. The large Islamic calligraphic wooden medallion asks for God's blessing on the caliph Ali, the prophet Mohammed's cousin and son-in-law.*

that he seems to hover. The shape of the basilica dome is echoed in the fiery arc of flowerlike stars above his head. The orbs embedded in the floor may be the sun and the moon: in the Book of Revelation, Sophia (a personification of Christ's wisdom) is "arrayed with the sun, and the moon was beneath her feet, and on her head was a crown of twelve stars" (12:1).

The field of gold behind John represents spiritual space, the dimension of eternity. Words in Byzantine art—a name or a biblical text—float in the air, like a disembodied voice. Here the hanging Greek letters, read vertically as in East Asian scripts, say, "John Golden Mouth" (IOANES CHRUSOS TOMOS). The standard Byzantine backdrop of glittering gold has wonderfully become a misty extrusion of John's honeyed speech. Byzantine art is rigid and static because it shows a transcendent reality, beyond movement and change. But these Greek letters are so gracefully cut and detailed that they seem alive, like winged presences—vibrations from John's powerful personality.

John's receding reddish-brown hair is monastically cropped, and his short beard is flecked with gray. Under his long cloak, he wears a bishop's white vestment, based on the Roman tunic. Its color bands (clavi) on cuff and skirt are red and blue, recalling the stream of blood and water from Christ's side when it was pierced by a Roman spear. Over John's robe hangs a gold-fringed yoke (omophorion), a symbol of priestly duty imitating Christ's sacrificial burden. Its three blue-bordered red crosses allude to the Holy Trinity and to Calvary's triple crucifixions. John's head, framed by a spangled halo, seems disproportionately small, while his right hand is overlarge. Though tendons are carefully delineated, the hand is far less skillfully executed than the well-shadowed folds of his robe. Even allowing for the inflexibility of mosaic as a medium, these lapses demonstrate the costly loss of mastery of anatomy due to the suppression of the classical nude in Christian art. That skill would be slowly recovered by painters and sculptors studying ancient artifacts during the Renaissance.

The most unforgettable aspect of the image of Saint John is its implacable intensity of gaze. Byzantine icons are always severe and demanding in the uncompromising attitude they project toward us in our frivolity and sloth. The punitive asceticism of John's real life lingers in his haggard, unshaven look. His insomniac eyes pierce us, but do they really see us? The icon endorses fanatical devotion to God's word, a renunciation of pleasure and a mortification of the body, which seems to be flattening and shrinking, as tainted matter dissolves into perfect gold.

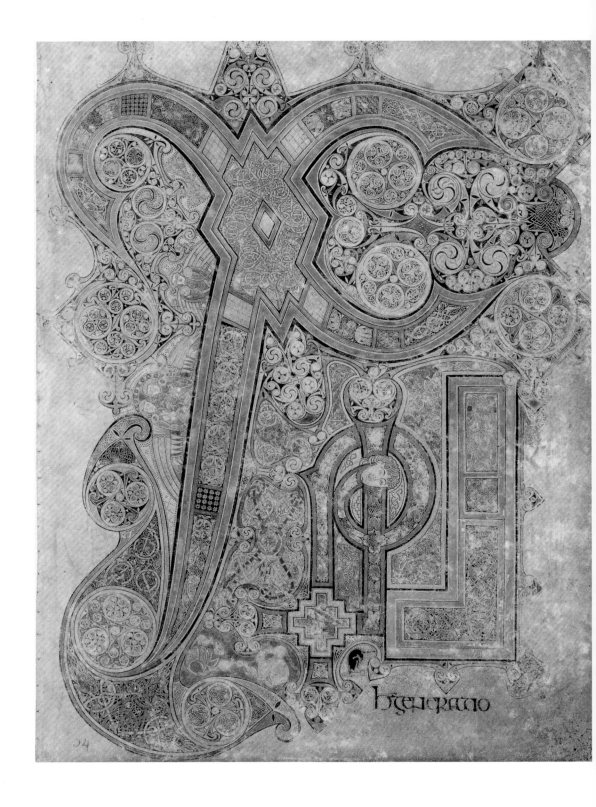

hgeneratio

7

LIVING LETTERS
The Book of Kells

The Book of Kells is an intricately decorated manuscript of the Gospels that is one of the most beautiful objects surviving from medieval Europe. It was probably produced in the late eighth century at an Irish monastery on the Scottish island of Iona. After a devastating attack by Vikings during which sixty-eight monks were killed, the book was taken to the Abbey of Kells in Ireland. The Annals of Ulster record its theft from a church in 1007; two months later, it was found buried but missing its jewel-studded gold cover. During the English Parliament's conquest of Ireland, when the decaying church was occupied by Oliver Cromwell's cavalry horses, the book was rescued and shortly afterward given to Trinity College in Dublin. Since the mid-nineteenth century, when it was still called Saint Columba's Book, it has been on public display at Trinity's Old Library.

We will never know how many sacred books were looted or burned during the Viking raids: the Danes were especially notorious for their wanton destruction of books. The principal manuscripts left from that period—the Book of Durrow, the Lindisfarne Gospels, the Lichfield Gospels, the Book of Armagh—represent the creative high point of Christian Celtic art, which began with the arrival of Christianity in Ireland in the fifth century, when Saint Patrick famously drove the snakes into the sea.

Pagan Celtic culture was born a thousand years earlier in central Europe, from which it spread in every direction. "Keltoi" was the Greek name for the barbarians of the far north. The Celts were tribal warriors, first shepherds and then farmers, who were extraordinarily adept at metalwork. Superbly crafted objects have been found in tombs, treasure hoards, and rivers, into which offerings were thrown—ornate sword hilts, helmets, shields, mirrors, jeweled brooches, braided torcs (heavy collars worn by both sexes). The Celts' nature religion, ruled by four hundred gods, was based on fear and pro-

Chi-Rho Page, Book of Kells. Eighth century. Vellum. Trinity College Library, University of Dublin, Ireland.

pitiation of the savage elements. Its symbols, heraldic beasts, and mobile plant forms curiously lingered in Christian Celtic art. Prehistoric standing stones, for example, incised with solar circles, evolved into the formidable, wheeled High Crosses that dot the Irish landscape.

The lacy maze of knotted and vegetal patterns in Celtic art may have originated in the ancient Middle East. Human figures are small and incidental, often tangled in the serpentine network or sprouting from it like shoots. At first, Celtic art, with its curvilinear rhythms, busy all-over format, and lack of a focal point, was not valued by critics schooled in the simplicity and symmetry of classicism. But when the Book of Kells went public during the Victorian period, it helped trigger a Celtic Revival and became a symbol of militant Irish nationalism. Its restless plant forms would reemerge in the stylish running vines and organic curves of Art Nouveau jewelry, posters, book covers, lamps, ironwork, and architecture.

The Book of Kells appears to have been made by three different monk artists. It contains a Latin Vulgate translation of the Greek Gospels plus supplementary prefaces and guides. The 339 leaves are sheets of calfskin (vellum), inscribed with duck, goose, or crow quills and painted with fur brushes. The inks were compounded of soot black and plant and mineral pigments, some quite rare. No gold whatever was used, implying its limited availability. Over time, the book suffered serious water damage and lost pages as well as margins, which were crudely trimmed by an eighteenth-century binder.

Lettering in the Book of Kells is profusely embellished, while the borders are filled with amusing caricatures of sprightly animals and acrobatic humans with twisting, taffy-like bodies. The anonymous monks left both a spiritual and a carnal record: in details so tiny they need a magnifying glass, men playfully yank each other's beards, sprawl in stupefied drunkenness, and grope each other under their cloaks. This renegade carousing, like that in the *Carmina Burana* (songs of wine and wenching by medieval German monks), suggests that the ascetic monasticism that had arrived in Ireland from Egypt in the sixth century had been replaced by a more relaxed and indulgent modus vivendi.

The most splendid page of the Book of Kells is the Chi-Rho. These two Greek letters (**X P**) attached to the Latin text are a conventional abbreviation of Christ's name, here appearing at the start of the Christmas story in the Gospel of Saint Matthew. Illuminated letters, enlarged as a visual aid, were a unique feature of medieval art and sometimes contained entire stories or

fanciful menageries. Matthew says, "Christi autem generatio sic erat" ("The birth of Christ moreover happened like this"; 1:18). The Book of Kells blows up the first letter of Christ's name (Chi) to huge size and tucks the smaller second letter (Rho) directly beneath, where it resembles a pinned brooch (like the filigreed Celtic Tara Brooch). "Autem," a minor conjunction, is deleted. Then "generatio" (birth) is compressed and dropped to a modest row of letters at bottom right, where it is overshadowed by the towering Chi.

Except for its crisp edging of heart-shaped leaves or pods, the Chi-Rho page has none of the usual Celtic plant forms. Nearly everything has turned geometric and crystalline, as in metalwork. The design is filled with spiraling curves and compartments of squares, rectangles, diamonds, trapezoids, rhomboids, and above all circles nested within other circles, like whirring gears. The smaller circles, called triskelions, contain three rotating or running legs, a symbol of the life force, as in the ancient swastika. The swirling triskelions resemble a shower of spores, conceptual bubbles from the ultimate Christian triad, the Trinity.

Scattered amid the dense abstractions of the Chi-Rho page are small animistic details, inserted without regard for direction because there is no up or down in celestial infinity. Three attentive flying angels of the Nativity hold books and flower scepters. A butterfly rimmed with tattoo-like red dots signifies metamorphosis and resurrection. Jesus as a vigorous blond youth pops from the coil of Eden's serpent, whom his mother will crush: the snake's body leads like a road to the Cross. A black otter catches a fish, an early symbol of Christ. Two fat, lazy cats watch mice stealing a Communion host (possibly a joke about Christ's crucifixion between two thieves).

The Chi fills and dominates the page. It seems like a bobbing blossom or ramping animal, perhaps a wide-eyed lion (a frequent motif in the Book of Kells), whose snorting nostrils are filled with the Creator's life-giving breath. The vibrating letter has an eager, supercharged energy that threatens to spin it into space. But its propulsive momentum is halted and controlled by a rectangular barrier at the lower right, like a carpenter's square from Nazareth or a fortress wall of the City of God. Perhaps this block is the "chief cornerstone" rejected by the builders with which Jesus identifies himself elsewhere in the Gospel of Saint Matthew. With its swooping hard edges and dazzlingly dense forms, the Chi-Rho of the Book of Kells embodies the mathematical perfection yet feverish vitality of an evolving cosmos designed by an invisible master architect.

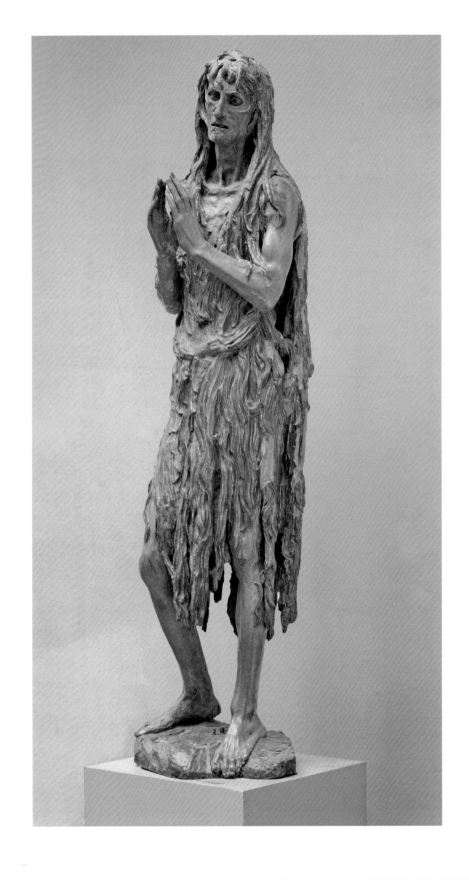

SOLITARY WATCHER
Donatello, *Mary Magdalene*

The sculptor Donatello was a pioneer of the Italian Renaissance, literally a "rebirth" of Greco-Roman ideals of reason and beauty. His bronze statue of David standing dreamily over the severed head of Goliath was one of the most influential works in art history—the first "beautiful" nude and the first life-size, free-standing sculpture since the fall of Rome. The fees for Donatello's prolific commissions are heavily documented in Florentine archives, but little else is known about him except that he was apprenticed to a leading sculptor and goldsmith, Lorenzo Ghiberti, and became a friend and protégé of the powerful merchant prince Cosimo de' Medici. Pugnacious, bearded faces (including that of Goliath) in several of his works may have been self-portraits. The erotic aura of his startlingly young David has led to speculation that Donatello was a pederast. Despite homosexuality being both illegal and persecuted, there was evidently a thriving gay subculture in Florence, clustered around salons of Neoplatonic philosophy. It was from this sophisticated milieu promoting Greek love that Botticelli, Leonardo da Vinci, and Michelangelo would emerge.

Donatello's chief sculptures are of men: resolute Saint George in armor; grim Habakkuk (Zuccone), an Old Testament prophet; vigorous Gattamelata, a mercenary warlord astride his splendid charger. Donatello's two most important female sculptures have masculine attributes: the Hebrew heroine Judith, raising a heavy scimitar over the languid body of an enemy general; and Mary Magdalene, standing watch with her square jaw, lopped bangs, sinewy calves, and boyish biceps.

The wooden statue of Mary Magdalene is so harsh and imposing (over six feet tall) that it often draws gasps from people seeing it for the first time.

Donatello, *Mary Magdalene*. 1453. Polychromed wood. 6 ft. 2 in. Museo dell'Opera del Duomo, Florence, Italy.

Donatello apparently executed it upon his return to Florence in 1453 after a ten-year stay in Padua. It marks a radical shift in style from his

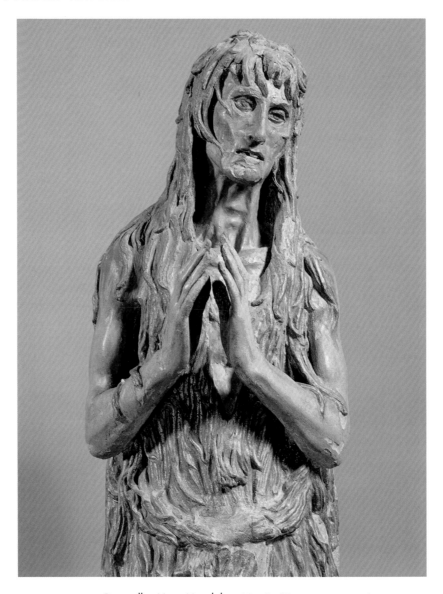

Donatello, *Mary Magdalene* (detail of image on page 42)

prior work. Nothing here appeals to or seduces the eye; on the contrary, we sense a despairing recoil from the physical. Donatello abandons nearly all his classical formulas and invokes instead the ghoulishness of northern European late Gothic, with its frightful apparitions of devils and gargoyles. In contrast, a

work produced fifteen years earlier, his wooden statue of the ascetic John the Baptist, shows the fiery saint speaking and proselytizing, expressively engaged with other people.

In the Gospels, Mary of the Galilean town of Magdala is a devoted disciple who appears at key moments in Jesus's story. Roman Catholics (but not all Christians) identify her with the adulteress whom Jesus saves from stoning and with the woman from whom he casts out seven demons. She anoints his feet with precious oil, stands with his mother and Saint John at the foot of the Cross, helps discover Jesus's empty tomb, and is the first to see him after his resurrection. The idea that Mary Magdalene was a prostitute began in a medieval sermon by Pope Gregory the Great. Legend claimed that Mary Magdalene accompanied the Virgin Mary to Ephesus, where they died, or to southern France, where Mary Magdalene became a hermit in a cave. European art has often shown her as a voluptuous, half-naked penitent with flowing red or blonde hair, its loosening and exposure signifying both her promiscuity and her contrition.

Donatello's gaunt Mary Magdalene, his last known statue, is one of the most extreme surviving depictions of this saint. Carved from white poplar wood with details in plaster gesso, the statue was once painted and its auburn hair gilt. A flat brown paint, applied for protection long afterward, hid the colors (including Mary's blue eyes) for centuries. During the catastrophic 1966 flooding of Florence's Arno River, muddy, oily waters broke into the Baptistery and submerged the statue, dissolving its dull coating and revealing tantalizing traces of Donatello's original polychrome. During restoration, the saint's diadem, added decades after Donatello's death and visible in many photographs, was not reattached.

What was Donatello, then in his late sixties, announcing to Florence by this stunning work? Taste in the city had become far prettier, more delicate and refined, as in the ceramic sculptures of children by Desiderio da Settignano. Was the aging Donatello, as divine judgment loomed, renouncing his past sexual adventures and proclaiming his remorse? There is a harrowing sense of isolation and desolation in his Mary. Is she a self-portrait?—capturing a feminine sensitivity beneath his masculine, muscular brashness. Or is this wizened, gap-toothed crone the artist's own grieving mother, burdened by his notorious escapades and refusal to marry and doing penance for her son's sins?

Draped in her long mass of hair, Mary Magdalene seems frozen in place, consumed with agonized thought. She is a sleepless sentinel, like Jesus at Geth-

45

semane. Her staring eyes are sunk in deep hollows, while her mouth gapes in dementia or shock. Her nasal muscles constrict and retract, as if she were stifling sobs or repulsed by a bad smell, the stench of mortality which similarly afflicts Hamlet. Her skull, like a memento mori, is surfacing through her sunken cheeks. Fasting has stripped away her female curves. There are emaciated, nearly skeletal Buddhas in Asian art, but they are images of contemplative ecstasy with none of the squalor and degradation seen here. Mary is a pariah, both feeling and causing disgust. She has been reduced to near-animal existence, shown by her foot gripping the rock edge like a bear claw.

That Mary Magdalene is sculpted of perishable wood, rather than Donatello's usual costly bronze or marble, alludes to the Cross as well as to earthly decay: her spirit is crucified on the flesh that betrayed her. Her cascade of hair, tied ropelike at her waist (as on a monk's robe), seems liquid—as if she were bathing in her own tears. With her weathered, leathery skin (unlike the fine white alabaster of Florentine ladies), she seems like a stony outcropping, beaten by the elements. Her still graceful hands, with their elongated fingers, almost meet in prayer, like a Gothic arch. But time has stopped in a moment of self-recognition or doubt. Perhaps she is paralyzed by a fiery vision, the annihilation of the damned. She is like Lot's wife, turned into a pillar of salt for looking back at God's destruction of the wicked Cities of the Plain. Was Donatello saying, through Mary, that he too had looked back and seen his own Sodom burn?

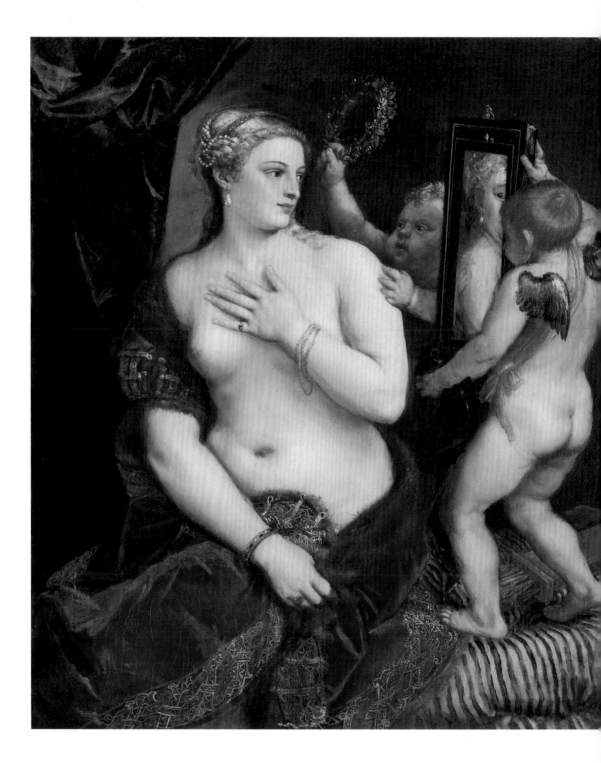

ISLAND OF LOVE

Titian, *Venus with a Mirror*

Abeautiful woman lounging in her boudoir: this mesmerizing scenario in European painting was created in Renaissance Venice, above all by Titian. Medieval art had often depicted sleekly robed ladies in a bower or walled garden, symbolizing both virginity and fertility. But Titian's grand tableaux of opulent nudes thrust sexual display and fantasy into the foreground. His *Venus with a Mirror,* for example, draws back a curtain on a private, privileged world where there is a visual continuity between the rich spill of sensuous fabrics and the goddess's alluring expanse of soft, glossy flesh.

Titian's luxurious paintings are emblematic of Venice itself, a wealthy, pleasure-loving port city built on a cluster of 117 islands in the Adriatic Sea. Cut by canals and always prone to flooding, Venice seems to float on water, shimmering with golden light. It is no coincidence that Venetian painters such as Giovanni Bellini, Giorgione, and Titian were master colorists. Venetian taste was also influenced by the ornate styles of the city's longtime trading partners in China and the Middle East, especially Byzantine Constantinople.

Titian was a successful businessman himself, with a large workshop catering to an international clientele of unprecedented scope: commissions poured in from popes, princes, kings, and an emperor. Titian was working in a relatively new medium—oil paint, refined in Flanders by Jan van Eyck. Because it dries so slowly, oil is much suppler than egg-based tempera for blending fine shades of color. Renaissance artists were shifting from wood panels to canvas, whose woven texture helps hold paint and gives it a livelier surface. Titian's innovation was to use strong brushwork with liberally applied layers of paint, creating dramatic luminosity and capturing complex flesh tones. Thanks to the appeal of oils, there was a huge boom throughout Europe for portable framed paintings for the home.

Titian, *Venus with a Mirror.* Ca. 1555. Oil on canvas. 49 × 41⁹⁄₁₆ in. Andrew W. Mellon Collection, National Gallery of Art, Washington, D.C.

Venus with a Mirror remained in Titian's possession until his death, perhaps because it served as a model for copies executed by his assistants. Or he may have been especially attached to it, as Leonardo da Vinci was to his *Mona Lisa*. Now at Washington's National Gallery of Art, Titian's painting was once owned by Czar Nicholas I and remained in the imperial collection until after the Russian Revolution. Titian shows the goddess of love attended by winged cupids, who hold up a mirror and crown her with a wreath of flowering myrtle, her traditional emblem. On the couch rests a red quiver of Cupid's arrows, their red-streaked feathers possibly daubed with victims' blood. When this painting was x-rayed in 1971, a pentimento (trace of a draft or earlier painting) was detected of two figures, a male and female couple. In reusing the canvas, Titian turned it on its side and oddly retained the man's arm and shoulder, whose dark-crimson fur-lined velvet robe, sparkling with metallic embroidery, can be seen sweeping down beneath Venus's left elbow. So the goddess has wrapped herself in a man's garment. Is it a souvenir of a past conquest?

Hanging from a cupid's left hand is a black cloth, as if he has just removed it from the mirror. Mirrors were sometimes covered during periods of mourning. Is Venus awaking from mourning for her young lover, Adonis? Titian painted several versions of Adonis pulling himself from Venus's anxious embrace on his way to the hunt, where he was gored and slain by a boar. Hence perhaps Venus's surprise here as she rediscovers her own beauty and, meeting our eyes in the mirror, resolves to live again—a thought accented by the light flooding in behind her head. Her distorted reflection certainly seems older or sadder, a past self she is discarding. If that is so, then it is Adonis's red robe that Venus has been obsessively wearing and caressing, a fetish replicating his physical embrace.

Venus's pose—one hand raised to her bosom and the other concealing her genitals—is derived from a much-imitated classical type called the Venus Pudica (Modest Venus). Beginning with Praxiteles's lost sculpture of Aphrodite at her shrine on the island of Knidos, the nude goddess of love was shown slightly stooping as she stepped down into her bath. The viewer becomes a voyeur, a spy who stumbles on a forbidden scene, which can be dangerous for mere mortals. Aphrodite's association with water started with her mythic birth from sea foam: hence Botticelli's Venus, her hands high and low as in the Pudica, scuds to shore on a seashell. A hint of liquidity remains in the decor of Titian's boudoir—the shiny dark green of the draperies and the sofa's rip-

pling silk stripes, like a brook or waterfall. Venus is hidden away on her magic island of love.

The ideal woman of Florentine art, like Botticelli's Venus, was tall and slim with long legs and small breasts. But in Venetian art, women are round, plush, and a bit indolent. Titian's statuesque Venus, with her fashionable blonde hair and tweezed brows, is adorned with gold, jewels, and pearls, the treasures of Venice. His model was a sophisticate and perhaps a prostitute. According to his friend the scandalous writer Pietro Aretino, Titian as a widower enjoyed the company of prostitutes, although he supposedly declined their services.

The hushed spectacle of a woman gazing into her mirror has exerted a powerful fascination on male artists. Is she a puppet of vanity or a sorceress in eerie dialogue with her double? Most feminists reject the mirror as woman's oppressor, the internalized eye of judgmental society. But Titian's mirror, handsomely framed like a painting, centers and aligns Venus with her two sons, as if they too are her reflection, her extruded essence. They support her sexual ecosystem: the cupid's raised crown echoes the crescent of fur above Venus's pubis, and a dangling bow on the other cupid's chiffon sash looks mischievously like a scrotum and uncut penis.

Venus with a Mirror is seductively tactile, drawing a parallel between the goddess's ample, exposed breast, which she gently touches, and the round buttocks of her son, with his robustly muscular legs. Titian blurs the line between the erotic and the maternal, perhaps revealing the deepest truth about heterosexuality. The painting is a return to a half-remembered paradise state, the infant's blissful sheltering within the mother's magnetic aura. Indeed, the entire composition is a self-complete revolving circle (turning counterclockwise from the wreath), as if Titian had discovered Venus's eternal orbit of desire.

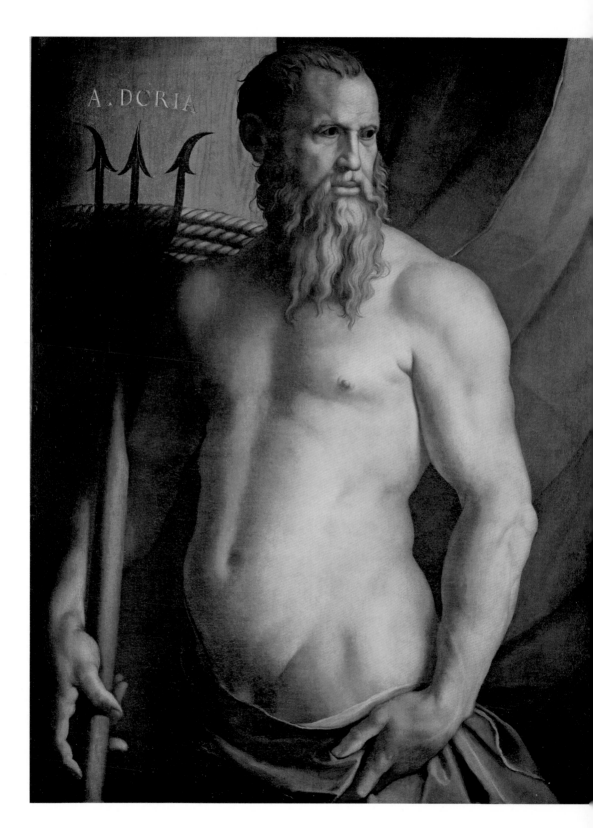

LORD OF THE SEA

Agnolo Bronzino, *Portrait of Andrea Doria as Neptune*

Mannerism was the chilly last phase of Renaissance art, produced against a background of political instability and corruption. Its name comes from *maniera,* an Italian word for stylishness or artificiality. In Mannerist paintings, space is enclosed or compressed, and figures are elongated and slightly distorted. The mood is wary and tense. Mannerism has a polished theatricality but an unsettling stasis, as if gestures have jelled.

Bronzino's portrait of the Genoese admiral Andrea Doria is set on the open deck of a ship. But we still feel vaguely oppressed by the impenetrable black sky, the massive mast, and the heavy sail wrapping Doria like a toga. The "armored" quality of Mannerism can be seen in the sculptural contours and metallic palette, dominated by brown, gray, and muted green. Doria is shown in the nude like a classical statue because of his allegorical identification with Neptune, the Roman god of the sea. The cartoonish black trident head and inscription of Doria's name carved in Roman lettering were added by an unknown artist long afterward. In Bronzino's original painting, documented in contemporary prints, Doria was holding an oar, whose squared blade is still faintly visible. That simple oar, the meaning of which had been lost, represented Doria's command of his private fleet of war galleys. These were narrow, flat, fast, artillery-bearing vessels with triangular lateen sheets, but they were powered in battle by rows of oarsmen, sometimes slaves who were condemned criminals.

The northern Italian port city of Genoa, hemmed in by mountains, has produced many seafarers and explorers, including Christopher Columbus. The Dorias (perhaps originally de Auria) were one of four principal families of medieval Genoa—another being the Grimaldis, later the royals of Monaco. Andrea's ancestor Branca Doria murdered his father-in-law at a banquet and appears as a sinner trapped in a

Agnolo Bronzino, *Portrait of Andrea Doria as Neptune.* Ca. 1530. Oil on canvas. 3 ft. 9 in. × 1 ft. 9 in. Pinacoteca di Brera, Milan, Italy.

lake of ice in the ninth and lowest circle of Dante's *Inferno*, where the Genoese are portrayed as irredeemable evildoers. Another ancestor was Pagano Doria, a famous fourteenth-century admiral.

By the time Andrea was born (both parents were Dorias), his family had lost political power but was still influential as bankers, landlords, and soldiers. Orphaned in childhood, he joined the Papal Guard, made a pilgrimage to Jerusalem, and worked as a naval mercenary. He became wealthy from confiscated treasure on his bold expeditions against the Muslim pirates of North Africa's Barbary Coast. For these exploits he was hailed in Ariosto's epic poem, *Orlando Furioso*, as a new Pompey (Julius Caesar's son-in-law, who rid the Mediterranean of pirates). In 1528, Doria restored his family to dominance when he freed Genoa from French control and became de facto dictator of the new republic. For the next thirty years, he ruthlessly crushed opposition, particularly after the assassination of his nephew and heir, Giannettino Doria.

Although he had been a leader of sixteenth-century Europe, Andrea Doria's name gradually faded outside Italy, until a sea disaster put it back in the news. In 1956, an Italian Line luxury passenger ship, the SS *Andrea Doria*, collided with a Swedish freighter off Nantucket and sank with a loss of fifty-one lives. The *Andrea Doria* had been launched five years earlier at the Ansaldo shipyards in Genoa, its home port. Architect Gio Ponti designed its sophisticated interior decor, which included a 157-foot mural of an ideal Italian Renaissance city painted by Salvatore Fiume to wrap the first-class lounge. Presiding over the same room was a bronze statue of Doria clad in cape and armor and holding a sword. In 1964, salvage divers located the statue still standing in place. After a struggle to extract it, they sawed it off at the ankles and sent it on a forty-year odyssey from a social club in New Bedford, Massachusetts, to a hotel in Pompano Beach in southern Florida (where its sword was stolen) to a Fernandina Beach saloon on Amelia Island in northern Florida. It then became a local lawn ornament, its missing feet disguised by sneakers or cowboy boots. Finally, a sympathetic marine artisan crafted new bronze feet for the statue and returned it to Genoa for a museum exhibit in 2004.

The ocean liner was neither the first nor the last ship with that name. The Italian navy has dedicated four ships to Andrea Doria: two battleships (1885 and 1913), a missile cruiser (1964), and a frigate (2007). There have even been two American ships named *Andrew Doria*—Andrea evidently sounding too feminine for English speakers. The first was a merchant brigantine purchased in 1775 by the Continental Congress and converted into a fourteen-gun war-

ship commanded by Captain Nicholas Biddle of Philadelphia; it saw duty in the Battle of Nassau in the Bahamas. The second, the USS *Andrew Doria*, was a commercial oil tanker acquired by the U.S. Navy during World War II; it won a battle star for its support role in the liberation of the Philippines in 1945.

In early Rome, Neptune was a minor water deity, invoked during summer drought, until he was conflated with Poseidon, the great Greek god of the sea and earthquakes. Neptune was now widely depicted like Poseidon—as a burly, robust, and still virile middle-aged man with a full beard. Poseidon, whose emblems were the dolphin and the trident, was sometimes shown driving a chariot pulled by sea horses. In Bronzino's painting, Doria's flagship has presumably become the god's chariot.

With his calm, implacable gaze, Doria demonstrates Neptune's lordly dominion over the sea. His spray-whipped hair falls forward to mimic the tufted crop of Roman emperors. The flowing gray tendrils of his beard resemble sea fronds or ship wakes. He stands in a bleak raking light, as if under a full moon. Or the ship may be heading into the high wind of a thunderstorm, the gathering clouds of war. Galleys were deft in amphibious assaults but notoriously unstable in rough seas. Perhaps the sail has suddenly been struck as the galley, propelled by oar, plunges toward enemy vessels.

Although he is stern and resolute, Doria's hands, especially his delicate, super-elongated right index finger and cocked left wrist, are refined and "mannered," with the grace of a dancer. His posture is slightly strained: his head turns one way, but his hips and buttocks remain in near profile, the effort registering in his grooved thigh muscle. This uneasy torsion departs from two of Bronzino's heroic sources, Michelangelo's *David* and *Moses,* who also glance fiercely to their left. Doria's portly but taut belly seems to drive its power into his penis, from which shadowy pubic hair spreads like moss.

Doria was at least in his mid-sixties but still relentlessly active when this painting was commissioned for a private museum of portraits of illustrious men in a villa near Como. Bronzino reinforces the innuendo of an erection with the stiff trident shaft and tree-trunk mast, bound with cable. The implicit theme is civic paternity: Genoa had granted Doria the title "Liberator and father of his country" (*Liberator et pater patriae*). But perhaps the painter's truncation of Doria's penis also alludes to the fact that for all his macho derring-do, Doria never produced an heir. His long marriage to Princess Peretta Uso di Mare was childless. The gathering hand with which Doria covers his nudity echoes that

of Botticelli's androgynous Flora as she cradles rosebuds in her dress in the *Primavera*. If Doria's pointing right index finger signifies leadership (as well as direction on a nautical chart), then his scooping left hand represents his ability to create groups—crews, armadas, cities, and foster heirs.

Penises have proved troublesome in Western art. Nudity is innocent for babies and toddlers, who scamper about bare-bottomed in warm climates. But depicting the unruly adult penis presents the artist with knotty challenges of form and taste. The classical nude provided an ambiguous precedent: in Greek art and culture, a small penis was valued as a mark of intellect; a large penis was thought comical and animalistic. This nagging doubt about the dignity of the penis lingers in the double standard of modern movies, where female nudity abounds while full-frontal male nudity remains rare. Bronzino's painting evades these problems by treating Doria's entire body, from his planted thigh, veiny forearms, and brawny shoulders to his hard brow and pouched eyes, as a tumescent column of sheer willpower.

BLAZE OF GLORY

Gian Lorenzo Bernini, Chair of Saint Peter

Baroque art overwhelms the senses with flamboyant grandeur. The Baroque was born in a period of conservative reconsolidation of authority in church and state. Roman Catholicism was counterattacking against the Protestant Reformation, while absolutist monarchs like Louis XIV were centralizing government in gargantuan palaces and in court life of lavish ostentation. With its irregular curves and spirals, Baroque style has movement and theatrical energy yet also weight and mass. It is a public art curiously suffused with emotional intensity, sometimes bordering on hysteria.

The sculptor and architect Gian Lorenzo Bernini virtually invented the Baroque, which spread from Rome throughout Europe. Born in 1598 to a Florentine father and a Neapolitan mother, he was a child prodigy in his father's sculpture workshop in Rome. The suavely dynamic statues of classical gods and heroes that Bernini produced as a young man restored sculpture to preeminence after painting had become the prestige genre of the Renaissance. He later became renowned for extravagant, mixed-media set pieces, often using clashing, multicolored marble columns from ancient Egypt, found buried in Roman ruins. He was a staggeringly prolific executive producer with a huge studio of apprentices and master artisans specializing in stone, plaster, metals, and fine gilding. Toward the end of his career, he was supervising his vast projects while merely making final corrections with his own chisel. Conception and design, however, remained entirely his.

Among Bernini's most popular legacies are the fountains of Rome. The city had always had many fountains, fed by ancient culverts and aqueducts. Bernini turned them from plain and functional to giddily hyperbolic—a trumpeting Triton perched on a scallop shell tossed by porpoises, an Egyptian obelisk on the fancy saddle of an impudent

Gian Lorenzo Bernini, *Baldacchino.* 1624–1633. Gilt bronze canopy over papal main altar in the central nave of St. Peter's Basilica. The Chair of Saint Peter is visible in the far apse. Vatican City.

59

elephant. His most daring fountain, adorning the Piazza Navona, features four allegorical colossi of major world rivers, sprawling around a see-through grotto crowned by an obelisk. Bernini loved clever trompe l'oeil (fool the eye) effects, as in the tomb he made for his patron Pope Alexander VII, where a winged bronze skeleton, waving an hourglass, shoots up from beneath a shroud whose red and gold jasper is as fluid as real tapestry. Bernini himself thought the most beautiful thing he ever sculpted was his altarpiece of Saint Teresa of Avila, the militant Spanish nun, expiring in ecstasy as her heart is pierced by an angel's arrow. Nestled in the secluded chapel of a small Roman church, the work has a witty theater setting, with statues of the donor family watching and chatting from marble balconies.

Bernini was the final master architect of Saint Peter's Basilica, the home church of Catholicism. Its most important possession is the remains of Saint Peter, the Galilean fisherman whom Jesus called the "rock" ("Petrus" in Latin) upon which he would build his church. Both Saint Peter and Saint Paul were martyred in Rome during Nero's persecution of Christians. The circus where this happened lay at the foot of Vatican Hill, then outside the city. In the fourth century, the emperor Constantine ordered the first church built to mark Peter's grave. Its foundations, along with a pagan cemetery, have been found under the present basilica.

In 1506, Pope Julius II laid the cornerstone of today's cruciform basilica, which remains one of the world's largest buildings. When Bernini began working on it, the soaring dome by Bramante and Michelangelo was already in place. Bernini designed the embracing arms of the tall colonnade of Saint Peter's Square, where the faithful gather to receive the pope's blessing. He also designed the wide steps leading to the basilica doors as well as the eye-popping Baldacchino, a ninety-five-foot-high canopy (bronze simulating silk), supported by four mammoth, serpentine bronze columns. This canopy, at the crossing beneath the dome, marks Saint Peter's tomb and covers the high altar, where only the pope may say Mass.

Pilgrims entering the basilica look straight through the columns of the Baldacchino (acting as a picture frame) and see their final destination in the far distance of the apse—the strange, seething spectacle of Bernini's Chair of Saint Peter (Cathedra Petri). This grandiose and fabulously costly monument, which took nine years to complete, honors the church's second-most-valuable possession. Saint Peter's chair had already gotten its own feast day by the time of Constantine. It is the concrete symbol of a bishop's power: "cathedra"

SAINT PETER'S BASILICA, VATICAN CITY *Dome by Michelangelo. Colonnade by Bernini: key-hole shape evokes Saint Peter's keys to the kingdom of heaven. Long, narrow brown roof of Sistine Chapel to right of basilica. Belvedere Courtyard (home of Laocoön) to right of that. Tall, square Papal Palace at right center.*

(Latin for "seat") would eventually be applied to any building (cathedral) where a bishop sits. Bernini's chair is empty because it is more important than its transient mortal occupants. Hidden in a reliquary box under the seat is a fragile, worm-eaten object: a small chair made of oak and acacia and paneled with ivory, with iron rings for transport poles on its sides. The chair might incorporate fragments of ancient wood, but two papal investigations beginning in the nineteenth century (when it was photographed) concluded that it dates from the early Middle Ages.

Bernini's heavy bronze throne (suspended in midair by hidden iron chains from a bell tower) miraculously floats toward heaven above a fiery altar

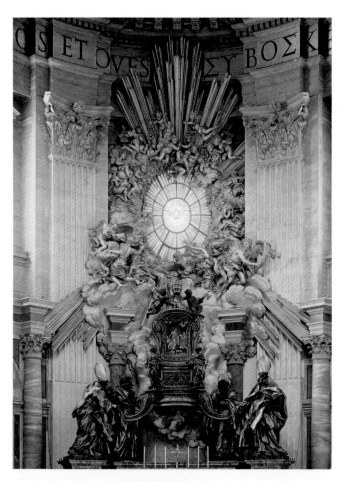

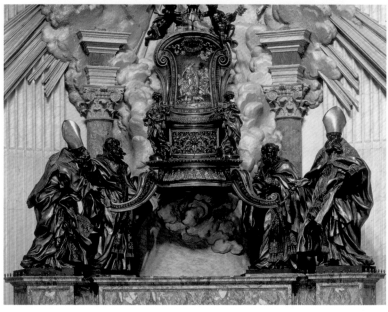

of Sicilian red jasper on a platform of black-and-white marble from Aqui-
taine. The chair's honor guard consists of four great doctors of the church:
fifteen-foot-high, gilded black bronze statues of Saints Ambrose, Augus-
tine, John Chrysostom, and Athanasius, their robes and gestures agitated by
the wind of the Holy Spirit. They represent the medieval Greek and Latin
churches, the two front figures showing by their bishops' miters the victory
of the Western branch. The saints' hands, extended in awe, do not touch the
wildly curved legs of the throne, which rises from its own God-guided power.
Passenger angels perch at its arms, while cherubs flit overhead with the pope's
triple-tiered tiara and his keys to the kingdom of heaven. One of the three
bas-reliefs touched with gold on the scrolled backrest shows Jesus as the Good
Shepherd with his flock. Running along the high gold frieze of the apse is an
inscription in giant Latin and Greek letters addressing the pope: "O shepherd
of the church, you feed the lambs and sheep of Christ."

Above the throne, an oval window of yellow Bohemian glass, painted with
the flying dove of the Holy Spirit, explodes through the basilica wall in a
blinding sunburst or "glory." It's the Big Bang of God's revelation, a blast that
seems to pulverize the marble cornice. Billowing, gilded-stucco clouds stream
down to boil beneath the throne. Three groups of bronze solar rays (symbol-
izing the Trinity) shoot out over the basilica's marble pilasters, pointing to two
papal tombs below and violating the normal borderlines of art. Defying the
four saints' dutiful sobriety is a rollicking swarm of pretty male angels and
prankish putti peeking through the rays or hugging them like bundles of reeds.
Embryonic cupids form like bubbles out of a maelstrom of fertility. Divine
light (whose beam impregnated Mary) seems to be churning and congealing
like a frothy batter of scrambled eggs and whipped cream.

Bernini's Chair of Saint Peter is one of the most delirious constructions of
the Baroque and perhaps the paradigmatic work of that style. It vividly illus-
trates why the Protestant social reformer and art critic John Ruskin would
denounce Bernini for "false taste and base feeling." But Bernini's chair cel-
ebrates the power of the Roman church triumphant. It also captures the heady
spirituality of the reform movement within Catholicism that brought a new
inwardness to worship by clergy and laity alike.

Gian Lorenzo Bernini, Cathedra
Petri (Chair of Saint Peter).
1657–66. Gilt bronze, wood,
plaster, and stained glass.

Bernini's artistic imagination was split be-
tween sensuality and piety. He was a virtuoso
illusionist and carnivalesque entertainer who
enjoyed terrifying theater audiences with trick

sets or shocking churchgoers with garish spectacles of sex and horror. Yet he was deeply devout and attended Mass daily. Indeed, he put his art uncritically at the service of papal propaganda (a term originating in the quasi-military propagation of the faith launched by the Vatican at that time). Bernini thought his ideas were inspired by God. Observers reported that he worked in a state of "divine frenzy," dancing in such fervor that, as he aged, apprentices were stationed to stop him from falling off his platform. When they appealed to him to rest, he would say, "Leave me alone here, for I am in love!" The fire and motion that Bernini gave to the Baroque poured from his own passionate, divided soul.

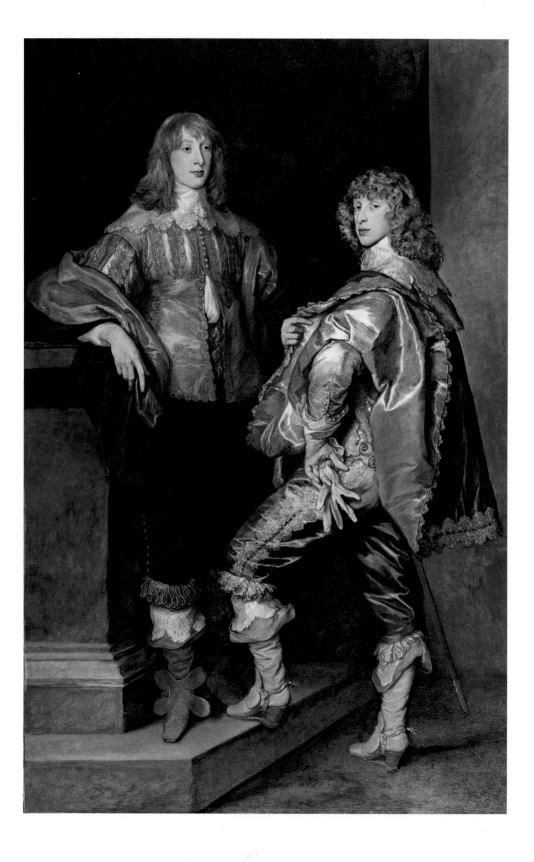

SATIN KNIGHTS

Anthony Van Dyck, *Lord John Stuart and his Brother, Lord Bernard Stuart*

Lords John and Bernard Stuart, young English bucks dressed at the height of fashion, strike a pose at the foot of a dark staircase. Perhaps the somber stone walls represent the cold northern castles of their Scottish ancestry. The Stuart brothers were cousins of Charles I, who was born in Scotland and was the second Stuart king of England; his father, James I, had ascended the throne after Elizabeth, the virgin queen, died childless, ending her Tudor dynasty. Anthony Van Dyck painted the teenage lords' portrait just before they left for a three-year European tour. What gives the picture special force is that both brothers would be dead within a few years, killed during the English Civil War that erupted between Charles and Parliament and led to the king's execution.

Our image of the reserved, cultivated, and stylish Charles was indelibly shaped by Van Dyck, whose depiction of the king's troubled court as an ideal Arcadian realm was a brilliant exercise in political puffery. Born in Antwerp in 1599, Van Dyck traveled and worked in Italy before settling in England as Charles's official court painter, where his position paralleled that of Velázquez at the Spanish court of Philip IV. According to Peter Paul Rubens, the great Baroque painter who had been Van Dyck's teacher, Charles of all living monarchs was the greatest connoisseur of art. The king amassed an immense collection of paintings, prints, and sculptures, which were sold after his death and scattered across Europe. Through his sponsorship of Van Dyck, a devotee of Titian, Charles radically transformed British art, which had become static and isolated from the Continental Renaissance.

Anthony Van Dyck, *Lord John Stuart and his Brother, Lord Bernard Stuart.* Ca. 1638. Oil on canvas. 7 ft. 9½ in. × 4 ft. 9½ in. National Gallery, London, Great Britain.

Charles's love of beauty and court costume and ritual inspired an outbreak of dandyism among young Englishmen. Ministers and civic watchdogs had been speechifying against luxuri-

ous or gender-bending dress since Elizabeth's reign, when Shakespeare arrived in London. The culture wars intensified under Charles as soberly dressed Puritans (dubbed Roundheads for their cropped hair) clashed with sumptuously dressed Royalists, later called Cavaliers for their attachment to horseback riding—a chivalric pursuit producing the dominance of Royalist cavalry on the battlefield and surviving today in the cult sport of equitation among the English aristocracy.

Van Dyck's early work drew on classical and Christian themes, but after his arrival in England lucrative portraits became his stock in trade. Even in Italy, Van Dyck had been known as "il pittore cavalleresco" (the Cavalier painter) for his elaborate dress, accessorized by gold chains and plumes. Charles knighted him and gave him a stipend and a riverside house in Blackfriars, then outside London, so that he could escape the jealous jurisdiction of the city guilds. A landing and staircase were specially constructed for easy access to his studio by the king and his family from their royal barge on the Thames. Van Dyck strove at great cost to maintain a standard of hospitality and musical entertainment equal to that of his noble patrons, with whom he confidently socialized. The Blackfriars house, where he died unexpectedly at age forty-two, was destroyed, along with his tomb in Saint Paul's Cathedral, by the Great London Fire of 1666.

Van Dyck's facility with portraiture manifested itself early, when he was a fourteen-year-old prodigy. His invariably flattering British portraits celebrate rank and personality, enhanced by some symbolic gesture. It was his quick practice to sketch his subjects for an hour, after which assistants blocked in the background. Then he refined and completed the painting, usually working from the sitter's own clothing, which he had sent to him. Women often seem placid or generic in Van Dyck's portraits, while powerful or handsome men radiate charisma. He was clearly fascinated by the British nobility's foppish new elegance. His minute attentiveness to clothing can be traced to his childhood: both his father and grandfather had been prosperous Flemish fabric merchants, while his mother was renowned for her fine embroidery.

Van Dyck's paintings wonderfully re-create the weight, sheen, and quality of silk, satin, velvet, linen, and lace. They also capture the myriad textures of men's hair. Elite women then wore a few simple coiffures, notably flat ringlets clustering like tendrils around the face. After neck ruffs became passé, however, men let their hair flow long and free in pyramidal layered cuts. Van Dyck's male portraits catalog the erratic individualism of motley, crossbred

northern European hair, with its glinting highlights, angelic clouds, coarse manes, or stubborn wisps, corkscrews, and cowlicks.

Van Dyck's double portrait of the Stuart brothers is a theatrical fashion statement. John, as the elder by two years, stands a step up. He is more composed and introspective than the dashing, athletic Bernard, who seems to have just dismounted from his horse and been blown inside on a gust of energy. Although a sword hangs beneath Bernard's cape, we see not a hilt on his thigh but a dangling glove—often perfumed by young men as a love gift to women. The unnatural elongation of his upper arm accentuates his flashy hand-on-hip stance—a debonair mannerism adopted by Van Dyck in a self-portrait.

The brothers flaunt the new look of studied negligence that supplanted the stiffer formality of prior decades. Breeches had recently replaced men's stockings. John's high-waisted, midriff-baring gold doublet shows off his fine cambric shirt through panings (slashes) down his chest and tapered bishop sleeves. Broad, scalloped tie-on collars of Flemish bobbin lace spread over the brothers' shoulders. The maroon velvet lining of John's cape matches his trousers, edged with buttons and ringed at the knee by corded loops. Bernard's sky-blue satin cape, lined with silver, falls over matching breeches trimmed with lace. The young men's thigh-high kidskin riding boots have Cavalier square toes (Puritans' boots were pointy) and flipped "bucket" tops, over which spills the lace edging of footless linen boot hose, worn for protection over fine silk stockings. Butterfly wings of wide spur-leathers cover their insteps, while Bernard's boot bottoms rest on clog-like "slap soles," pattens donned to prevent high heels from sinking into the mud—a male fashion that spread to women.

If Bernard's posture seems proudly dance-like, it's because dance played a central role in Charles's court masques, in which both the king and his French queen regularly performed. Ballet was emerging from the exquisitely artificial court etiquette of France, where Cavalier culture (re-created in Alexandre Dumas's *Three Musketeers*) also flourished. Aristocratic arrogance was so accurately read in Van Dyck's portraits that his work was eclipsed for most of the twentieth century, when leftist avant-garde art ruled. But his reputation has been revived by fresh interest in fashion as an art form.

Who were John and Bernard Stuart? The brothers (who shared their long, narrow family nose with the king) were the youngest of eleven children of Esmé Stuart, the Third Duke of Lennox, and his English wife, Baroness Clifton. Their father was a patron of playwright Ben Jonson, who lived in the duke's house for five years. The brothers' grandfather the First Duke of Len-

nox, also named Esmé Stuart, was a shrewd political operator rumored to be the gay lover of his cousin the king James I, from whom flowed gifts of titles and property that swelled the family's wealth and influence.

Both John and Bernard became commanders of cavalry in the Civil War. Bernard's unit, the king's life guard, was called the Show Troop because of the luxury of its armor, weaponry, and habits. An officer, for example, boasted that he shaved only in sack (sherry). In 1644, John, then twenty-two, was fatally wounded at the Battle of Cheriton. The following year, Bernard was killed at the Battle of Rowton Heath. The king was watching from the Chester city walls and witnessed the annihilation of the last of his cavalry forces. He was said to be crushed with grief at his cousin's death. He had knighted Bernard for valor at the Battles of Newbury and Naseby and had planned to make him Earl of Lichfield. All three Stuart brothers (including George) who were killed in the Civil War were buried together in Christ Church Cathedral in Oxford.

Van Dyck has preserved the rosy vitality of two young men who seem as alive here as they were nearly four centuries ago. "Carpe diem" (seize the day) was the pagan motto of Cavalier poets such as Robert Herrick and Sir John Suckling: time flies, so live now! Similarly, art seizes a moment and makes it permanent. Before the invention of photography, painted portraits served an indispensable documentary function for those who could afford them. The ancient Western tradition of portraiture has filled palaces and museums with images of the dead, whose eyes follow us. Half fact, half fiction, these works retain value both for what they show and how they show it. The dashing Stuart brothers, caught by Van Dyck's idealizing eye, are shimmering presences who have evaded the tyranny of time.

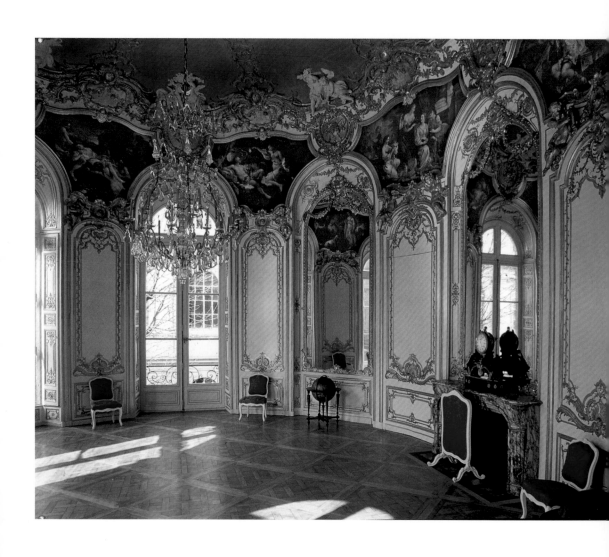

SWIRLING LINE
The French Rococo

White rooms spun with gold: the cool sanctuaries of the French rococo
have a crystalline perfection. Few rococo interiors have survived
intact: vandalism during the French Revolution took less of a toll than routine
gutting and remodeling, as elite taste changed. But thousands of beautifully
detailed architectural blueprints from the rococo period, particularly those for
royal commissions, remain in French archives.

"Rococo" was originally a term of derision for excessive or fantastic orna-
mentation. The word comes from *rocaille,* meaning rock or shell work used
for grottoes and fountains. French rococo began as delicate arabesques, whose
swirling line had multiple sources: ancient borders of Greek acanthus leaves
or Roman flowers; Islamic vegetal patterns; Celtic interlace; French Gothic
tracery; Italian Baroque curves. French rococo is an art of surface. The effect
is weightless, elegant, and oblique, pointedly rejecting Baroque's mass, gran-
deur, and intensity.

Rococo used to be called *le style Pompadour,* after Louis XV's mistress,
a tireless collector and urbane patron of the arts. But rococo had already
peaked before Madame de Pompadour first met the king at a masked ball in
1745. The real impetus for rococo came three decades earlier with the death
of Louis XIV, the imperious Sun King who had transferred French govern-
ment to his huge country estate at Versailles. His heir, the five-year-old future
Louis XV, was sent to Paris under the Regency of the sybaritic, art-loving
Duke of Orléans (who gave his name to New Orleans). Liberated from royal
surveillance at Versailles, French aristocrats embarked on a building boom of
country châteaus and town houses (called *hôtels*) for private living, for which
effervescent rococo was ideally suited.

Germain Boffrand, Salon of
the Princess. 1737–40. Hôtel
de Soubise, Paris, France.

French rococo was a style less of architecture
than of interior decor: intricately carved wood
panels (boiseries); graceful chairs, tables, and

cabinets inlaid with rare wood; curvy ormolu clocks, mirrors, and sconces; charming porcelain figurines. The facades of most Parisian *hôtels* stayed austerely classical in contrast to their playful interiors. Because of space limitations or irregularities imposed by winding city streets, rooms were sometimes laid out asymmetrically, the primary goals being the comfort of the family and easy access by their servants. Thus emerged the plan for the modern home, with a formal first-floor reception area and a private, casual upstairs family retreat. The overpowering scale of Baroque institutions, with their awesome vistas, was superseded by more modest spaces designed for relaxed and intimate dialogue among equals.

Among the few important rococo interiors still in near-pristine condition are the suites executed by Germain Boffrand, the greatest French rococo architect, for the Hôtel de Soubise in Paris. The first recorded structure on this site was a Templar building acquired in 1371 by a constable of France, the one-eyed Olivier de Clisson (called the Butcher), who converted it into a fortresslike mansion. Two centuries later, the noble Guise family refurbished it, leaving in place the handsome medieval turrets that still guard the gate. It was from this house that Duke Henri de Guise launched the Saint Bartholomew's Day Massacre of French Protestants (Huguenots) in 1572. It became the headquarters of the Catholic League, formed by the duke to purge Protestantism from France. In 1700, after the Guise line had gone extinct, the house was bought by François de Rohan, Prince of Soubise, whose renovation produced the building's present classical facade. Boffrand created interiors, now lost, for the house. Thirty years later, he was commissioned by Rohan's son Hercule Mériadec de Rohan, then in his sixties, to construct apartments for his second marriage to a nineteen-year-old widow, Marie Sophie de Courcillon. We owe the preservation of the Hôtel de Soubise to Napoleon, who made it state property for storing the imperial archives. It is now a national museum of French history.

Boffrand built a two-story pavilion attached to the main house, with Hercule's apartment on the ground floor and his wife's above. Most striking are the matching airy oval salons. The Salon of the Prince, as befitting Hercule's political status, is furnished with understated classicism. The Salon of the Princess, however, is a tour de force of decorative energy and finesse. It is considered Boffrand's masterpiece and the crowning achievement of French rococo. The room's white wood panels, alternating with high arched windows, doors, and mirrors, are edged with exquisite arabesques, which were

HÔTEL DE SOUBISE, PARIS, FRANCE *Eighteenth-century lithograph. The conical spires of the two medieval turrets at the old gate are visible in the background. Today, they are the only example of fourteenth-century architecture still remaining in Paris.*

carved and gilded in place. These are three-dimensional works of low-relief sculpture—garlands, fronds, and tendrils that run and turn gaily around the crisp geometric forms. Ornamentation becomes more elaborate as the walls rise. At the top are plaster wreaths, medallions, trophies, cupids, and flaring plant masses whose trailing spires meet in a large rosette crowning the blue domed ceiling.

The fireplace in the Salon of the Princess, as typical of rococo, is reduced in size, with a flush chimney. A mirror, instead of the customary painting, is installed over the mantel. The chandelier, with its large drop crystals, is hung unusually low, near the level of social interaction. The tall, lovely all-glass French double doors, overlooking the garden, flood the room with light, which bounces off the mirrors. In the spaces (spandrels) between the arches are embedded paintings, accented by curvilinear gold frames—eight scenes by Charles Natoire from the Greek myth of Psyche, an allegory for the spiritual life of a young bride. Concealing the walls' intersection with the ceiling, the paintings deepen a sense of heady disorientation coming from the angled reflections in the multiple mirrors. The visitor, as if freed from earth, floats in a serene, enchanted space.

Luxurious rococo was flourishing at a time of grave economic inequities and periodic food shortages in France. Indeed, Boffrand's suites at the Hôtel de Soubise were still under construction during the first food riots, which broke out in the provinces in 1739 and spread to Paris the next year. The self-absorbed hedonism of the French leisure class was captured in rococo painting—the *fêtes galantes* (outdoor parties) of Jean-Antoine Watteau, the erotic intrigues of François Boucher, with his soft pastels and fluttery brush-strokes. Rococo is a feminine style: women are shown as rosily nymph-like, while men are often languid and effete.

Rococo was a chapter in the history of pastoral, an ancient genre that worships but sentimentalizes nature. Rococo's twining, twisting creepers show nature invading and recapturing the social realm. But instead of purifying what they touch, they introduce a self-conscious perversity. The empty white background of rococo paneling is a willed blankness, a blocking out of unpleasant realities. French rococo interiors have clarity, yet they are suspended, elusive, unresolved. So much pretty motion, and yet so much golden paralysis.

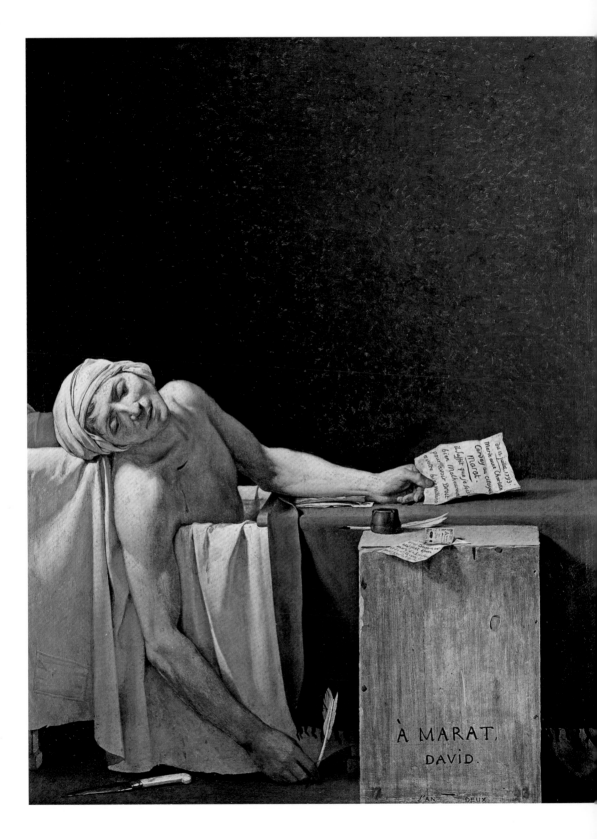

MARTYR OF THE REVOLUTION
Jacques-Louis David, *The Death of Marat*

Who done it? A bloody kitchen knife, a smudged letter, a corpse toppling from a bathtub. The viewer becomes a police inspector sifting clues at a crime scene. Jacques-Louis David's shocking painting was no mystery story when it first went on public display three months after the assassination of Jean-Paul Marat, a radical populist and crusading journalist who was already the focus of an emotional mortuary cult in Paris. Whatever explanatory notes it may need today, *The Death of Marat* still stands on its own as a powerful image of strange, repellent beauty.

Cherchez la femme: missing from the picture is Marat's murderer, Charlotte Corday, a tall, attractive, and articulate twenty-five-year-old who had traveled from Normandy to strike this daring political blow. A fervent supporter of the moderate Girondin Party, Corday blamed Marat for the carnage then consuming the French Revolution, as faction warred against faction. Modeling herself on the heroes of antiquity whom she studied in Plutarch, she had planned to assassinate Marat, like Julius Caesar, in a public forum—the floor of the National Convention. But when illness made Marat stay home, Corday tracked him to his apartment and, after several tries, won a private audience.

Because of his "leprous" skin condition (probably arthritic psoriasis), Marat worked and wrote while bathing his emaciated body in sulfur salts, a vinegar-steeped rag (to soothe the fiery itching) wrapping his head. This was how he had received his friend and ally David just the day before. After conversing with Marat about the Girondins, whom she pretended to denounce and he promised to guillotine, Corday stabbed him once in the chest with a butcher knife she had purchased at a Paris shop. The six-inch blade pierced his lung and heart, and he was dead within minutes.

The picture shows none of the tumult that erupted after Marat's cry for help. Here time

Jacques-Louis David, *The Death of Marat*. 1792. Oil on canvas. 5 ft. 5 in. × 4 ft. 2½ in. Musée d'Art ancien, Musées Royaux des Beaux-Arts, Brussels, Belgium.

has stopped: the gently smiling bather seems asleep and pleasantly dreaming. But in the first angry rush, Corday was knocked to the floor and soon arrested. She spent four days in prison before her trial, where she never wavered in her defense of the righteousness of the murder. She was convicted the same day and immediately sent to the guillotine. It was said that when the executioner held up her severed head and slapped it on the cheek, the other cheek blushed. Madame Tussauds made on-site wax death masks of both Marat and Corday.

David, who was a militant Jacobin deputy at the National Convention, organized the lavish mass spectacle of Marat's funeral procession and service. Because of the scorching midsummer heat, heavy perfumes were used to mask the corpse's decay. A portrait of Marat was commissioned from David to adorn the Convention's great hall, one of a pair of icons of martyrs of the Revolution framing the lectern. Coincidentally, on the day *The Death of Marat* was first shown to the public in the courtyard of the Louvre, Marie Antoinette was guillotined. David sketched the haggard queen as she rode by in the cart with her hands bound behind her back. The following year, when David and other partisans of the regicidal Maximilien Robespierre were arrested, the two martyr paintings were removed.

After his release from prison, David reacquired *The Death of Marat* but never showed it again. Indeed, within a few years, he made a sharp career turn and became a supporter of Napoleon Bonaparte, whom he commemorated in a glamorous series of heroic portraits. Though he disliked Napoleon's metamorphosis from idealistic First Consul to megalomaniacal emperor, David's chameleonlike shift opened him, then and now, to the charge of political opportunism. The Marat painting was hidden away until it was briefly seen among the contents of David's studio, auctioned after his death in 1825. Exhibited two decades later, the picture caused a sensation and was hailed by the poet Charles Baudelaire as David's "masterpiece."

David's breakthrough painting, *Oath of the Horatii* (1784), had triggered one of the most momentous shifts in style in the history of art: three athletic Roman brothers, blessed by their father, fling out their arms in a militant salute as they vow to sacrifice their lives for the nation. The picture, painted in Rome, symbolized dawning neoclassicism and electrified everyone who saw it. Rococo suddenly seemed empty and frivolous compared with this vigor of assertion, rendered with austere colors and hard sculptural contours. With

this one work, David revived history painting and contributed to an urgent sense of purpose that would sweep France toward revolution.

Neoclassicism (new classicism) was inspired by the recent excavations of Herculaneum and Pompeii, ancient Roman resort towns buried by the eruption of Mount Vesuvius. There was a sudden craze for antiquity that influenced everything from fashion to interior decor. *The Death of Marat* has a sharp, clear neoclassical design. The grisly narrative has been reduced to simple shapes and blocks of color, anticipating modern abstract art. The plain background, like the marble wall of a Roman temple, is daringly diffuse, as if dissolving in the raking light. (It reproduces not Marat's bleak apartment but David's Louvre studio with its high windows.) The colors are subdued, except for drips and smudges of blood. The picture is a parable of frugality and civic devotion: *L'Ami du peuple* (Friend of the People) was the newspaper published by Marat on a printing press in his apartment. The white sheet lining the tub (to cushion his sores) is old and patched, while the nicked wooden crate, converted to a humble side table for ink pot and quills, is rudely studded with nails. David streaked brown paint over white primer to achieve the box's rough yet beautifully glowing surface.

David has reworked the scene. Marat is more muscular here than in real life, and his raw blisters and scales have been erased. Distracting objects shelved on the wall are gone, and the ebony knife handle and boot shape of the tub have been altered. (Both tub and knife survive in a Paris museum.) Marat was not nude but wore a dressing gown over his shoulders. Nor did he die holding Corday's letter, whose language David has revised to highlight her treachery and sophisticated cadences, at odds with the brusqueness of the urban working class (sansculottes) whom Marat championed. Seemingly poking from the canvas is a note Marat has just written, donating money to a widowed mother of five. The competing letters pit one type of woman against another: the eloquent elite of the ancien régime versus the voiceless poor for whom Marat speaks. At first glance, the sight of a naked man slain in his private quarters might pique suspicions about romance and revenge. Indeed, the erotic subtext was luridly dramatized by Edvard Munch in two 1907 versions of this painting, where the nude Corday has become a warrior-like femme fatale and the tub a bloody bed cradling a castrated Marat.

David's beatific treatment of Marat's body recalls Italian paintings of the dead Christ being laid in his tomb. But the heaviness of composition, with

everything falling to the bottom, conveys the finality of mortality. The wood box is like a tombstone with its maker's signature and dedication ("To Marat," carved in Roman letters), also subtly sinking. The date in tiny letters ("Year Two") uses the short-lived Republican calendar, not yet in effect at Marat's death. David's original title was *Marat at his last breath*, capturing the fleeting moment between life and death. The quill still loosely grasped in Marat's right hand suggests his words taking wing and living beyond him. Like the dove of the Holy Spirit, revolutionary ideas will illumine and inspire. Marat would one day become a hero of international Communism. But it is an open question whether this ruthless activist, author of so many massacres, was a saint or a monster.

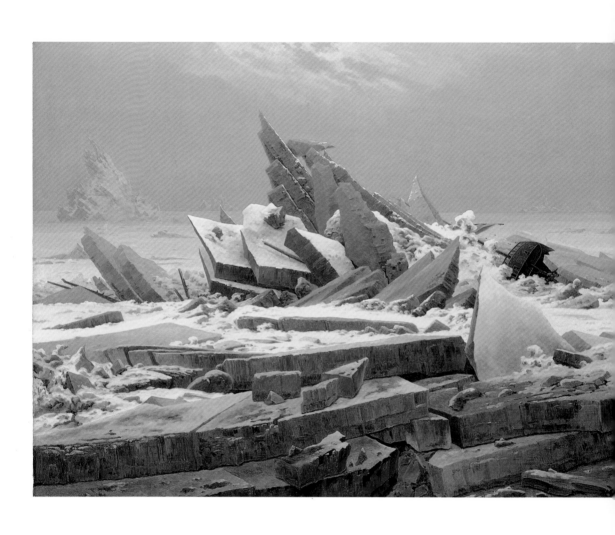

ARCTIC RUIN

Caspar David Friedrich, *The Sea of Ice*

Romanticism, energized by the political revolutions of the late eighteenth century, helped produce the modern individual, detached from tradition and uneasy with authority. Elevating emotion over reason, Romantic art and poetry supplied the missing spirituality in a dynamic new commercial society confident that material progress would bring universal happiness. The Romantic cult of nature, supplanting organized religion, raised the status of landscape painting, previously considered a minor genre. John Constable's pictures, for example, captured the peaceful farm villages and sparkling green meadows of an English countryside that was gradually receding because of industrial urbanization.

Caspar David Friedrich, an exact contemporary of Constable's, was born in the flatlands along the Baltic Sea and spent most of his career in Dresden. His lifetime subject was the German landscape, which he championed as equal to the Italian landscape celebrated by artists since the Renaissance. Friedrich made constant studies of rocks, trees, clouds, and Gothic ruins, drawings that he stockpiled and later wove into paintings. The figure never interested him. When human beings appear in his work, it is usually with their backs to us: they are looking at nature and thus directing our gaze. Friedrich's reclusive, melancholic temperament was evidently formed by family pressures and childhood tragedies, including the drowning of his younger brother (which he witnessed) in a skating accident on a frozen lake.

Early commentary on Friedrich classified him as a Christian artist because roadside shrines often appear in his paintings, such as a gilt-framed altarpiece, *The Cross in the Mountains*, which brought him acclaim in 1808. All of his work was scrutinized for hidden Lutheran symbolism. But Friedrich has come to be recognized as a prophet of modernism, with its themes of loneliness and deso-

Caspar David Friedrich, *The Sea of Ice* [*Das Eismeer*]. 1823–24. Oil on canvas. 3 ft. 2 in. × 4 ft. 2 in. Hamburger Kunsthalle, Hamburg, Germany.

lation. Rescued from near-total obscurity in the early twentieth century, he would have far-reaching impact—on the Surrealist painter René Magritte, for example, and the Irish playwright Samuel Beckett, who declared that the staging of *Waiting for Godot* was inspired by Friedrich's *Two Men Contemplating the Moon*, with its blasted tree on a dim mountain crag.

Friedrich's spooky paintings of coffins, cemeteries, ruins, and skeletal trees project the morbidity of late-eighteenth-century Gothic romances, which would be recast by Emily Brontë and Edgar Allan Poe and end up in horror movies. The majestic shell of the thirteenth-century Cistercian abbey at Eldena, near Friedrich's hometown, appears again and again in his work, sometimes even curiously transported to other locales. Unlike most landscape painters, Friedrich never considered himself a documentarian. He wrote, "The painter should not just paint what he sees in front of him, but also what he sees within himself." Like the British poet-artist William Blake, Friedrich believed in the priority of inner vision: objective reality was inferior to Romantic imagination. Friedrich spiritualized landscape, into which he imported formless emotions embodied in glowing auras or hanging mist, blurring neoclassicism's sharp edges. Friedrich himself shunned broad daylight and loved the twilight of dusk or dawn, when he took long solitary walks. Nature seemed full of omens to him, the archaic worldview implicit in the prehistoric megaliths he sometimes painted. He cherished fierce displays of nature's power, as when he hurried to see a tall tree split by lightning. He exclaimed, "How great, how mighty, how wonderful."

Friedrich's *The Sea of Ice* is a great Romantic image of the sublime, a terrifying encounter with nature's awesome immensity and blind indifference to humankind. It shows a barely visible wooden sailing ship being crushed by fractured sheet ice, pushed by wind and water into high, jagged peaks. Torn timbers and shredded masts are scattered across the picture. Whether the sailors escaped or are entombed in the ice is left unclear. Friedrich did two Arctic paintings: the first is lost but is often confused with this one, which has had several names since Friedrich's death, such as *Arctic Shipwreck* and *The Polar Sea*. (It is definitely not, as commonly claimed, *The Wreck of the "Hope"*; this ship is nameless.) At its debut at the Prague Academy in 1824, the painting was called *Imagined Scene of an Arctic Sea: A Wrecked Ship on the Towering Mounds of Ice*. Reviewers of its later exhibit in Germany curtly dismissed it as "utterly lifeless," "monotonous," and unrealistic. Friedrich was never able to sell it, probably because it was too severe for private homes. As his career

waned, the painting dropped from view. In the inventory of his estate after his death in 1840, it was listed as *Ice Picture: The Failed Expedition to the North Pole.* Purchased by a friend, the Norwegian painter Johan Christian Dahl, it stayed with the latter's family until 1905, when it was acquired by the Kuntshalle in Hamburg and put on public display.

Arctic expeditions had been big news because of the 1819–20 voyages of the British explorer William Edward Parry, who was searching for a Northwest Passage from Greenland to the Pacific. Despite many ordeals, however, Parry never suffered a disaster like this. Friedrich's ice blocks are based on oil studies he had done in luminous pale green of a dramatic ice breakup in 1821 on the river Elbe, which flowed past his Dresden studio windows. Surely in his youth he must also have seen ice jams on the brackish Baltic Sea, which even today can trap steel-hulled vessels and block ports with gigantic ridges of wind-blown ice.

The thick, layered slabs of *The Sea of Ice,* with their mineral tints of green, gold, and rust, look like stone—exactly like the fallen rocks in Friedrich's watercolor study of a quarry. Platform steps in the foreground seem to lead to a cathedral whose spire has collapsed. The thrusting central triangle (echoed by a misty, distant iceberg) evokes both an Egyptian pyramid and the pediment of a Greek temple. Strewn around are chunks of ice like leaning tombstones or the capstones of broken obelisks. Friedrich's ice field is a panorama of world destruction.

There is another epic story here—that of the new science of geology, whose theories were not yet common knowledge. It's as if we are seeing the slow formation of mountains, jammed upward by mysterious subterranean forces. The snow-encrusted main peak also resembles a foaming, cresting wave, catching the ship in its wide vortex. The scenario parallels that of Hokusai's wood-block print *The Great Wave* (1831–33), where three slim fish boats are nearly swallowed up. Furthermore, Friedrich's painting prefigures an event that has become paradigmatic for our own time: the collision of the "unsinkable" *Titanic* with an iceberg on its maiden voyage in 1912, a symbol of nature's humiliating disregard for the hubris of Western technology. Though *The Sea of Ice* may have looked like a dull mess to Friedrich's contemporaries, its bold lines and angular vectors seem familiar to our eyes because of modern architecture—the stainless-steel spires of Art Deco skyscrapers or the cantilevered concrete slabs of Frank Lloyd Wright's Fallingwater.

Does Friedrich's massive spiral of erupting peaks represent an epiphany

of divine power? If so, it is certainly not a goddess of love: sexuality never appears in Friedrich's paintings. There is no promise of redemption or rebirth in this brutal, frigid landscape, where nature grinds the organic down into basic elements. The god of this holy mountain is silent; his stone tablets are blank as they shatter the frail crosses of the ship masts. Friedrich's apocalyptic tableau demolishes all sentimental assumptions about existence. On the horizon, below the ghostly fingers of a passing cloud, sea merges with sky in the blue of infinity, from which mankind has been erased.

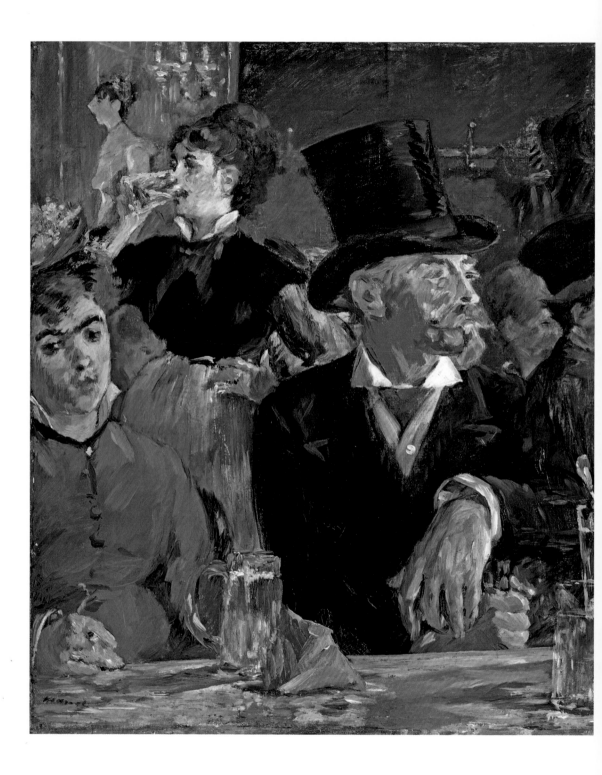

CITY IN MOTION

Édouard Manet, *At the Café*

Nineteenth-century European art was a battleground of competing styles. Jacques-Louis David's once thrilling neoclassicism became an oppressive orthodoxy, the official canon of good taste. Commercial art galleries open to the walk-in public did not exist yet, so it was hard for young artists to get their work seen. The mammoth Salon de Paris show, with its entrenched conservatism, was held only once every two years, then annually after 1863. By mid-century, war was raging between the cultural establishment and a bohemian avant-garde, who tried to reach the public through privately funded exhibits of middling success.

Édouard Manet, a radical artist challenging the status quo, actually came from the prosperous upper-middle class. His career choice was strongly opposed by his dictatorial father, a civil magistrate and judge. Like his friend the decadent poet Charles Baudelaire, Manet felt that art should address modern life. He refused to enter the prestigious École des Beaux-Arts and studied instead with a prominent Salon painter, Thomas Couture, with whom he clashed. Quarreling with a nude male model striking classical poses in Couture's studio, Manet declared, "We are not in Rome, and we don't want to go there. We are in Paris—let's stay here."

Realism, the insurgent movement to which Manet belonged, was launched by the far-leftist Gustave Courbet, whose somber, large-scale paintings of peasants reflected his working-class origins. In both art and literature, realism turned away from Romantic drama and exoticism toward the concrete contemporary world. Realists cultivated a scientific objectivity and impersonality; an artist's emotions or fantasies were irrelevant. Courbet said that painting should represent only the "visual and tangible": art was a mirror held up to life. Realists were accused of wallow-

Édouard Manet, *At the Café*. Ca. 1879. Oil on canvas. 18⅝ × 15⅜ in. The Walters Art Museum, Baltimore, Maryland, United States.

ing in squalor: Manet, for example, was denounced as "the apostle of the ugly and repulsive."

Manet detested the smooth shapes and varnished surfaces of neoclassical paintings. He was drawn to the rougher brushstrokes of the seventeenth-century Spanish painter Diego Velázquez, whose work he saw in the Louvre. It was in fact in front of a Velázquez that he met his friend and ally Edgar Degas, who was sketching it. Manet began experimenting with a freer, more visible brushstroke, loosely applied to leave the form incomplete, so that the painting coheres only when one steps back from it. Manet used an unusually fine white canvas, which he coated with oil so that his brush glided over it as in watercolor. Because he skipped the standard first step of applying primer, his colors have a raw, stark look and seem to cling to the surface, reducing the illusion of depth, which had been valued by European painters since the Renaissance. Manet's accentuation of the surface, partly influenced by Japanese art, and his self-referential play with paint have led to his repute as the first truly modern artist, laying the groundwork for abstract art.

Both Manet and Degas were intrigued by photography, which had steadily evolved after its invention in the late 1830s. The two painters often reproduce the random, casual, confused look of candid photographs, cutting figures off at the edge. Degas's close-up views of jockeys astride their jostling horses look like snapshots with a handheld camera, which had not yet been invented. At first, photography seemed to threaten artists' livelihoods, especially in portraiture. But over time, photography liberated painting from the obligation to depict the physical world as it appears to the eye. While he admired photography's speed and frankness, Manet rejected its literalism. There is systematic distortion in his major paintings—shallow space, ambiguous composition, uneven execution. Even Courbet complained about the reclining vamp of Manet's *Olympia*: "It is flat; there is no modeling; you would imagine she was the Queen of Spades in a pack of cards coming out of her bath."

Manet's *Le Déjeuner sur l'herbe* (Luncheon on the Grass) ignited the first big scandal of modern art. Rejected by the Salon of 1863, it became the prime exhibit at the Salon des Refusés (the Refused Ones), mounted in protest against the Salon jury. Public sensibilities were offended by this picture of two raffish bohemians lounging with a nude female companion who meets our eyes with bold amusement. Nudity in art was acceptable if safely distanced in antiquity, but the contemporary dress and impudent tone of Manet's painting seemed crassly provocative. People openly laughed, as they did again when *Olympia*

was shown two years later. The latter drew such hostile, unruly crowds that guards had to be posted, and it was finally moved to the Salon's farthest gallery and rehung near the ceiling. Based like many of Manet's works on prior paintings (in this case Titian's *Venus of Urbino*), *Olympia* shows a sophisticated courtesan languidly relaxing in the nude as her Caribbean maid presents a large bouquet, the gift of her past client or the new one—us, on whom she fixes her cool, complacent gaze. Her trim, sallow flesh, bathed in bleak light, lacks the pearly glow of neoclassical nymphs. There is an uncomfortable compression of space, permitting us neither to breathe nor to escape.

In real life, Manet was a consummate flaneur, an elegant, witty man of the boulevards who loved to wander his native Paris on foot. The city was being transformed by Baron Haussmann, who leveled narrow, twisting medieval streets and plague-ridden tenements and imposed grand avenues and plazas. Haussmann's reforms, which not incidentally facilitated military control of popular insurrections, also spurred pedestrian traffic and nightlife on newly gaslit streets. Cafés set up tables on widened sidewalks, turning people-watching into a sport. The entertainment industry was exploding, serving the leisured middle class as well as hordes of tourists.

A new institution was the café concert, which served food and alcohol with a variety show of racy songs and jokes, during which patrons openly chatted and circulated. Manet's *At the Café* captures the lively mix of social classes and characters in this noisy environment, where young artists met to debate ideas. We are positioned almost as if we, like the waitress quaffing beer, were at work—behind a marble bar with glassware and a tap handle partly visible to the right. (Manet will reverse this perspective for one of his greatest paintings, *A Bar at the Folies-Bergère,* with its posh gold-capped champagne bottles.) The bar's gently sloping edge, not precisely parallel to the picture bottom or brass hat rack, draws us subliminally into the swirl. Reflected in the large, framed mirror is a brass chandelier as well as a performance going on behind us—a pert young woman with gamine bangs and a smart neck band singing onstage.

Slumped at the bar is another young woman who looks tired, bored, lonely, and a little depressed. She has thick unplucked brows and is wearing a plain brown dress that might be a shopgirl's uniform. But she certainly does not belong to the exclusive corps of shopgirls clad in black silk who worked at the best Parisian department stores and whose private lives were heavily supervised. That she is smoking in public suggests she is not quite respectable. Per-

haps she is moonlighting as a prostitute. The yellow flowers in her hat should convey springtime promise, but they are artificial, and she seems at a dead end. The foam has settled on her beer, which, judging by her inertia, might be her second or third. Her curling cigarette smoke seems truncated—like her thoughts and dreams. If the pyramidal object before her (echoing the picture's triangular design) is a pastry wrapped in blue tissue paper—slightly disheveled, as she is—then it expresses her limited life of hidden, postponed pleasures.

The dapper, gray-haired gentleman draping a graceful hand over his gold-tipped cane belongs to a distinctly higher class. He wears an elegant silk-plush stovepipe hat with a flared brim. The rest of his ensemble is the latest fashion of the 1870s, starting with his long, straight frock coat with padded shoulders and wide, peaked lapels: men's coats before this had sloping shoulders, nipped waists, and ballooning hips. His white wing collar is also new, as is the silk cravat tied with a loose knot and the cream vest buttoned high. His long chin puff and handlebar mustache with twirled tips are in the "imperial" style of facial hair associated with the recently deposed Napoleon III. A faint red circle, like the hint of a monocle left by Manet on the man's cheek, intensifies his gaze and gives him a hound-like alertness: is he stalking the girlish singer?

The hearty waitress is mistress of all she surveys. No proper middle-class lady would stand with hand brusquely on hip like a sailor. But this waitress seems physically and mentally robust, poised for any demand or disruption. She wears a black velvet bodice over a white muslin half-apron with a reddish scarf tied around her crisp standing collar. Freely circulating waitresses, as opposed to stationary, barricaded barmaids, were relatively recent and intriguing arrivals in Paris restaurants. The beer theme is also highly charged because wine was the favored beverage in Paris; beer was considered a crudity of farmers or northern European tourists. Beer drinking, as well as public drinking of any kind by women, had caused controversy in the press.

At the Café has a you-are-there quality. But while it distills Manet's on-site observations, all of his café pictures were executed in the studio with separately posing models. The result here is a fascinating composition with blocky strokes and subtle effects, such as the scattered, unifying patches of yellow and gold. The figures' sight lines shoot out like rays in five different directions, suggesting their psychological disconnection in this temporarily shared space. The sitting girl's right hand limply holding a cigarette parallels her neighbor's right hand confidently clutching his cane. Manet's signature, flattened like a

graffito scrawled beneath her fingers, may tenderly suggest his sympathy and solidarity with her.

Photo cropping is imitated in how Manet daringly cuts through the young woman's body and slices even more out of the laborer on the opposite edge. The latter's blunt-cut, flyaway hair and loose clothing—a coarse blue workaday smock and soft mechanic's cap—contrast with the gentleman's taut, upscale costume, as compact and structured as armor. Always a sharp dresser, Manet was a keen student of fabric, style, and tailoring. Fashion for him was not superficial ornamentation but a sensitive barometer of cultural change. Clothes in Manet's paintings are badges of identity, the public heraldry of a mercantile society in restless flux.

MELTING COLOR

Claude Monet, *Irises*

Impressionism, the second phase of realism, was scorned by critics and the general public for its mundane themes and sketchy technique, which looked childish and inept. But over the past century, probably no style of art has become more popular around the world. Museum shows on Impressionism draw sellout crowds, while pastel knockoffs of Impressionist paintings are standard decor for hotels, offices, and doctors' waiting rooms. Impressionism's idyllic themes—sunny fields, picnics and boating, flowers and gardens, women sewing and children playing—evoke a nostalgic state of restful reflection. Salon juries in Paris expected important subjects from painting—ancient myths, Bible stories, glorious episodes of French history in a polished neoclassic style. But Impressionist pictures, showing middle-class friends and families mingling in riverside cafés or seaside resorts, seemed pointless. Beyond this, Impressionist brushwork (partly inspired by long out of fashion rococo painting) was bizarre—a blur of dibs and dabs. A journalist mocked Monet's strolling urbanites in *Boulevard des Capucines* as indecipherable "black tongue-lickings."

Claude Monet was the principal creator of Impressionism. In his youth in Normandy, he excelled at satirical caricatures and might have become a professional portraitist. But he was drawn to nature, his refuge from school, where he felt imprisoned. Inspired by an older local painter, Eugène Boudin, he began to paint in the open air, which would become a foundational principle of Impressionism. Artists had always done drawings or watercolors outside, but complex oil painting was another matter. The invention in 1841 of portable tin tubes for oil paints liberated artists from the studio. "I was overcome by deep emotion," Monet said of his first outing with Boudin. "Suddenly it was as if a veil was torn away. . . . My destiny as a painter opened out before me."

Claude Monet, *Irises (The Artist's Garden at Giverny)*. 1900.
Oil on canvas. 2 ft. 8 in. × 3 ft.
Musée d'Orsay, Paris, France.

Encounters with nature became Monet's obsession. He wanted to capture the precise play of light in every locale in the mercurial climate of northern France. With their focus on the fleeting moment, all of the Impressionists worked with startling speed. Trekking with his supplies and canvases, Monet braved extremes of heat and cold and stoically painted through wind, rain, and snow. Sand grains and shell fragments have been found trapped in the paint of his deft, Japanese-style picture of his wife sitting with a parasol at Trouville beach. Some of his most striking pictures are of bleak, nearly featureless country roads in autumn or winter.

In Paris, where he haunted cafés and met the core group of future Impressionists, Monet found his groove and became a workaholic. Over his lifetime, he produced two thousand oil paintings, six hundred drawings, and more than three thousand letters. Unlike his friends, however, he never changed his style, except for a gradual lightening of colors; he remained a committed Impressionist until his death at age eighty-six in 1926. At that point, he was virtually forgotten by the art world, which had embraced a more aggressively conceptual avant-garde, led by Pablo Picasso. Monet was stereotyped as a facile fabricator of pretty, frivolous, undemanding paintings for rich clients. In the 1950s, however, his reputation was dramatically rehabilitated when he was hailed as an ancestor of Abstract Expressionism.

Previously, Monet's best work was attributed to the Impressionists' most active and cohesive decades (1860s–1880s), when they launched eight independent exhibits amid great controversy in Paris. But two groups of Monet's late paintings are now recognized as formidably pioneering. The first was sequences of a single subject—grain stacks, poplars, the facade of Rouen Cathedral—at different seasons and times of day. They anticipate serial repetition by modern artists such as Mark Rothko and Andy Warhol. The second group was Monet's giant tableaux of water lilies (*Nymphéas*), produced over the last dozen years of his life. They seem nearly abstract, with land, water, and sky merging in floating reflections that disrupt our sense of direction. Monet's mural-sized water-lily canvases (up to forty-two feet long) prefigure Jackson Pollock's vast "all-over" paintings. Furthermore, the circular housing designed by Monet for his water-lily pictures—wraparound galleries in the windowless basement of the Orangerie in Paris—looked forward to installation and environmental art of the 1960s.

Although he had suffered neglect and poverty (exacerbated by his expensive tastes), Monet was a shrewd businessman who by mid-career had become

very wealthy. In 1890, he bought a house in the village of Giverny in the Seine River valley, where he had been renting for some years. He began construction of a water garden, which became the main subject of his art. Enlarging a pond, he planted flowers, water lilies, and weeping willows, and added a Japanese-style wooden footbridge. Because of Monet, Giverny had become a tourist magnet by the late 1890s. It drew a sometimes intrusive American colony: Monet's work had achieved early success in the United States, probably because of the national taste for nature painting. With the waning of the Salon, the art market was becoming more commercial. In 1886, a shrewd French dealer, Paul Durand-Ruel, exhibited forty-eight of Monet's paintings in a large Impressionist group show at a New York gallery, where they found eager buyers. Fifty years after his death, American funding proved crucial in the restoration of Monet's old house and abandoned garden. It is now one of France's top tourist sites.

Irises is a spring garden scene from Giverny. A dirt path lies between massed beds of violet blooms, which cross the picture at a sharp diagonal. In the background can be seen Monet's pond, mirroring tree trunks and weeping willows on the opposite bank. But there is no real recession in depth: our eye keeps returning to the picture surface, which is as flat as a Japanese screen. (A collection of Japanese wood-block prints adorned Monet's dining room at Giverny.) The blaze of light suggests it is midday. The only shadow, falling on the path and flowers in the foreground, is from an overhanging tree behind us.

Using stabbing, choppy strokes, Monet has built up the gracefully splayed iris blossoms with thick layers of paint (impasto), which gives the picture a tactile, three-dimensional quality that is impossible to appreciate in photographs. His hand motion is also evident in slashes boldly juxtaposing unblended green with orange, which is his transcription of bright sunlight falling on leaves or tree trunks. The painting records the effect of light on color, as it is read by the human eye. Everything seems to be melting. Contours, so firmly drawn in neoclassicism, are dissolving in the atmosphere, which Monet called the "envelope." The painting captures an "impression" as the artist's eye rapidly takes in the whole before identifying and classifying *what* is being seen.

Monet declared that he sought "instantaneity," direct experience of the ephemeral moment. "Nature never stands still," he said. This statement parallels maxims by the Greek philosopher Heraclitus—"All things flow" and "One cannot step into the same river twice"—which were adopted by the British literary Impressionist Walter Pater. Inspiring a generation of young

aesthetes (including Oscar Wilde), Pater espoused a doctrine of intense total perception, which he compared to a "hard, gem-like flame," an "ecstasy" that makes all material concerns of life vanish. Monet's *Irises* seems to be burning with the same quality of ecstatic vision. His friend the painter Paul Cézanne said, "Monet is only an eye, but my God, what an eye!"

This incandescent painting is in Monet's *féerique* (fairylike) style—a term he used to describe his deployment of rainbow colors so vivid that forms lose solidity and simply become a flickering, vibrating energy. His magical *féerique* pictures appeal to the public but have been treated as merely decorative by some scholars. Parallels might be found in the states of enchantment in British Pre-Raphaelite painting, where sleepy knights and ladies are embowered in gardens or brambles. The heightened perception in *Irises* is almost psyche-delic: we seem submerged in a sea world of fantastic, wavering vegetation. Ambiguity arises from the picture's lack of a central focus (Monet's usual method). The entire scene is treated evenly, without emphasis on one part over any another. There is no story—as there always was in the paintings of France's greatest colorist, Eugène Delacroix. The sense of suspension in *Irises* resembles the floating contemplativeness of Impressionist music, such as Claude Debussy's exquisite odes to nature.

If *Irises* has any theme, it is the beauty and fertility of nature. Monet's trees seem packed with orange fruit, but these bursts are simply green leaves touched by solar fire. The thronging irises, with their personalized heads, are as lively and sociable as the bustling pedestrians of Monet's early Paris scenes. The blossoms have a spirit of their own—like the host of dancing daffodils that enraptured the Romantic poet William Wordsworth on a lakeside walk. Like Wordsworth, Monet was an atheist wary of ideological systems. There is a luminous pantheism in his landscape paintings. His concentration on the act of seeing reaffirmed the power of the senses. Art was his faith, repairing the broken connection between man and nature.

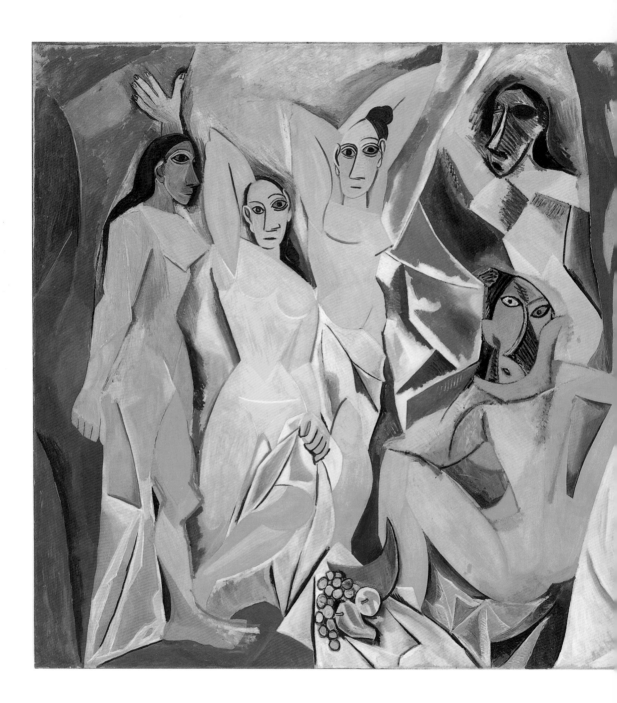

HEAVEN AND HELL

Pablo Picasso, *Les Demoiselles d'Avignon*

The most important painting of the twentieth century": this was said of Pablo Picasso's *Les Demoiselles d'Avignon* before the century was even half over. It remains one of the most original and disturbing works in the history of art. Unlike Impressionist paintings, initially rejected but eventually warmly embraced by the general public, *Les Demoiselles* has never been fully assimilated. Most Impressionist paintings were comfortably scaled to middle-class living rooms. But at eight feet high, *Les Demoiselles d'Avignon* is an overwhelming and intimidating presence. Reproductions in books shrink its power.

The painting was executed over three months in 1907 in Picasso's jammed, squalid one-room studio apartment in bohemian Montmartre in Paris. Then twenty-five, he was one of many ambitious young artists in the city. As a teenager in Spain, he had won attention for his expertise with realistic drawings and paintings. Even before moving from Barcelona to Paris, the capital of the art world, he was working his way through established styles in search of one of his own. Picasso's first unique style was his Blue Period (1901–4), consisting of elongated portraits of the ill, aged, and destitute against a melancholy backdrop of blue. He soon moved on to a Rose Period (1904–6) where gentle family groups of circus performers are suffused with pink, violet, and orange.

The fleshy pinks of *Les Demoiselles d'Avignon* are a survival from Picasso's Rose Period but with a stunning change of tone. There is no longer any humor or pleasure. On the contrary, we seem to have wandered into a torture den. It's the reception room of a brothel, where bored women lounge with their hair down as they wait for customers—a scene frequently drawn by Degas and Toulouse-Lautrec. Picasso had painted prostitutes in Paris cafés, where they were dancing or flirting with one another. In *Les Demoiselles,* however, each of

Pablo Picasso, *Les Demoiselles d'Avignon.* 1907. Oil on canvas. 8 ft. × 7 ft. 8 in. The Museum of Modern Art, New York, New York, United States.

the women seems locked in her own severe, remote consciousness. They are like Fates, frigid masters of man's destiny.

When this painting finally became known to the world after its acquisition by New York's Museum of Modern Art in 1939, commentary on *Les Demoiselles d'Avignon* focused on its formal properties as a prefiguration of Cubism, co-created by Picasso and Georges Braque before World War I. A 1972 essay by the art historian Leo Steinberg demanded honest recognition of the painting's illicit sexuality. Because so many of Picasso's preparatory sketches were preserved, studies of the painting's genesis are extensive, but little or no attention has been paid to a variety of later details. Its demurely ambiguous title, "The Maidens of Avignon," has proved an irritant: Picasso did not coin it, and he disliked it. He simply called the painting *"mon bordel"* (my brothel).

Les Demoiselles is staged like a *tableau vivant*. The woman standing at left lifts a heavy curtain, while her opposite bursts like a wind into the tentlike space. On a stool at lower right, a nude sits with legs brazenly spread. The two apparently upright central figures are actually reclining with arms behind their heads, a white sheet draping their legs. Picasso's startling conflation of two points of view was revolutionary. Ever since the Renaissance, perspective had been based on the spectator's fixed position, reproducing where the painter had set his easel. Here, however, we stand on the brothel floor and also hover near the ceiling—a duality not seen since Byzantine art.

Multiple perspective, soon to be a hallmark of Cubism, also applies to the spiderlike sitter: we view her legs and bare buttocks from behind, but her torso demonically twists to make her head and arms face forward. She is resting her menacingly boomerang-like chin on her fist. The reclining ladies are also hybrid: their eyes and faces are frontal, while their noses are profiled. Picasso's disjunctive method is partly derived from Cézanne, whose sloping country tabletops are imitated here in the giddily angled coffee table.

But Picasso had also studied Egyptian art, with its anatomical contortions. His left-hand lady, hand clenched at her side and one foot forward, is based on pharaoh sculptures and the Greek athlete statues (kouroi) that they inspired. Furthermore, as the sole clothed (or semi-clothed) demoiselle, she evokes the Winged Victory of Samothrace, plastered with wet drapery as she lands on a ship's prow, a monumental ancient sculpture that Picasso saw dominating the magnificent Daru Staircase at the Louvre.

Meanwhile, the reclining demoiselles allude to the Venetian tradition of lazy,

opulent nudes, who reappeared as hookah-smoking Turkish or Algerian odalisques in nineteenth-century French paintings. Picasso based the two women's domed heads and large ears on pre-Roman Iberian sculptures recently found near his hometown of Málaga in Andalusia. Their raised elbows come from a homoerotic statue that always fascinated him—Michelangelo's Neoplatonic *Dying Slave*, a life-sized plaster copy of which can be seen in photographs of Picasso's studio after his death.

Thus *Les Demoiselles d'Avignon* densely embodies a procession of styles in Western art, read from left to right: antiquity through the Renaissance to modernity, which Picasso shows transformed by the abrupt arrival of non-Western cultures, represented by scarified tribal masks from Africa and Oceania. Picasso had seen and admired many examples of what was then collectively called *l'art nègre*. The Fauve painters, including Henri Matisse, the artistic leader of Paris, were acquiring tribal objects from 1904 on. Although he later tried to minimize it, Picasso also had an intense spiritual experience at the Trocadéro ethnographic museum just as he was formulating *Les Demoiselles*. Sixteen years earlier, Gauguin had abandoned Paris for Tahiti. Picasso saw Gauguin's South Seas paintings at two posthumous retrospectives; their influence can be detected in the dusky complexion of the left-hand demoiselle, who resembles Oceanic ancestor spirits like the stone sentinels of Easter Island.

But how tranquil Gauguin's Tahitian pictures seem compared with Picasso's visceral adaptation of what was then called "primitivism." Picasso zeroes in on the violence of ancient nature cults, with their rituals of blood sacrifice. Sex as portrayed in *Les Demoiselles d'Avignon* is a gateway to an impersonal world of pure biologic force where man is nothing and where woman, a mother goddess splitting into her weird sisters, is everything. The little table has been seen as a phallically thrusting prow (in early sketches, a sailor sat at stage center). But it can also be viewed as a ruined altar laden with ashy forbidden fruits—a melon slice resembling a scythe-like crescent moon, a mottled pear and apple looking like hacked meat. Has castration already occurred? The meat motif is blatant in the left-hand figure, whose floor-length pink peignoir gives her a third leg, like a slab of well-marbled beef. French argot for a working-class brothel was "slaughterhouse" (*maison d'abattage*; compare "abattoir"). Yes, whores are meat on the rack. But the bladelike leg resting on the floor suggests it is the lady's clients who have been butchered, their blood washing down onto her sturdy, mannish foot.

There are no welcoming smiles in this cabal of urban nymphs. Their snake-like lidless eyes are fixed and blank or at mismatched angles or missing altogether. They are sleepless watchmen of the heaven-hell of sex, where the price of momentary ecstasy may be disease or obliteration of identity. The jewel-like, geometric facets of Cubism are anticipated in Picasso's transformation of round breasts into aggressive squares with razor points (combined with unsettlingly reversed underarm hair). The instability of Cubist objects is illustrated in how a blue curtain becomes shattered window glass through which we see sun, clouds, and a mountain peak, a mirage of freedom. A seeping cloud next to the middle lady's left hip even forms a ghostly white spine, as in an X-ray, the vertebrae gradually cohering as in a Darwinian dream.

The colors of *Les Demoiselles d'Avignon* paint an elemental drama from earth brown to sky blue. These fierce women enact what the Bible credits to Jehovah—the division of land from ocean and the creation of the firmament with sun and moon. The cosmic birth process is literalized in a splash of blood ringing the splayed demoiselle. Her squat stool is a bordello bidet but also a low birthing chair, basic to old rural societies all over the world. In Picasso's first sketches, a male medical student or city health inspector holding a book locks eyes with the crouching demoiselle: the gruesome mystery of procreation can be observed but not explained by science.

Picasso called *Les Demoiselles d'Avignon* "my first exorcism painting." It was an experiment in black magic. With its graceful, chalky outlines yet jagged fractures and distortions, it weds beauty to ugliness. Despite many claims that the title refers to a brothel in Barcelona, no archival evidence has been found of a brothel ever existing on respectable Avignon Street. It was in fact on that very street, just around the corner from his parents' house, that the young Picasso bought art supplies. These statuesque demoiselles, crowding the flat picture plane, are Picasso's carnal Muses, patrons of his genius and titanic productivity. (He left fifty thousand works in a vast range of genres and materials.) In real life, one woman would never be enough for him. He had to rip through the veils of personality to capture woman's essence, which always eluded him. In this, his greatest painting until his political protest mural, *Guernica,* thirty years later, he confronts the mothers of his creative vision. Mutating through many faces, they are the models for the restlessly mercurial styles of his long career. He cannot conquer them, but their intense gaze conveys that they are choosing him, and only him.

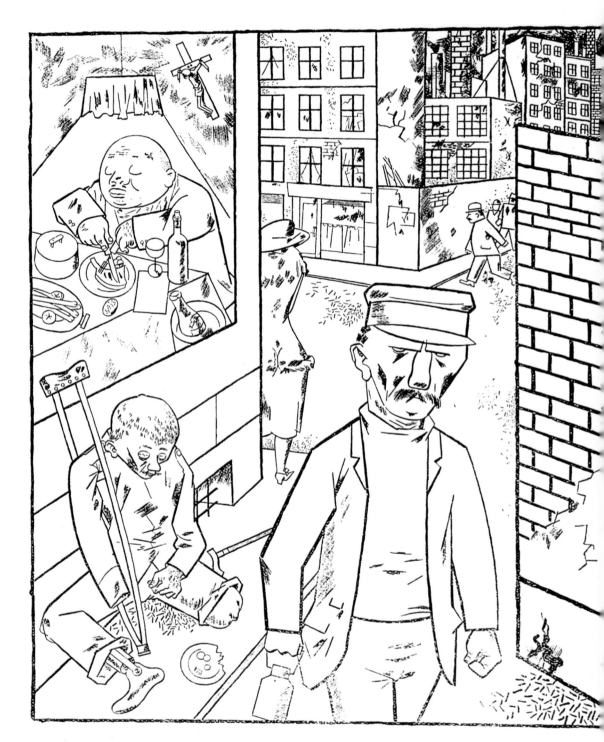

Freut Euch des Lebens!

HEART OF STONE
George Grosz, *Life Makes You Happy!*

The catastrophe of World War I, then called the Great War, ended Europe's view of itself as the most enlightened civilization in history. After four years of stalemate and over eight million lives lost, little was achieved beyond the redrawing of a few borderlines. Artists decades earlier had prophetically sensed fractures and tremors in the confident European empires. In the late nineteenth century, Symbolism in both literature and art turned away from the social world toward a hallucinatory mysticism, often marked by decadence. A prototypical Symbolist painting was the Norwegian artist Edvard Munch's *The Scream,* where a withered, asexual elf stands paralyzed on a bridge, buffeted by waves of energy from a lurid red sky.

George Grosz was born in Berlin in 1893 and raised in a Prussian town now part of Poland. He attended art school in Dresden, where training was still very conventional, requiring drawing from plaster casts of classical statues. But he was also exposed to the radical work of a local group, Die Brücke (The Bridge), who were developing a new style: Expressionism, as prefigured by Munch. Its principal characteristic is distortion of the outer world through inner suffering. Expressionism expresses the artist's emotions but without Romantic lyricism or ecstasy. Its keynotes are anxiety, fear, disgust, and despair, reflecting alienation from a disordered society.

Grosz was always fascinated by popular culture and, even as a student, contributed to satirical magazines. He loved children's art as well as the sensational pictorial press. He copied toilet graffiti and collected pornographic postcards and other cheap memorabilia usually dismissed as kitsch (trash). His mischievous taste for the macabre resembled that of his British contemporary Alfred Hitchcock. Inspired by horror stories and crime annals, Grosz produced over his lifetime a host of grisly pictures of torture, mutilation, murder, and rape. It was as if he had

George Grosz, *Life Makes You Happy! [Freut Euch des Lebens!]*. 1923. Ink drawing from *Abrechnung folgt!*

multiple personalities: "How many people live within us?" he asked in his autobiography.

In 1912, Grosz enrolled at an arts college in Berlin. The following year, he studied briefly in Paris, where he encountered Fauvism and Cubism. When Germany declared war in 1914, he volunteered for service. But his traumatic experiences in the trenches led to a nervous breakdown and hospitalization. Like many others of his generation on both sides of the conflict, he turned against militarism and lost all respect for authority and institutions. Back in Berlin, Grosz joined the Dada movement, which used nonsense to attack the absurdity of the war. Dada derided everything that people held sacred: thus Marcel Duchamp drew a mustache on the *Mona Lisa* and exhibited a urinal as art. Grosz performed in many Dada stunts, which were an ideal forum for his prankish humor.

After the war, Grosz abandoned Dada and also scrapped his Cubist collages of faceless automatons in barren cityscapes. He needed a new artistic style to respond to Germany's escalating chaos. There was widespread civil unrest—thousands of workers' strikes and violent suppression of leftist riots by paramilitary troops. The kaiser abdicated after a revolt in late 1918. Following the humiliating Treaty of Versailles, Germany struggled with economic instability and runaway inflation. Wounded veterans had to beg on the street, crowded with desperate women who had turned to prostitution. Now a militant leftist, Grosz joined the Communist Party. But after a five-month trip to the Soviet Union, when he met Lenin and Trotsky, he became disillusioned with Communism and left the party in 1922.

Under the shaky Weimar Republic in the 1920s, Germany was a vast spectacle of wild contrasts, which Grosz captured in acidly satirical, often grotesque drawings, returning to the simple black line of political caricatures that he had done as a teenager. His instrument was a flexible reed pen, the fragile tool of scribes and artists since ancient Egypt. Fearlessly lampooning generals, politicians, financiers, and war profiteers, Grosz was arrested, prosecuted, and fined several times. His slashing cartoons, with their garish scenarios and crude, primitivistic shapes, won fame via German newspapers and magazines as well as best-selling portfolios of lithographs. His 1921 collection, *The Face of the Ruling Class,* sold twenty-five thousand copies. He firmly rejected abstraction: "Great art must be discernible to everyone," he said.

Grosz was a big drinker and convivial hedonist who haunted bars, cafés, cabarets, and brothels, where he sat sketching the human parade. It was the

decadent era of Christopher Isherwood's *Berlin Stories* (later made into a musical and movie, *Cabaret*), when prostitution, homosexuality, transvestism, and sadomasochism were flagrant and unapologetic. The manic, corrupt world portrayed by Grosz seemed ripe for apocalypse, which arrived with the Nazis and their promise to clean up Germany. The names of provocateurs like Grosz, a vocal early opponent of Hitler, were placed on an arrest list. In 1933, he probably escaped death by sailing to New York only eighteen days before Hitler became Chancellor.

Freut Euch des Lebens! (*Life Makes You Happy!*) illustrates Grosz's great Expressionist style of the 1920s. The bitterly ironic caption is actually the title of a lilting waltz by Johann Strauss, who epitomized sophisticated central European culture before World War I. The drawing shows postwar Germany cruelly divided between the haves and the have-nots. People are struggling to survive in an arid grid of broken windows and cracked facades, conveying government indifference and neglect. Café curtains in an unmarked storefront across the way suggest the presence of squatters, urban refugees.

A workman carrying his meager lunch pail walks toward us down an alley. His cheeks are gaunt and his eyes smudged from stress or fatigue. Perhaps he is coming from the dilapidated factory in the distance. The paper-thin brick wall hemming him in (like a Cubist stage set) may be a projection of his bunkered mental state. A streetwalker, huddled against the cold in a shabby, soiled suit, waits on the corner. She is faceless because that is how she is perceived by her clients. A grizzled veteran, a triple amputee, slumps drowsily against the restaurant wall, a chipped plate holding coins he has cadged from passersby. He is one of the lucky ones: his artificial leg and foot constitute one of two prostheses legally due to German veterans but difficult to obtain. A portly, mustachioed businessman with a bowler hat hurries across the intersection, as if to avoid looking too closely at the seediness around him. The prostitute looks hopefully in his direction, but he leans purposefully forward on his trajectory.

Safely glassed in above it all dines a wealthy capitalist, as Grosz usually depicts the type—smug, obese, and bestial. He has blubbery lips, a piggish snout, and apelike hands. Oblivious to the plight of his fellow citizens, he zestfully slices into a fatty chop, accompanied by a seeded bun and a salad of leeks and cucumbers. Champagne waits on ice, while he quaffs wine with his meal. The bill edging off the table is a minor matter for him. It's warm under the flooding lamp, as if heaven itself were blessing him. But the crucifix is

awry: Jesus looks like a prisoner, roped arms dangling like broken wings. His message of compassion and ministry to the poor has been forgotten. Grosz was fiercely critical of the collusion between German church leaders and the military and political establishment. His 1928 antiwar drawing of the crucified Christ in a gas mask and army boots led to charges of blasphemy filed by church authorities against him and his publisher. Like William Blake, Grosz saw the church as hypocritically allied with the powerful rather than the powerless.

The exact center of this picture is empty, a vacuum representing society's spiritual hollowness. The barred basement window, its iron rods parodying the Cross, shows there is no social mobility, no access to the ladder of success. The title of Grosz's 1923 portfolio containing this drawing was *Abrechnung folgt!* (literally "Account follows"), translated as *The Day of Reckoning*, that is, doomsday. The approaching workman's expression is ambiguous. Does it register stoical endurance, his eyes like slits to avoid taking in too much? Or are secret thoughts of rebellion crystallizing? Is his left hand, with its stubby, malformed thumb, becoming a fist? The workman is another Grosz automaton, absorbed into the industrial machine that he serves. Social injustice is shown as an inhuman process of brutalization. Shadow twin to his gluttonous oppressor, the workman too, through his harsh life story, has a heart of stone.

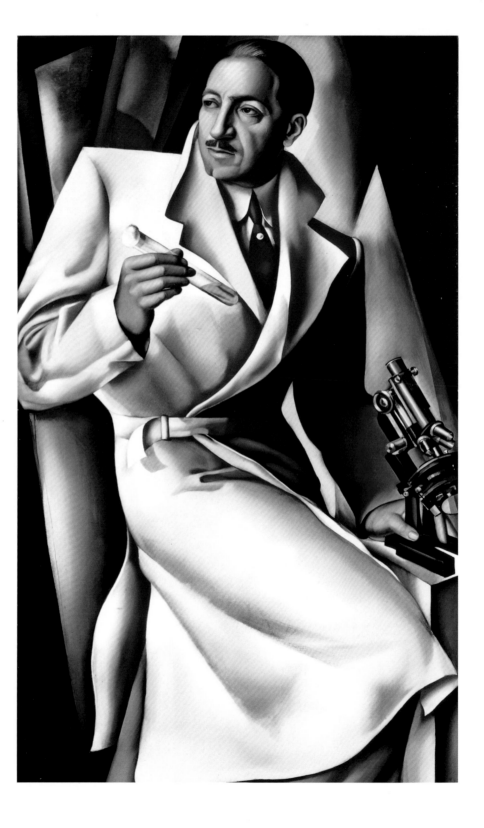

DANCE OF THE MIND

Tamara de Lempicka, *Portrait of Doctor Boucard*

As the story of modern art coalesced in the mid-twentieth century, critics and scholars awarded supremacy to the avant-garde—the shock troops of rebel artists since Romanticism who had been rejected by a hostile public. Artists and styles not conforming to this heroic, oppositional model were demoted or excluded altogether. Finely wrought Victorian paintings, for example, were now deemed embarrassingly sentimental or didactic and buried in storage by museums or sold off. Another dismissed style was Art Deco, which was born in Paris just before World War I and flourished internationally in the 1920s and 1930s. Even its abbreviated name was not invented until 1966, when a retrospective was held in Paris of that city's massive 1925 trade show, the Exposition Internationale des Arts Décoratifs et Industriels Modernes.

Art Deco was fragrantly commercial, catering to an elite clientele with suavely handcrafted objects—chrome cocktail shakers, diamond and platinum wristwatch bands, sleek glass figurines of nymphs or greyhounds, cabinets inlaid with contrasting strips of high-varnish exotic woods. Whereas late-nineteenth-century Art Nouveau used undulating, organic motifs like flowers or running vines, Art Deco was based on angular, streamlined geometry—aluminum or stainless-steel chevrons, zigzags, and sunbursts. In the United States in the 1930s, Art Deco became a more populist style favored by businesses and public works commissions, producing New York's Chrysler and Empire State Buildings and Rockefeller Plaza. Hollywood also embraced Art Deco, from Cedric Gibbons's chic set designs to Busby Berkeley's kaleidoscopic dance routines.

Tamara de Lempicka, *Portrait of Doctor Boucard*. 1929. Oil on canvas. 4 ft. 5 in. × 2 ft. 5½ in. Private collection.

After it became passé in the 1940s, gay male collectors kept Art Deco alive as "camp," laying the groundwork for the style's later revival and its current high value at auction. But Art Deco is still underrep-

resented in major museums and minimized or ignored by many art historians, partly because it does not support the ruling paradigm of art as leftist resistance. On the contrary, Art Deco was promptly adopted for political posters and public architecture by fascist regimes in Germany, Italy, and Russia.

The leading painter of Art Deco was Tamara de Lempicka, born to a wealthy Russian family who had fled to Paris to escape the Bolshevik revolution. Her father was probably Jewish; her mother was Polish Catholic and descended from French émigrés who had fled their own revolution in the eighteenth century. Though she was one of the most strong-willed and fanatically industrious women artists in history, Lempicka's work can be seen in few museums outside France. Most of her paintings are privately owned, often by movie stars, which has compromised her reputation among art critics. Performers identify with the theatricality of her portraits, which confer glamour and status. In contrast, the favorite woman artist of mainstream feminism is Frida Kahlo, because of her folkloric themes, her militant Communism, her marital humiliations, and her ailments, accidents, and surgeries, which she graphically detailed in grisly paintings of symbolic martyrdom.

With her haute couture and Garbo cheekbones, Lempicka did not disguise her naked ambition for social prestige as well as commercial success. Her sophisticated persona was the antithesis of the scrabbling bohemian mythos. She attended and threw lavish, risqué parties in Paris and expertly manipulated the media for maximum publicity. Arrogant and opinionated, she never deferred to men in the art world or courted romances with male artists. As detailed in Laura Claridge's riveting 1999 biography, Lempicka was a liberated new woman with her own agenda, which included cocaine-fueled bisexual adventures in seedy riverside bars.

Lempicka was also a serious, driven artist with a unique aesthetic. Her principal mentor in Paris, André Lhote, introduced her to Gauguin's sensual Tahitian paintings as well as to the distortions and spatial compression of Cubism. But she was essentially self-taught. She avidly roamed museums and galleries in France and Italy. Her work reflects the neoclassical revival of the 1920s, to which Picasso contributed with his colossal seaside nudes. Lempicka belongs to the line of painters, extending through Jacques-Louis David and Jean-Auguste-Dominique Ingres, who stress sharp outlines and sculptural mass. Indeed, a contemporary critic, noting Lempicka's heavy, languid forms and polished surfaces, called her "the perverse Ingres of the Machine Age." She admired Botticelli, Antonello da Messina, and Mannerists like Bronzino

and Pontormo, with their refined, armored style. Her subjects were the glittering habitués of postwar Paris café society, where new money met old and where cosmopolitan refugees mixed with Jazz Age entertainers and madcap youth.

Though she is best known for her voluptuous female nudes crowding the canvas, most of Lempicka's work was in commissioned portraiture, a genre then losing prestige. A remarkable example is her 1929 portrait of Dr. Pierre Boucard, who contracted with her to paint his family and who optioned her new works for two years. This lucrative arrangement allowed Lempicka to buy a new house and personally design it as an Art Deco showplace. Boucard was a biochemist who had become a millionaire through his development and marketing of Lacteol, one of the first probiotics, which restored intestinal flora to patients with severe diarrhea. Boucard's company, Laboratoire du Lacteol du Docteur Boucard, still exists as a subsidiary of a Canadian biotechnology firm.

Lempicka presents Boucard as a dynamic man of ideas. He has the cool, penetrating look of a philosopher in the tradition of Gallic skepticism, yet he overflows with physical energy and panache. The picture suggests he has been overcome by a thought and dashed into the laboratory to test his hypothesis before leaving for a social engagement—perhaps, judging by his informal, sharply creased brown pants, at a sporting venue like the racetrack. With his dapper mustache, cleft chin, graceful, manicured fingers, and deep tan, he is a gentleman and bon vivant, at home on the boulevards or at the beach. His white lab coat has metamorphosed into a belted, oddly buttonless, double-breasted overcoat inspired by officers' trench coats of World War I. It has a raffishly turned-up collar and exaggerated, hypermasculine padded shoulders. Underneath can be seen a fashionable blue-gray shirt and a tightly knotted tie with a pearl stickpin. As an advanced theorist, Boucard has composure and focus, but his eyes rake the horizon as if he were a ship's captain on a voyage of discovery—an effect heightened by his rippling coat flap, his ballooning lapel, and the silvery collage of sail-like Cubist planes behind him. It's as if he feels the wind of history at his back.

Boucard's figure assertively fills the picture, which is cropped like a photograph, cutting off his right elbow and left fingers. There is a trace of the flamboyant poster designs for Serge Diaghilev's Ballets Russes, which had been a sensation in Paris for two decades. Boucard's twisted, angular posture (near-frontal chest with profiled legs and hips) is Egyptian, a major influ-

ence on Art Deco after the 1922 discovery of King Tut's tomb. The Egyptian motif is reinforced by a ghostly pyramid in the background. With his raised, out-thrust right knee, Boucard might almost be doing the tango, a craze of the decade. Indeed, a photograph taken on his colonnaded portico by his friend Jacques-Henri Lartigue captures Boucard doing the tango with Lartigue's peppy wife, Bibi. Other Lartigue photos show the Boucards sitting in their spiffy Rolls-Royce roadster or their blonde teenaged daughter, Arlette, cavorting aboard their yacht the *Lacteol III* at Cannes. (Sunk by the Nazis in Saint-Tropez harbor after it was used for gun-running by the French Resistance, the yacht was later owned by actor Peter Ustinov.) Yet another Lartigue photo documents a charcoal sketch of this very painting hanging loose on an easel in Lempicka's plush bedroom. Here the doctor's dance partner is not a beautiful woman but an elegant microscope, a triumph of industrial engineering gleaming on its pedestal like an objet d'art. Boucard's true love is science.

Tamara de Lempicka has been criticized for the artificiality and frigidity of her unique and instantly recognizable style. But her painstaking application of layer after layer of pigment and glaze gives her pictures the glow of early Renaissance sacred panels, washed in egg tempera. One of Lempicka's outstanding gifts was her hallucinatory resynthesis of classic artworks. For example, her forceful positioning of Dr. Boucard's head, chest, and leg resembles that of the mustachioed Napoleonic cavalryman whirling with sword drawn on his rearing Arabian stallion in Géricault's *Officer of the Chasseurs Commanding a Charge* (1812)—a masterpiece of Byronic Romanticism that Lempicka surely saw in the Louvre. The horse's noble head and golden bridle have become Boucard's multi-eyed black microscope, its brass fittings turning to gold, as if he has an alchemist's touch. Instead of a swinging saber, Boucard delicately holds a glass test tube. Its blood-red liquor—the only brightness in this austere picture—implies that Dr. Boucard, like the Egyptians, is searching for the secret of eternal life. But as Lempicka demonstrates in this splendid painting that resurrects a once famous but now forgotten man, only art has that power.

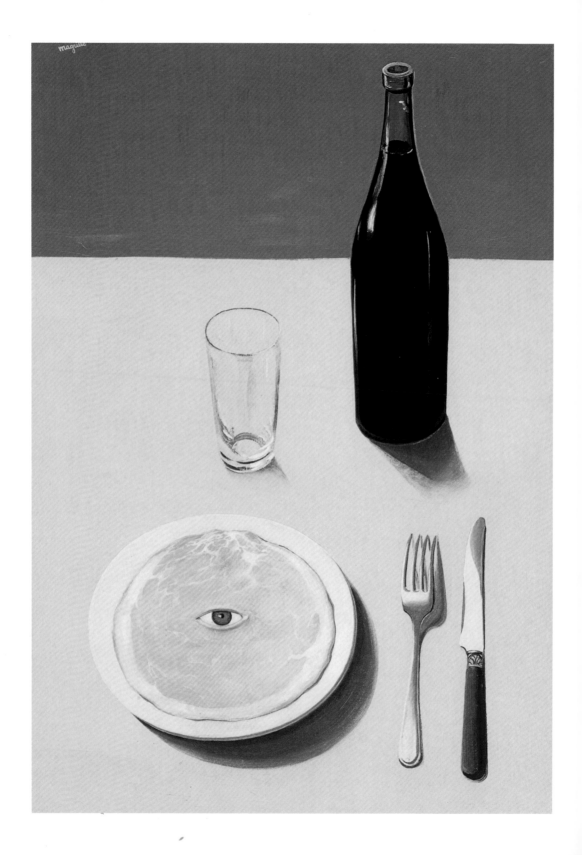

LUNCHEON IN THE TWILIGHT ZONE
René Magritte, *The Portrait*

Surrealism was born amid the chaos of World War I. Like Dada, Surrealism sought to expose the absurdity of Western institutions and assumptions. But Dada soon sputtered out, partly because of its attack on art itself. Surrealism, in contrast, spread throughout the 1920s and 1930s. Initially an insurgency of young poets in Paris, it eventually encompassed many other arts. Politically, the Surrealists were anarchists who flirted with Marxism but abandoned it. Because of translation difficulties posed by Surrealist poetry, the worldwide impact of Surrealism has been mainly through painting, particularly that of Salvador Dalí and René Magritte.

In 1917, poet André Breton, the founder of Surrealism, was working in a mental hospital where he witnessed the use of new psychology to treat shell-shocked soldiers. Breton became convinced of the existence of a powerful unconscious, as identified by Sigmund Freud. In Breton's view, Western reason and logic had led to disaster; thus revelation and purification had to be achieved through the release of irrational energies. The Surrealists valued art by psychotics as a direct transcription from the unconscious. They admired primitive artifacts and works of vision and fantasy, such as Lewis Carroll's cryptic *Alice* books. They played children's games to sabotage adult thinking and experimented with trancelike automatism and oracular speaking and writing.

The now common term "surreal" conveys the Surrealists' search for an elusive truth "above" or "beyond" physical reality. Freud had shown how dreams use metamorphosis and dissolve normal categories of space and time. Thus in Dalí's *The Persistence of Memory* (1931), giant, melting pocket watches are draped limply across a barren desert. Freud's theories about the punning wit of the sex-saturated unconscious inspired the Surrealists' aggressive jokiness. Dalí conflated noses

René Magritte, *The Portrait*. 1935. Oil on canvas. 28⅞ × 19⅞ in. The Museum of Modern Art, New York, New York, United States.

with penises, portrayed sexual desire as swarming ants, and gave such provoc-
ative titles to his landscape paintings as *Necrophiliac Springtime* and *Atmo-
spheric Skull Sodomizing a Grand Piano*. Magritte depicted a nightgown
sprouting luminescent breasts or a face becoming a female torso, with nipple
eyes and a furry pubic mouth.

Dabbling in magic and the occult, the Surrealists were constantly alert to
coincidences, signs of the "marvelous." They paid keen attention to ordinary
things—random stones or street trash, which they transformed into art pieces.
Any "found object" (objet trouvé), preferably untouched by human interven-
tion, had potential value. This faux-naif openness came from Dada's Marcel
Duchamp, who seized on everyday things like a bicycle wheel or coal shovel
and renamed them or changed their environment so that they could be seen as
art. The Surrealists were similarly fascinated by high fashion, which had been
dizzily accelerating with women's emancipation. Both Duchamp and Dalí
designed shopwindows, and Dalí collaborated with the couturier Elsa Schia-
parelli on such Surreal caprices as a painted red-lobster dress and a snappy hat
shaped like an upside-down high-heeled shoe.

The Surrealists staged massive exhibits that forced disoriented visitors to
wander on a ritual journey. The entry courtyard at the 1938 International
Exposition of Surrealism in Paris was dominated by Dalí's bizarre construc-
tion *Rainy Taxi*: water poured down inside a real taxi driven by a shark chauf-
feur; in the rear sat an agitated, half-dressed female mannequin in a stringy
blonde wig as two hundred live Burgundy snails crawled over her and a bed
of lettuce. Stationed like prostitutes along a mock city street within the build-
ing were sixteen mannequins adorned with risqué rags or futuristic trinkets.
One nude mannequin sported a blood-transfusion machine, its cord wound
snakelike around her arm. In the main hall, lit by a single bulb (visitors were
handed flashlights), Duchamp had strewn the floor with ferns and dead leaves
and hung over a hundred sacks of coal from the ceiling. It was all a Surrealist
satire of art exhibits, fashion shows, and industrial expositions.

Surrealism lost steam during the Nazi occupation of France. Following
World War II, the cultural mood turned grimmer and shifted into Existen-
tialism. However, Surrealism lingered in film. Dalí and his countryman Luis
Buñuel had made two pioneering Surrealist shorts, *Un Chien Andalou* (1929),
where sex and art struggle against guilt and repression, and the anticlerical
L'Age d'Or (1930), which triggered a right-wing riot and was shut down
by the police. Buñuel continued to direct major films with Surrealist inter-

ludes well into the 1970s. Alfred Hitchcock invited Dalí to design the dream
sequences of *Spellbound* and used Surrealist techniques in *Vertigo* and *North
by Northwest.*

Surrealism survived as an art movement in Brussels, where René Magritte
had been the center of an active group of artists since the 1920s. Unlike the
Parisian Surrealists, who loved provocation and scandal, the Belgian Surre-
alists led quiet lives and held middle-class jobs. Their orderly surface con-
formism is registered in Magritte's paintings, which often feature a bourgeois
businessman in his prim uniform of overcoat and bowler hat. Magritte did
not even have a studio: he painted in his living room, where he and his wife
also dined. He was a professional graphic designer who took assignments like
cigarette ads and wallpaper patterns. His clean, dry, precise style resembles the
format of trade catalogs. That may be why his paintings, even during his life-
time, were so successfully utilized to sell a wide range of corporate products,
from pens to computers. Thus Magritte, even if he lacks name recognition,
is probably the modern artist most known to and embraced by the general
public. His painting *The False Mirror,* showing blue sky through the pupil of
a large eye, became the logo of the CBS television network.

Magritte's primary influence was Giorgio de Chirico, a modern "Meta-
physical" Italian artist who painted empty plazas adorned by broken classical
statues or frozen tailor's dummies. All of the Surrealists loved de Chirico's
eerie, desolate sunset light. Magritte had been doing abstractions until, some-
time around 1925, he saw a de Chirico painting in a magazine, which he said
showed him his path forward. For the rest of his career, Magritte created
enigmatic pictures of flying boulders, burning tubas, giant apples trapped in
rooms, or rainstorms of stolid businessmen falling on towns. Typical Ma-
gritte paintings show a water glass precariously perched atop an airborne
umbrella, or a squadron of baguettes hovering like menacing blimps near a
stone balcony. At times, as in his tableaux of twilight skies emblazoned by
triple moons, Magritte evokes the spectral northern landscapes of Caspar
David Friedrich.

Magritte's titles usually have little or nothing to do with his pictures.
Always crafted afterward, the titles were often coined by others as a collective
Surrealist project. Magritte insisted that the viewer experience the image as
its own entity, beyond the verbal realm. He also rejected symbolic meanings
and demanded respect for "the inherent poetry and mystery of the image." He
found the Freudianism of the Parisian Surrealists reductive: "In my painting, a

bird is simply a bird. And a bottle is a bottle, not a symbol of a womb." However, Freudian readings are tempting of his bleak paintings of riverside scenes: his mother committed suicide in the Sambre River when he was thirteen, an event about which he rarely spoke. His familiar motif of hidden faces, some wrapped in cloth, may relate to reports that his mother's body was found two weeks later with her nightgown wrapped around her head.

Magritte's *The Portrait* is typically Surrealist in the way it presents an ordinary scene disturbingly altered by something unreal. A table set for lunch has been invaded by an eye, staring at us from where the marrow bone should be in a ham slice. The meal and tableware are unpretentious, even rustic. Although the scene is painted realistically, with shadows angling from an unseen light source like a window, tension is felt from the unnaturally compressed space. There is no intelligible distance between table and wall, which are merely two flat areas of sober color. It feels as if everything were about to slide off the table onto our feet. In so charged a silence, this meal, with its baleful eye, is hardly inviting. Have we already picked up the fork, then hastily dropped it facedown? It's as if we have stepped into the twilight zone, that extrasensory realm mapped by another Surrealist, Rod Serling, who like Magritte grew up under sooty gray skies in a provincial industrial region. Unlike Dalí, Magritte was interested not in dreams but in the fluid hypnagogic state between waking and sleeping, where objects vibrate and change shape. Has a drowsy diner nodded off at table?

The Portrait shows a mundane daily ritual touched by something beyond our control, shadowy forces without personal identity. Magritte treated human figures as if they were objects and treated objects as if they had rudimentary consciousness, as in primitive animism. He said that "man is a visible apparition" like a cloud, tree, or house: "I don't deny him importance and neither do I accord him any pre-eminence in a hierarchy of the things that the world offers visually." In *The Portrait*, the ham eye couched in its fatty aura resembles the all-seeing solar eye that descended from Egypt to Masonic iconography and thence to the U.S. dollar bill. Magritte's red wine and white disc may also be a sly parody of the Communion service, a routine replay of Christ's Last Supper.

One of Magritte's heroes was Edgar Allan Poe, whose mystery tales are heavy with foreboding. When Magritte made his only trip to New York (for a 1965 exhibition of his work at the Museum of Modern Art), he asked to visit Poe's cottage in the Bronx. A penetrating "vulture eye" appears in Poe's "The

Tell-Tale Heart," where it drives a hysterical narrator to murder. There might also be a touch of Lewis Carroll in Magritte's watchful ham, which evokes the courtly leg of mutton that rises from its plate to bow to a startled Alice. But if this is a portrait, as the title states, whose is it? The dish, like a terra-cotta medallion in the Renaissance, might well be hanging on a wall, like a mirror. We are therefore looking at our own open eye, the gateway of art.

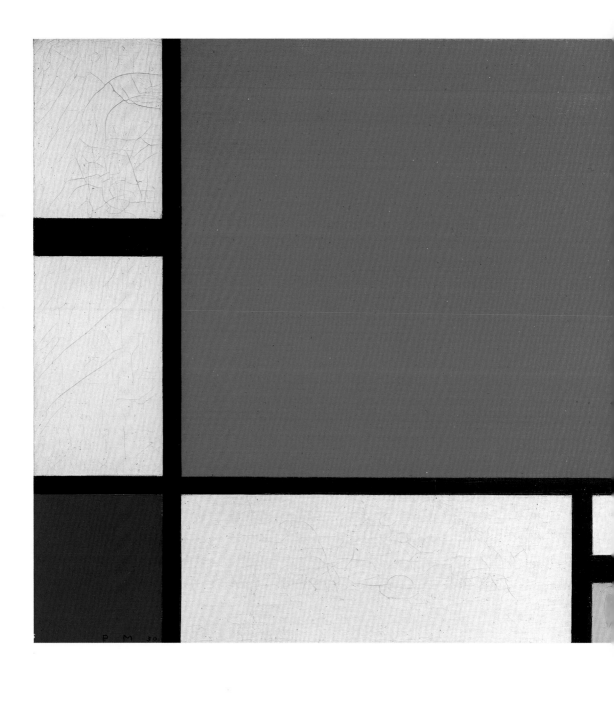

ROMANCE OF THE GRID

Piet Mondrian, *Composition with Red, Blue, and Yellow*

Piet Mondrian, one of the heroes of modern art, lived as simply as a monk, with few possessions or needs aside from his work, to which he was passionately devoted. Modest and reserved, he never sought material success and was sometimes nearly destitute. Pursuing his creative experiments with the methodical persistence of a scientist, he developed a unique style of radical abstraction that is now known and admired around the world.

Mondrian was born in 1872 into a pious Dutch Calvinist family. His father, an authoritarian schoolmaster, opposed his desire to become an artist and refused to finance his training. At age thirty-seven in Amsterdam, Mondrian joined the Theosophical Society, a mystical movement that fused Eastern and Western religions. His departure from his father's strict Calvinism, with its ceaseless battle of good and evil, can be sensed in this euphoric passage from Mondrian's notebooks: "Each man, each thing, everything in this world has its reason for being. Everything is beautiful, everything is good, everything is necessary." A portrait of Madame Helena Blavatsky, the founder of Theosophy, hung like an icon in Mondrian's studio as late as 1916.

At the start, Mondrian was heavily influenced by his countryman Vincent van Gogh, as well as by the Barbizon school of French landscape painters. Mondrian's subjects, treated in somber hues, were everyday Dutch scenes like farmhouses, fields, and windmills. Over the following decades, Mondrian would undergo one of the most astonishing transformations of style in the history of art. Because so much of his work survives, we can follow his thrilling trajectory point by point from realism to abstraction. Under the impact of Cubism, when he was already in his forties, his trees turned into spindly networks, mirrored in water. His colors lightened, and recognizable objects gradually vanished. His design became a mathematical spread of jots and dashes, until his famous signature style

Piet Mondrian, *Composition with Red, Blue, and Yellow.* 1930. Oil on canvas. 1 ft. 8 in. × 1 ft. 8 in. Kunsthaus, Zurich, Switzerland.

suddenly appeared: a grid of color blocks and black lines, intersecting at right angles. Mondrian's evolution never stopped; when he died at age seventy-one in New York, his black lines had become shimmering segments of festive color.

Mondrian belonged to a group of avant-garde Dutch artists and architects called De Stijl (The Style), after the name of their magazine. De Stijl had no meetings, and some members hardly knew each other. Their 1918 manifesto was printed in four languages to dramatize their vision of "an international unity in life, art, and culture," opposing the bankrupt nationalism that had led to World War I. De Stijl called for a marriage of the fine arts with the applied arts, a progressive goal of the nineteenth-century Arts and Crafts movement, which sought to return quality workmanship to industrialized Britain. De Stijl was also inspired by Frank Lloyd Wright, who had brought Arts and Crafts ideals to American architecture. Wright's interest in private homes appealed to the Dutch, whose love of domesticity had been expressed for centuries in genre paintings of cozy interiors and food-laden tables.

Mondrian's classic work embodied De Stijl's major principles: primary colors; asymmetry; geometric form; and horizontals and verticals, banishing the curve. De Stijl's minimalist and utopian doctrine had great impact across Europe, notably in Germany, where the Bauhaus school published Mondrian's writings. De Stijl's influence could be seen in Walter Gropius's efficient, cube-like designs for student and worker housing as well as in grand monuments of the International Style, such as Ludwig Mies van der Rohe and Philip Johnson's glass-walled Seagram Building office tower in Manhattan. Mies coined the motto of minimalism: "Less is more." Gerrit Rietveld's starkly structural De Stijl furniture inspired Marcel Breuer's chrome-plated steel-tube chairs, which are still marketed. Rietveld's idea for cheap "crate" furniture, boxed for home assembly with nuts and bolts, has been popularized globally by IKEA, a Swedish firm reflecting De Stijl's massive success in Scandinavia. Another example of the latter was so-called Danish Modern decor, a vogue in the United States for two decades after World War II.

In a long essay in the first issue of *De Stijl*, Mondrian set forth his creed of "new image creation" (*nieuwe beelding*). Awkwardly translated into French as *néo-plasticisme*, the term ended up in English as the ugly and much-parodied "neoplasticism." This became Mondrian's third religion, supplanting Theosophy. He broke with De Stijl in the mid-1920s when a colleague dared paint a diagonal—which Mondrian regarded as heresy. His faith in the power of art to transform character and society sustained him through years of rejec-

tion and poverty. When his abstract paintings were first exhibited, reviewers called him "mad," "a sick, abnormal man." Pivotal support came from a forward-looking American heiress and artist, Katherine Dreier, who bought several Mondrian paintings and took them to New York, where they were successfully exhibited in a group show at the Brooklyn Museum of Art in 1926, beginning his enduring reputation in the United States. Despite his long residence in Paris, however, French museums and collectors remain largely resistant to his work.

Mondrian presented his own sparsely furnished studio as a model of future living, with bare white walls and uncluttered surfaces. He converted discarded orange crates into tables and shelves. He did not work on an easel, which he used only to prop up finished pictures, but painted instead on canvases nailed flat to a table. Young artists made pilgrimages to Mondrian's studios in Paris and New York, to which he fled via London to escape the Nazis. He played jazz records for visitors on a small gramophone painted red. He considered jazz the music of the future and gave jazz titles to several late paintings like *Fox Trot* and *Broadway Boogie Woogie*. He loved to dance, but some witnesses found his "ramrod" stance absurdly formal. Despite his fondness for partner dancing, he never had a serious relationship with a woman, although there was at least one broken engagement. His courtly but detached manner put women off. In the antechamber to his studio in Paris, Mondrian kept a round vase holding a single artificial tulip with whitewashed leaves; it represented, he said, a woman's "feminine grace and charm"—significantly exiled from his work space.

Mondrian's abstraction, reinforced by his neutral titles, has sometimes been dismissed as mere engineering, cold and clinical. The smooth adoption of his look by high fashion (as in Yves Saint Laurent's epochal shift dresses of 1965) raised further questions about his stature and significance. At the same time, many fervent proponents of abstraction have reduced Mondrian's paintings to exercises in pure form and denied there is any symbolism or higher meaning in his mature style. But in his copious essays and letters, Mondrian explicitly identified his horizontal lines with repose, the sea, and the feminine principle and his vertical lines with action, spirituality, and the masculine principle. His intersections, moreover, are blatantly cruciform. Although he had abandoned Christianity, Mondrian spoke in an essay of representing "sea, sky, and stars" with "a multiplicity of crosses." He insisted elsewhere that he sought spiritual and material "equilibrium" in every painting, a harmony extending to

gender. "The artist is asexual," he wrote, a "spiritual hermaphrodite": "The man-artist is female and male at the same time; therefore he does not need a woman."

Mondrian's abstract period began in 1918 with a checkerboard of sixteen by sixteen squares. Although he tried oval and diamond-shaped canvases, he settled on squares and rectangles, encouraging a dialogue between his outer edge and the inset blocks. He kept altering the size and position of his color planes until he achieved one of the great breakthroughs of modern art—balanced asymmetry, which he identified with freedom. Since antiquity, most Western art and architecture had been centrally focused and symmetrical, symbolizing order and perfection. The Impressionists, inspired by Japanese art and candid photography, had broken from that. Mondrian's more systematic asymmetry would heavily influence modern interior design and typography, already in flux from Futurism, Dada, and Russian Constructivism.

At first, Mondrian used blended colors against a gray background; then he shifted to bold primary colors against white. For the rest of his career, his only colors were red, blue, and yellow. He scrapped chiaroscuro, the shading by which Renaissance and Baroque painters created volume. Despite his roots as a nature painter, Mondrian came to hate green: he pulled the shade down on trains and demanded to switch chairs in cafés to avoid seeing trees. He built up his white areas so that they did not recede, falsely implying depth. Everything for him had to operate on and across the surface. What reproductions cannot catch is the texture of Mondrian's brushstrokes, grooving his whites in contrasting directions.

Mondrian's black lines became more prominent in the 1920s, with horizontals usually thicker than verticals. He said his black lines were "deadly" until he glossed them with shiny varnish. Structure always came first: he sketched lines in charcoal on paper or canvas and added color later. Mondrian's lines hypothetically shoot out into infinite space, creating a charged new relationship between a painting and its surroundings. Hence his revolutionary step of discarding the frame, that heavy, ornate golden rim of traditional portable paintings. Thanks to Mondrian's innovation, every department store today sells narrow black frames and frameless plastic blocks for mounting art and photographs.

Clarity of edge was crucial to Mondrian's aesthetic. He used a ruler and strips of transparent paper tape but mainly relied on his own eye and "intuition." He made constant minute adjustments, sometimes no bigger than a

half centimeter. In the 1930s, he decreased the size of his color planes and increased the number of black lines, producing an animated rhythm. But his primary goal was always alignment and balance, as typified by *Composition with Red, Blue, and Yellow,* dating from 1930, midway through his abstract period. The painting consists of seven rectangles of varied sizes evenly threaded by uniform black lines, except for two short, fat horizontals. The vivid red area is unusually large, looking forward to Mark Rothko's hovering color-field paintings, which that artist too described in spiritual terms. While Mondrian's painting is square, the red patch deceptively is not: it's very slightly wider than it is tall. In a letter to the patron who commissioned this painting, Mondrian identified his reds with the "real," the earthly realm. Red here is a glorious blast, filling its broad plane, while touches of cerebral blue and vital yellow discreetly comment from the margins.

Despite their sharp lines, Mondrian's geometries are never rigid or oppressive. His paintings have a serene, contemplative stillness. Motion is supplied by the eye, which roves from point to point and finds refreshment in the intricate pathways and juxtapositions. Despite the apparent simplicity of his pictures, it has proved virtually impossible to fake a Mondrian. Working out the finest details of proportion and transition, he applied up to seven layers of pigment, shaved lines off at the outer edge, and faded out his colors near the lines, producing a subtle flickering at the crossings, like a mirage.

Mondrian's rectilinear paintings have been compared to the Dutch landscape, with its flatlands and canals; to medieval leaded stained-glass windows; to Dutch tiling and brickwork; and to blueprints and floor plans, in keeping with De Stijl's enthusiasm for architecture and town planning. Mondrian's reduction of content and elimination of the figure have also been seen as a modernist version of the iconoclastic Protestant "plain style." Was the purity of Mondrian's grid a strategy to control emotion and desire in his austere studio? His work was a process of discovery where color and form were explored for their own sake—a step toward painting that is "about" painting. But Mondrian's floating, weightless images vibrate with an internal drama. Do his black lines define and limit his colors? Or is color, like a divine spark, an autonomous force pushing its way toward life?

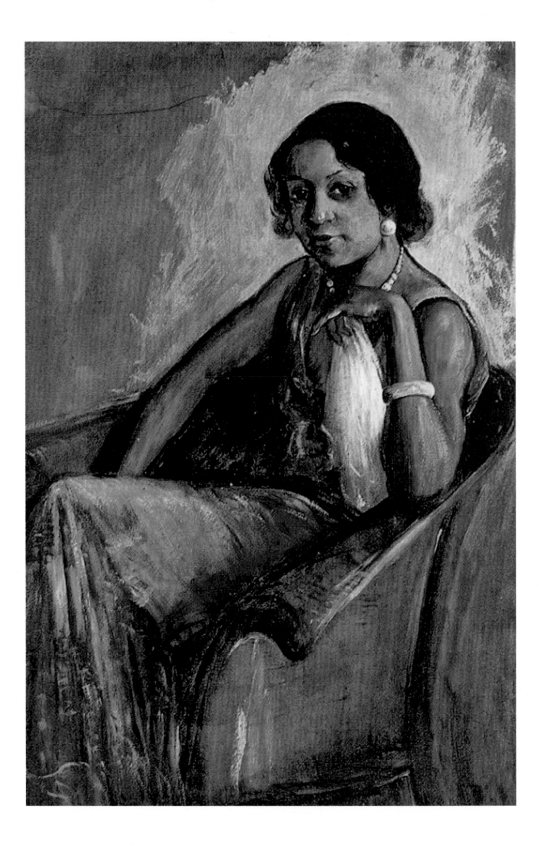

ELEGANCE AT EASE

John Wesley Hardrick, *Xenia Goodloe*

In the nineteenth and early twentieth centuries, American artists eager to see the latest daring trends in painting had to make a pilgrimage to Paris. Museums were still relatively few in the United States and were solidly oriented toward the classical tradition. Members of wealthy families, such as the Impressionist painter Mary Cassatt, could sail to Europe and take up residence to mingle with the leaders of the avant-garde. But there were countless other artists, perhaps equally gifted, who lacked the resources for transatlantic adventures. One example was John Wesley Hardrick, an African-American painter born in 1891 who spent his entire career in his heartland hometown of Indianapolis. Heavily influenced by Degas, Renoir, Van Gogh, and Gauguin, Hardrick had few opportunities to see original paintings by these pioneers and was forced to study their work in reproductions of uneven quality.

Hardrick's family had fled from Kentucky to Indiana twenty years before he was born. Under threat by the Night Riders, precursors of the Ku Klux Klan, they were given a day's notice to quit their farm. Loading their possessions onto a wagon, they abandoned their house and property and crossed the Ohio River to find refuge in Indianapolis. During Hardrick's childhood, Henry Ossawa Tanner, the first African-American artist to win international recognition, moved to France to escape discrimination and abuse in Philadelphia. As Hardrick reached adulthood, the Great Migration was bringing millions of southern blacks to northern and midwestern cities in search of factory jobs and security from Jim Crow persecution. A by-product of this massive movement was the dissemination of jazz from its birthplace in New Orleans to cities like Indianapolis, where lively clubs sprang up along Indiana Avenue. By the 1920s, inspired by the New Negro movement, the arts were flourishing in New York's Harlem Renaissance, from which Hardrick was separated by six hundred miles.

Hardrick's talent manifested itself early: he

John Wesley Hardrick, *Xenia Goodloe*. 1930. Oil on board. 36 × 20 in. Collection of Derrick Joshua Beard.

was drawing at six and within two years was doing watercolors. He later taught himself oil painting. At thirteen, he exhibited in his first group show. Despite racial segregation in the elementary schools, Hardrick seems to have received consistent support in his art classes and ambitions from the white community. His principal teachers were Otto Stark and William Forsyth, members of the Hoosier Group who did Impressionist paintings of the Indiana landscape. As a teenager, Hardrick won numerous art awards, including several first prizes at the Indiana State Fair. For just one fair competition, he submitted a startling fifty-three works in different media. When he was seventeen, *The Indianapolis News* singled him out in the headline of a review: "Colored Boy's Work as Artist Astonishes."

Because of financial pressures, however, Hardrick would never be able to paint full-time—a dilemma facing most artists of any race, then and now. He sold newspapers, worked in a foundry, and hauled coal to survive. After he married, the situation turned even more acute: to support his wife and four daughters, he drove a truck and cleaned carpets. He sometimes set up his easel on a downtown street and made pictures on the spot for passersby. When for health reasons he could no longer handle a truck, he became a taxi driver and sold his paintings out of the trunk. There was local interest in sending him to Europe to study, but he declined because of family loyalties and duties. Nonetheless, he maintained a high level of productivity and placed his pictures in group shows in Chicago, New York, Atlanta, and San Diego. Because his prolific work remains uncataloged, his paintings are probably scattered, unrecognized, all over the Midwest and beyond.

Hardrick loved to paint landscapes from memory after visiting the rolling hills and meadows of Brown County in southern Indiana. During the Depression, he executed school murals for the government-funded Public Works of Art Project. But his specialty was commissioned portraiture. Hardrick had a phenomenal aptitude for portraits, quickly capturing the vital essence of his sitters. His paintings, particularly of African-American women, including his daughters, have a dazzling variety of stagings and moods, with special attention paid to fabric, texture, and skin tones. In 1929, a publicly subscribed Hardrick Picture Fund purchased his pensive *Little Brown Girl* for the John Herron Art Institute (later the Indianapolis Museum of Art); it was only the second work by a black artist in its collection.

One of Hardrick's most brilliant paintings, *Portrait of a Woman*, won first prize at the 1933 Indiana State Fair and is now owned by the Hampton Uni-

versity Museum in Virginia. It shows a commanding ninety-year-old black woman whose name has been lost. Wearing a black scarf tie and white cotton blouse (vigorously rendered by Hardrick with a palette knife), she is quietly sitting, hands in her lap, with nearly military bearing. Her eyes, turned sharply to her left, are fierce and piercing. Hardrick's strong sculptural modeling of her taut, lined, burnished face makes her look like Egyptian royalty. Her large gold-hoop earrings and her very dark, unmixed African skin possibly suggest she was of Caribbean origin.

A splendid example of Hardrick's virtuosity as a portraitist is his 1930 picture of Xenia Goodloe, a dress designer at the upscale L. S. Ayres & Company department store in downtown Indianapolis. Xenia was married to Ayres's head baker, who was renowned for his Lady Baltimore cakes (a white layer cake with a candied fruit and nut filling). Her unusual first name may allude to a town more than a hundred miles away—Xenia, Ohio, which had been a hub of the Underground Railroad and was the site of Wilberforce College, founded before the end of slavery as the first black-owned and -run college in the United States. Perhaps her forebears had been students at the college or fugitive slaves helped to freedom in Xenia.

What Xenia Goodloe represents, enthroned in her chic brown-leather tub chair, is a generational leap forward by African-American women. She is no domestic servant but an independent personality and prosperous professional, confident in her own style and accomplishments. When Hardrick painted this picture, black women performers were also evolving from the proletarian ruggedness of blues belters like Bessie Smith toward the urban elegance of torch singers like Billie Holiday and Lena Horne in their glamorous gowns. Relaxed in her gauzy, low-cut, sea-green silk chiffon evening dress, Xenia flirtatiously dangles her handkerchief with little finger raised as if she were holding a teacup. She has aplomb and savoir faire. Her trim, lithe, uncorseted figure embodies a new ideal of female beauty, forged during the defiantly liberated flapper era, which produced her assertive lipstick, rouge, tweezed brows, and bobbed, straightened hair. Her costume jewelry is also au courant, especially her big ivory Bakelite bracelet.

Inspired by Degas, Hardrick positions Xenia against a blank, shallow background, removing every distraction from our focus on her. Her chair, turned at a dynamic angle and side lit from an invisible window, seems to be flowering: its swooping curves contrast with her squared knee and thigh, jutting out like a tulip pistil. Xenia's direct gaze is amused and slightly impatient. The dimpled

corners of her quizzical, pursed mouth make her seem about to speak, as if she can barely contain her satiric energy. Her probing eyes are enlarged beneath by black swatches suggesting her work ethic and experience.

Xenia's merry, frank, perspicacious glance resembles the striking expressions of mercurial intelligence in two classic French paintings: Ingres's portrait of Mademoiselle Rivière and Manet's of Berthe Morisot with a bouquet of violets. Hardrick's picture can also be profitably juxtaposed with Sir Henry Raeburn's charming 1793 portrait of a well-bred Scottish girl, Miss Eleanor Urquhart, who is turned at a three-quarter angle against an umber background virtually exactly like Xenia Goodloe. Pink-cheeked Eleanor looks like a classic "English rose"; her pristine white muslin dress has a springtime freshness. Xenia, however, seems maturely sensual, exuding an earthy practicality and a sultry mood of balmy summer. Always attuned to the rich palette of black skin, Hardrick appreciatively streaks Xenia's shapely, bare arms and shoulders with tawny, caramel tints—fashionable "high yellow." The aura around her head, achieved with confident, choppy strokes, captures her aspirations and creative hunches, a scintillating burst of gingery gold. This is a woman who knows the world and feels at home in it.

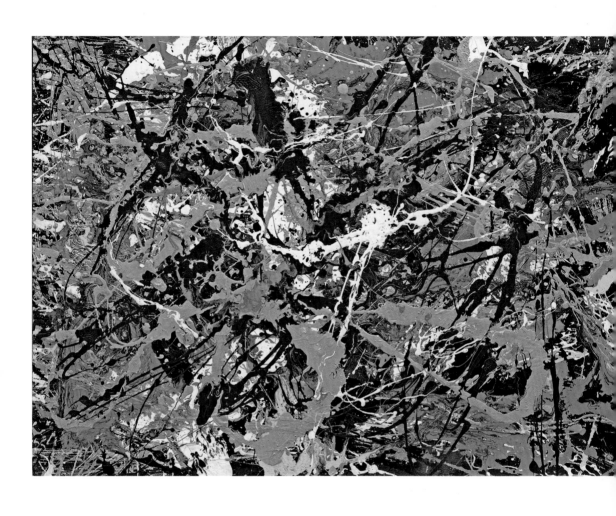

SHOOTING STARS
Jackson Pollock, *Green Silver*

Abstract Expressionism has conquered modern design, where it has become a familiar decorative motif for everything from gift paper to kitchen linoleum. But surprisingly many people outside the urban centers in the United States still regard abstract painting with suspicion, as if it were a hoax or fraud. Given this lingering skepticism, it might be wise to admit that there is more bad than good abstract art, which has been compromised over the decades by a host of inept imitations. All the more reason to celebrate the masterworks in this difficult genre.

Jackson Pollock was both beneficiary and victim of the American cult of celebrity. He was the first superstar of American art, which had always been overshadowed by Europe. After World War II, he became a symbol of the transfer of the world capital of art from Paris to New York, following two centuries of French dominance. Born on a sheep ranch in Wyoming, Pollock seemed to embody the brash independence of the American frontier. His rough dress and tough manner broke the stereotype for artists, whom practical, mainstream Americans had often spurned as milquetoasts or snobs.

While his family did have pioneer roots—his mother was born in an Iowa log cabin—the young Pollock was no paragon of virility. Neighbors described him as a mama's boy and "crybaby." Timid and clumsy, he avoided sports and played with girls. In his late teens, he studied Theosophy and admired the dandyish guru Krishnamurti, whose long hair and Byronic open collars he aped. It was ironically only after he moved to Manhattan and fell under the spell of his teacher, the macho muralist Thomas Hart Benton, that Pollock became the iconic cowboy painter who later exploded onto the world. His alcoholism was already chronic, leading to psychiatric hospitalization in the 1930s. This affliction plagued him throughout his life and caused

Jackson Pollock, *Untitled (Green Silver)*. Ca. 1949. Enamel and aluminum paint on paper, mounted on canvas. 22¾ × 30¼ in. Solomon R. Guggenheim Museum, New York, New York, United States.

repeated injuries and accidents, culminating in the 1956 car crash near his Long Island farmhouse that killed him and a female passenger.

Originally, Pollock wanted to be a sculptor and dreamed of rivaling Michelangelo. As a student at New York's Art Students League, he began painting naturalistically but was frustrated and embarrassed by his difficulties with drawing. His large hands shook, and his right index finger was mutilated from a childhood accident with an ax. He experimented with Benton's Social Realism, then adopted the theatrical primitivism of Mexican muralist José Orozco. But the real revolution for him was Picasso. Pollock had no interest in Cubism until he saw Picasso's *Les Demoiselles d'Avignon* and *Guernica* at a 1939–40 retrospective at the Museum of Modern Art. He was galvanized by Picasso's big, bold forms, shallow Cubist space, and ambivalent vision of mythic woman, which complemented Pollock's engagement in therapy with Carl Jung's archetypal psychology.

Out of his competitive zeal for Picasso came the first works to win Pollock attention—ominous paintings of shadowy, totemic figures executed in a cryptic, semiabstract style. Pollock's reputation for violence began early: he had always been a nasty binge drinker (acquaintances said he had a "Jekyll and Hyde" personality), but now his pictures veered toward the grotesque. An untitled 1938–40 painting, later called *Naked Man with Knife*, shows a muscle-bound assailant grappling with a contorted victim in what could be a ritual sacrifice; the composition is choked and churning, a writhing mass of blood-brown knots of flesh. This stunning emotional turbulence was the "expressionism" in Pollock's new style—a welling up of anguish from the artist's tortured inner life. The modern artist, Pollock insisted, works "from within," "expressing his feelings rather than illustrating."

Even as his style became increasingly abstract, Pollock still began every painting with a figure, which he then concealed. "I choose to veil the imagery," he stated. Traces of those figures receded and eventually disappeared. The transition can be seen in *Mural*, a gigantic painting (nearly twenty feet long by eight feet high) that he did in 1943 for the entry of the New York town house of heiress and art dealer Peggy Guggenheim. A procession of black stick figures can be detected marching amid undulating slashes, which unfriendly critics labeled "glorified wallpaper" and "baked macaroni." *Mural*, which Pollock claimed to have painted in a single night, was executed in his epochal "all-over" style: the surface is treated uniformly, edge to edge; no part of the painting is more important than any other.

Although he had already become the enfant terrible of New York's avant-garde world, Pollock and his outspoken wife, artist Lee Krasner, were enduring poverty and hardship because their paintings did not sell. But Pollock's productivity never flagged. During the summer of 1947, there was a major breakthrough: he invented his signature "drip" style, which would transform contemporary art. Unrolling sheets of coarse sailcloth on the floor of his small barn-studio, he used sticks or hardened brushes to toss and spatter paint at the canvas. Before this, he had squeezed standard oil paints directly from the tube across his pictures and spread them with a palette knife. Now he was using cheap commercial materials—house paint, industrial enamels, silver radiator paint—and he no longer touched the canvas at all, except to step on it. There had been precedents for this free treatment of paint in experiments witnessed by Pollock as a student at the New York workshop of Mexican muralist David Alfaro Siqueiros, who called them "controlled accidents."

By dramatically expanding the size of his canvases and working on the floor, Pollock freed painting from the easel, which had been basic to portable paintings since the Renaissance. Walking around the canvas and improvising from all four sides, Pollock said he could "literally be *in* the painting," an experience he compared to "the method of the Indian sand-painter of the West." His friend the sculptor Tony Smith spoke of Pollock's "feeling for the land" and said that the floor was "the earth" over which he was "distributing flowers." Pollock told another artist friend, "I am nature." He called his painting "the arena," like a bullring: it had become an environment where there was neither up nor down. He never made final decisions about the direction or positioning of his paintings until he had studied them for weeks. Tacking his canvases to the wall as they would be publicly exhibited was a very late step in his process. He disliked signing his paintings or giving them titles, which eventually became mere numbers.

A sensational 1949 profile in *Life* magazine made Pollock famous overnight. The mocking headline asked, "Is he the greatest living painter in the United States?" Clad in dungarees and dangling a cigarette from his lips, he was photographed with arms pugnaciously folded as he leaned against a squiggly painting that looked preposterously chaotic to most readers. The article helped create the stereotype of the abstract painter as grubby weirdo that would become a scare staple of 1950s American movies and TV. A polemical essay in an art journal about the New York abstractionists coined the term "action painting," which simply meant that the act of painting, not

the finished product, was the new goal of art making. Pollock, for instance, never made preliminary sketches but drew in paint directly on the canvas. Nevertheless, he was now dogged by a caricature of the action painter hurling paint around the room in a mad frenzy. A full-page photograph in *Harper's Bazaar* of a brooding Pollock in denim jacket and blue jeans squatting on the running board of his battered jalopy fused his image with that of Marlon Brando, who had introduced a brutal naturalism to stage and screen acting. The Brando parallel was overt in a 1956 *Time* magazine article titled "The Wild Ones" (riffing on a Brando motorcycle film), where Pollock was dubbed "Jack the Dripper," as if he were a homicidal maniac. His hipster stance was also aligned with rebel Beat poetry, Existentialism, and the birth of the cool in jazz (which he played nonstop at home).

The media spotlight put huge pressure on Pollock, who now faced impossible expectations. Despite his celebrity, sales of his paintings briefly spiked but remained sluggish, and Peggy Guggenheim had trouble even giving them away: Yale University refused her offer of *Mural,* which was finally accepted by the University of Iowa Museum of Art, where it still resides. There was tension with other New York painters, who resented the media view of Pollock as their leader. His relationships with fellow artists were always prickly and sometimes hostile: he tried to destroy a Larry Rivers sculpture by running over it with his car in an East Hampton driveway. During the three-year period of his classic drip paintings, Pollock stayed sober. However, in 1950, after being filmed working outside on plate glass, he started drinking again, and the day ended in fiasco and farce: he overturned the dining-room table, spilling twelve roast-beef dinners to the floor. Restlessly changing his style, Pollock began using turkey-basting syringes to pour black paint on raw white canvas—the "soak-stain" technique perfected by Helen Frankenthaler. But his once prodigious output pitifully diminished, while his drunken scenes multiplied, often at the rowdy Cedar Tavern, where he manhandled women and tore the toilet door off the wall. Ankle breaks made his weight balloon, and he looked ravaged and paralyzed. Few members of the art world were surprised by his tragic death at age forty-four.

Pollock the man may have sunk into squalor and disgrace, but he left behind an immense body of stunningly original work, ranging from nightmarish apparitions of suffering and dread to dazzling tableaux of sublime beauty. No one has been able to duplicate the intricate skeins of soaring paint

in Pollock's greatest drip paintings, a webwork of gorgeous trails where there is never mess or muddle. His whirling lines hover in a strange, unidentifiable zone between his very shallow background and the rough surface, thickly layered with pigment and sometimes embedded with actual objects—keys, tacks, cigarette butts, bottle caps. Because of this incremental encrustation (each swatch of paint had to dry before the next was applied), Pollock's textured pictures have the shadowed concreteness of sculpture—the genre toward which he had first aspired.

Pollock's colossal paintings are impossible to appreciate in reproductions, which shrink them to a dismal page. Seen in person, they overwhelm the visitor with their majesty. Only close-up snapshots of details can convey the mesmerizing intricacy of those rippling, tangled surfaces, sprinkled with sand and glinting with metallic paint and broken glass. A small untitled picture now called *Green Silver*, executed on paper over canvas with enamel and aluminum paint, captures the exhilarating verve of Pollock's most refined drip style. Its luminous loops, curls, and splashes have a charming playfulness. Against an aquamarine background swoop calligraphic spurts of muted color and spidery black dashes, producing a bubbling ferment. Is it ocean, air, sky? The picture is a weather system and mental universe, a neurological map crisscrossed by image and impulse. There is no solitude or alienation here. *Green Silver* is an ecstatic jabber of chance spills, bursts, and skidding phrases.

Films of Pollock at work in his barn show neither violence nor frenzy in his creative process. He methodically flicked and flung his arcing paint with calm composure. Lee Krasner marveled at her husband's mysterious virtuoso technique of "working in the air and knowing where it will land." She called it "quite uncanny": "Even the Indian sand painters were working in the sand, not in the air." Pollock's dipping and bobbing movements were dance-like, activating his arm, shoulder, and torso rather than the painter's usual wrist and fingers, always his weakest point as a student. "My concern is with the rhythms of nature," he declared. These hypnotic pulses, which he said he explicitly invoked like a tribal shaman, brought him a contemplative serenity that can also be felt by the viewer of his best pictures. His trance state, drawing on unconscious depths, resembled Surrealist automatism, a literary practice that had never before succeeded with painting. It was as if the anxious or obnoxious Pollock were taking dictation from a higher, more enlightened self.

Visitors to a 1950 Pollock show said that it was like "walking into a meteor

shower." In front of a large Pollock drip painting, we don't know where to look; there is no story or focal point. The pictures seem alive, like magical, vibrating entities—a link, perhaps, to the imposing totems of Pollock's Picasso period. It's as if we are peering into physical reality at its elemental level, where matter turns into humming energy. Abstraction may have liberated Pollock from the burden of personality. His drip paintings have panoramic reach. They are a heaving primal landscape into which humans have not been born, and yet they project the infinite vistas of warp-speed time travel, the new frontier of the space age.

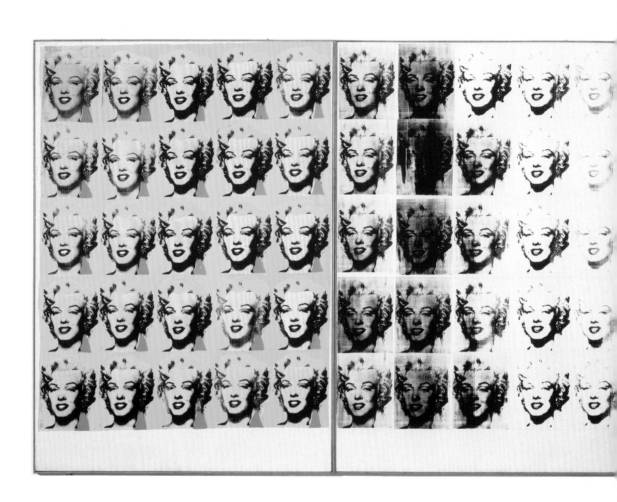

SUN AND RAIN
Andy Warhol, *Marilyn Diptych*

Pop Art danced on the grave of Abstract Expressionism. After Jackson Pollock's death in 1956, his estate was so shrewdly handled by his wife, Lee Krasner, that the prices for all abstract painting skyrocketed. Thus was born the contemporary art market, where investors and profiteers speculate in paintings as aggressively as in stocks and bonds. There had always been art dealers but no real gallery system yet for the abstract painters, who endured poverty, rejection, and derision. The main beneficiaries of their sacrifices turned out to be the next generation of hotshot young artists, who made quick fortunes while embracing everything serious painters had long disdained—the crass, capitalist consumer culture of ads, cars, fast food, movies, TV, tabloids, comic books, and rock 'n' roll. The entire framework of left-wing oppositional art since Romanticism collapsed. Painting has never recovered from the birth of Pop. Abstract Expressionism was the last authentically avant-garde style in painting. After Pop, the avant-garde migrated elsewhere—into Conceptual art, installation art, land art, and performance art.

Pop began in London and New York and was always strongly urban in sensibility. Its crisp edges and glossy surfaces came from commercial design, where many leading Pop artists were first employed. Whereas Abstract Expressionists were inspired by nature, Pop artists loved new technology and adopted its imagery and practices. British Pop emerged from the Independent Group, formed in the mid-1950s amid bleak material scarcity in England following World War II. They were captivated by the splashy pictorials of American magazines, which conveyed the energy, optimism, and prosperity of the United States. Hollywood, then countering the rise of TV, was in its spectacular CinemaScope phase, with brash, saturated, unreal colors that would become a Pop hallmark. The first work of Pop Art is thought to be Richard Hamilton's

Andy Warhol, *Marilyn Diptych*. 1962. Synthetic polymer paint and silkscreen ink on canvas. 6 ft. 10 in. × 4 ft. 9 in. The Tate Gallery, London, Great Britain.

147

1956 photomontage poster for a London exhibit, *Just What Is It That Makes Today's Homes So Different, So Appealing?* It shows a modish, TV-equipped living room dotted with commercial logos and occupied by two disconnected spouses on narcissistic sexual display. In New York in the late 1950s, a few brave artists mounted a risky insurgency against Abstract Expressionism: Jasper Johns bronzed and painted beer cans and impudently exhibited them as sculpture; Robert Rauschenberg belted a stuffed angora goat with a rubber tire. The brief phase preceding Pop was called "junk art" because it used street trash to engage the real world—a development that the artist Allan Kaprow (inventor of "happenings") traced to Pollock's embedding bottle caps and cigarette butts in his paintings.

American Pop was drawing heavy media coverage by 1962. Critics initially scorned Pop as "gag art." Roy Lichtenstein and Andy Warhol had separately been making paintings based on comic strips, then considered vulgar and juvenile. But Pop artists recognized in comics the same themes of love and war as found in ancient myth and legend. The public responded enthusiastically, and comics became hit TV shows and movies (*Batman, Wonder Woman, Superman*). Over the following decades, cartooning and animation steadily rose in cultural status, even as the fine arts declined. New computer technology would make animation a global medium for blockbuster movies, and by the early twenty-first century cartooning had even invaded serious fiction via adult graphic novels.

With its bright colors and simple forms, Pop Art projects an innocent child's view of the world. This can clearly be seen in the cheerful toy world of sculptor Claes Oldenburg, who used cheap vinyl to stitch soft, giant hamburgers, French fries, toothpaste tubes, and electric plugs and who created ticklishly tactile ice cream bars in furry fake leopard and tiger skin. Andy Warhol similarly never lost his naive, nonjudgmental eye. "The world fascinates me," he said; he found everything interesting, even boredom itself. A colleague said Warhol's persona was always that of the "village idiot." He made people see familiar things in a new way, as in his signature 1962 series of paintings of Campbell's soup cans, which he presented as objects beautiful in themselves. There is actually a latent concern with abstract form in much American Pop. The dense serial images of Warhol's assembly-line pictures, such as *Green Coca-Cola Bottles,* can even be seen as an extension of Pollock's "all-over" style.

As the son of struggling, working-class parents who emigrated from Czech-

oslovakia to industrial Pittsburgh, Warhol had an outsider's perspective on American popular culture. He saw brand names, logos, and advertisements as American heraldry. From childhood, when he was often sick and bedridden, he worshipped movie stars and craved celebrity gossip. After college in Pittsburgh, he moved to New York and made a living as a window dresser and freelance commercial illustrator. Despite his painful homeliness and social awkwardness, his professional rise was swift. He became a highly paid, award-winning designer of whimsical, ink-drawn fashion ads for women's accessories, especially shoes, with which he was nearly fetishistically obsessed. *Women's Wear Daily,* the industry bible, called him "the Leonardo da Vinci of Madison Avenue."

At first, Warhol worked out of his apartment, assisted by his pious, old-world mother, with whom he lived on separate floors for most of his life. His first Manhattan studio was a firehouse; his second was a cavernous old hat factory, later called the Silver Factory after a crony covered the decrepit brick walls with tin foil and Mylar and sprayed everything else, including the toilet bowl, with silver paint. The Factory embodied Warhol's proletarian philosophy of art as impersonal mass production. Silk-screening, which he adopted after abandoning easel painting in 1962, was originally a commercial process for fabric design. Applying it to fine art canvas, Warhol could now sell multiple copies of prints made from a single image—always a blown-up photograph, a file picture from newspapers or magazines or a grainy Polaroid shot by him. Re-creating the businesslike workshop of Renaissance master artists, he accepted commissions and chose his subjects but often delegated the making to others, notably his main assistant, poet Gerard Malanga. Warhol deliberately sought a mechanical effect to subvert the hallowed value of the unique "masterpiece." Disdaining authorship, he often used a rubber stamp to sign his paintings, and he professed indifference to their fate: they were as disposable as any other product of American manufacturing, then geared to planned obsolescence.

Warhol's soup cans made him famous all over the world, and he became a symbol of America itself. As eccentric transients gathered in the Factory—gay studs, waspish divas, strung-out junkies, and speed freaks—he was soon the recessive, voyeuristic emperor of his own Xanadu. The media furor around him reached its peak in 1965, when he appeared at public events in New York and Philadelphia with Edie Sedgwick, a gamine heiress and "It" girl of the new transatlantic youthquake. Warhol made over five hundred raun-

chy underground films in his Factory period, including groundbreaking work with video. Shifting into music and performance art, he sponsored a radical rock band, the Velvet Underground, and created a psychedelic environment for them at the Dom, a Lower East Side hall where strobe lights and a mirror ball (which he had found in a junk shop) forged the template for future discotheques. He designed the peelable-banana cover for the first Velvet Underground album and the lewdly operable zipper cover for the Rolling Stones' *Sticky Fingers*. From the moment he arrived in New York, Warhol had been openly gay, with a whiny, effeminate, "swish" manner that irritated the macho Abstract Expressionists. Closeted gay artists like Johns and Rauschenberg coldly rebuffed him. His later bold foregrounding of flamboyant, loquacious drag queens, whom he starred in films, was distasteful to many gay men who wanted to erase the fey past. Warhol's most original work ended after he was shot in the chest by a radical feminist at his Union Square offices in 1968; his health never fully recovered. In the 1970s and 1980s, he did rote commissioned portraiture for the rich and famous and oversaw *Interview* magazine, which he had conceived as a forum for transcripts of his incessant telephone conversations with friends.

Winding through Warhol's most productive period (a mere eight years) were the twin themes of fame and death. In 1962, he painted a huge, slightly stylized, acrylic copy of a front page of the *New York Mirror* with the blazing headline "129 DIE IN JET!" A chartered Air France plane carrying members of Atlanta's cultural elite back to New York from a European museum tour had crashed on departure from Paris. In the photograph, French policemen standing impassively near the towering, burned-out tail are proxies for the jaded consumers of mass media, with its daily diet of horror and delight. This was the first of Warhol's *Death and Disaster* series, which would include old tabloid photographs of grisly car accidents and an electric chair in a spectral execution chamber. (Given Pop Art's generally apolitical stance, the latter was probably not intended as a protest.) Warhol had begun working with photographs of Elizabeth Taylor the prior year after she nearly died from pneumonia in London, and he would later do a series of pictures of Jacqueline Kennedy as a stoical *mater dolorosa* at her husband's state funeral.

Two days after the death of Marilyn Monroe in August 1962, Warhol bought a publicity still of Monroe taken by studio photographer Gene Kornman for the 1953 film noir *Niagara*, where she played a seductive adulteress murdered by her husband. Warhol starkly cropped the photograph beneath

her chin, thus compressing the beaming energy of her face and curiously eliminating the plunging décolletage of her sundress. After the photo had been professionally silk-screened, he added flat, brassy color and set the head afloat in a cloudy field of spray-painted gold, like a Byzantine icon. That work, *Gold Marilyn Monroe,* was exhibited in November at Warhol's first New York Pop show at the Stable Gallery. Also on display was *Marilyn Diptych,* an imposing construction (almost eleven feet wide) whose symmetrical two panels mimic a Renaissance hinged altarpiece.

Warhol's photo portraits, including those of Elvis Presley drawing a pistol in a cowboy movie, represented a major return to the human face and figure in art after the triumph of modernist abstraction. It must be stressed that neither Hollywood movies nor rock 'n' roll was taken seriously yet. Warhol's zeal for pop lore was typical of gay male connoisseurs in the pre-Stonewall period, when they collected vintage movie posters and glamour photos, which could be found for a pittance at flea markets or curio shops. In his first celebrity por-

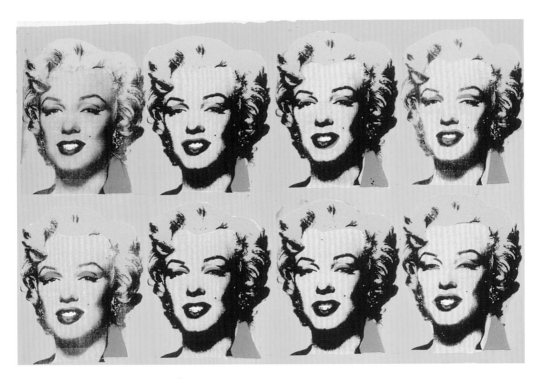

Andy Warhol, *Marilyn Diptych* (detail of image on page 146)

traits, Warhol was borrowing the apparatus of martyrdom and canonization from his childhood Eastern Rite Catholicism. In its rows of stacked images, *Marilyn Diptych* resembles a traditional icon screen before the altar, such as the one in Saint John Chrysostom Byzantine Catholic Church, where Warhol was baptized in Pittsburgh. Although Pop Art is normally coolly impersonal, *Marilyn Diptych* generates considerable emotion through its contrasting panels, whose juxtaposition may have been suggested in Warhol's studio by their first purchaser, Emily Hall Tremaine.

Marilyn's life is portrayed in all its sun and rain. On the left, we see her blazing glamour as a cartoonish symbol of the Hollywood studio system, which created her but, as it broke down, could no longer protect her. On the right is the real, humdrum, daily Marilyn, the eclipsed Norma Jeane Mortenson struggling for identity. The black-and-white images, streaked like soot stains or sodden newsprint, seem bathed in tears, the misery of a shunned Magdalene. By the time of her death, with her erratic behavior and sputtering career, she had already become yesterday's news.

The dizzying proliferation of Marilyns replicates the industry publicity machine pumping out her image. She was a product, as slickly packaged and heavily promoted as Campbell's soup. The crisscross register design also resembles a chessboard, with a sex queen rampant yet tragically solitary. Marilyn's heavy, sleepy eyes are provocatively combined with her open, lush, inviting mouth, yet her exaggerated lipstick and garish, wig-like hair verge on drag. She seems as artificial as spun sugar and as creamy as cheesecake. She is a shimmering projection of other people's dreams and desires.

This multiplicity of meanings is caught by Warhol's chance variations in inking and printing: none of the fifty faces are exactly alike. Marilyn's radiant charisma is blatant even without her famous voluptuous curves. She invented a mythic persona so powerful and vibrant that it took on a life of its own and vampirized her. The monochromatic right panel is her mortuary monument, weathered by the elements. Despite its melancholy, there is a purification in its gentle wash and a restfulness in its fading, as Marilyn's ghost drifts off to linger in popular imagination.

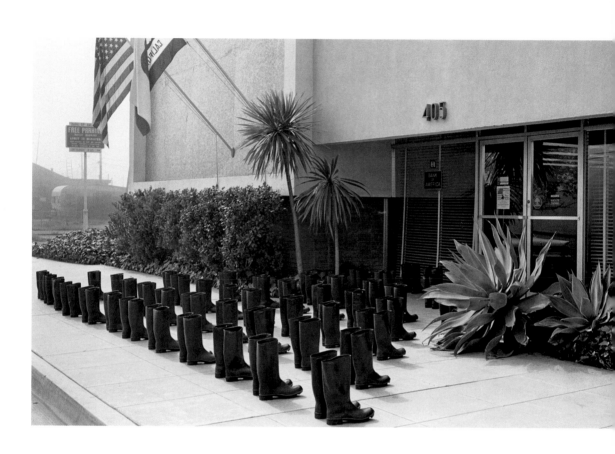

ON THE ROAD

Eleanor Antin, *100 Boots*

During the decades after Pop, artistic styles splintered and proliferated. No one style would ever dominate again. Depending on point of view, the pluralism of late-twentieth-century art was either headily democratic or uncertain and confused, with promising, fresh starts sputtering out. Style provides a reference point, positive or negative, for young artists: it is a foundation to build on or a monolith to destroy.

By the mid-1960s, a reaction was brewing against the materialism and glitz of the new art market that had sprung up after the death of Jackson Pollock. The emergence of Conceptual or "idea" art signaled a resistance by many artists to producing luxury goods for upscale galleries. Some artists turned to perishable or worthless "found" materials, while others reduced their art to whimsical texts or onetime installations or events, to which a price tag could never be attached.

The primary precursor to Conceptual art was a loosely allied group called Fluxus, whose cryptic name alluded to its fluid, boundary-blurring art making as well as to its stated goal of purging culture by flushing away dead art. Fluxus gained attention in the early 1960s with anarchic public events in Germany and the United States. Its irreverent spirit was prefigured in Dada and in Japan's widely influential postwar Gutai group, who staged such pranks as painting with their feet, rolling in mud, and shooting paint from cannons. Fluxus tried to obliterate the distinctions between art and life and between artist and non-artist. It called for the destruction of museums, art galleries, and concert halls and an end to racist "Eurocentric" high culture, a theme soon taken up by academic identity politics. Fluxus's vision of interactivity, "intermedia" (multimedia), and globalism would be realized with the rise of the Web several decades later. Because of

Eleanor Antin, *100 Boots at the Bank.* Solana Beach, California. February 9, 1971, 10:00 a.m. (mailed: April 26, 1971). Gelatin silver print. 8 × 10 in. Courtesy Ronald Feldman Fine Arts, New York, New York, United States.

their purposefully ephemeral nature, few Fluxus works survive. The sturdiest are the Fluxus yearbooks—wooden boxes containing cards, puzzles, and souvenirs—which were shipped by mail, thus evading the elite gallery system and creating their own far-flung audience.

Although it sought to open up art to the masses, Fluxus's quirky games could be fully understood only by an avant-garde minority. Fluxus pronouncements like "Everything is art" and "Everyone is an artist" (a maxim from Joseph Beuys) may have ultimately been counterproductive. In the industrial era and before, most artists could win respect for their skilled craftsmanship. But abstract modernism made that expertise harder to see. By polemically erasing craftsmanship as a value, Fluxus may have undermined public support for the arts in the United States. It helped create a cultural vacuum that would be filled by commercial mass media, with their feverish emotion and blunt appeals to the senses.

Fluxus made its debut with satiric "concerts" featuring the destruction of a piano or violin, an iconoclasm inspired by Gustav Metzger's 1959 manifesto, "Auto-Destructive Art," which attacked the artwork as precious object. This sedition was absorbed into rock music by Pete Townshend, whose smashing of guitars with the Who was inspired by seeing Metzger lecture at a London art school in 1962. Fluxus's guru was composer John Cage, who incorporated commonplace sounds into music and whose use of silence came from his study of Zen. Zen influence could also be seen in Yoko Ono's prolific work with Fluxus. Before she met and married John Lennon, Ono was known for artworks consisting only of enigmatic commands: "Listen to the sound of the earth turning"; "Swim in your dreams as far as you can"; "Boil water. Watch until it evaporates"; "Keep coughing a year." The most notorious Fluxus event was a 1967 performance in New York of Nam June Paik's *Opera Sextronique* during which cellist Charlotte Moorman stripped nude, leading to her and Paik's arrest for indecent exposure.

As Conceptual art spilled over into the 1970s, it mixed with Minimalism, whose rejection of the commercial excesses of the art market was even more militant. Minimalist statements had already been made in 1968 by Ian Wilson's *Chalk Circle,* simply a six-foot-diameter circle drawn in chalk on a wooden gallery floor, and in Carl Andre's *Joint,* consisting of 183 bales of hay stretching across a Vermont field—both works intentionally subject to erosion, decay, and obliteration. The following year, John Perreault demonstrated how Conceptual art could invade public space to make works that would not

normally be classified as art at all: in *Street Music I*, he dialed calls for two hours from one midtown Manhattan telephone booth to another and hung up after three rings, which may or may not have been heard by passersby. It was a work so displaced, scattered, and marginal that it resided only in the imagination of the artist and the audience to whom it was later described.

Although never a member of Fluxus, Eleanor Antin knew its members and attended their events in New York. In the early 1960s, she was painting and writing poetry, but she had begun her career as a professional actress. A self-described "New York Jewish Commie" ("My ethnic background is Russian Marxism"), she had been invited to join the radical Living Theatre on its world tour. Over her long career, Antin has more than any other American or European artist fulfilled Fluxus's ambition of bursting the barriers between artistic genres. She has utilized a staggering range of styles, media, and materials, and her work has combined theater, dance, literature, drawing, painting, sculpture, crafts, photography, video, and architecture. "All art works are conceptual machines," she said. And again: "All art exists in the mind." Antin deeply influenced the emergence of both performance art and Conceptual photography. Her *Movie Boxes* (1969–70), for example, where she created film stills for imaginary movies out of magazine and book photographs, was an antecedent to photographer Cindy Sherman's *Untitled Film Stills* (1977–80). Sherman has in fact cited Antin as a pivotal influence.

Antin's first major work, *Blood of a Poet Box* (1965–68), explicitly evoked the Fluxus boxes. It is a very early example of Conceptual art, a wooden box containing a hundred green-glass microscope slides dotted with the real blood of poets whom Antin knew or solicited. Today, the clever Fluxus boxes seem like whimsical curiosities. But *Blood of a Poet*, with its internal multiplicity yet bold unity of effect, retains its theatrical power. It has the shocking concreteness of a saint's reliquary. The title is an homage to Jean Cocteau's 1930 Surrealist film of that name: Antin's poet is a Romantic martyr making delphic, abstract patterns in his own blood. The orderly file of stained slides clicks by like decades of literary strife, seen from a pitiless scientific distance. Antin's prescient interest in information and classification systems was also demonstrated in her *Library Science* (1971), a satiric collage of mock Library of Congress catalog cards.

After moving to Southern California in 1968 with her husband, poet David Antin, Antin became involved with the new women's movement. She and many other feminists brought biographical and psychological issues back to art. But

she was aware from the start of burgeoning problems within second-wave feminism. In *4 Transactions* (1972), for example, she had a document notarized laying out her impish plan to disrupt her women's consciousness-raising session by being harshly unsupportive of her sisters and by alarmingly addressing them only from behind—an amusing example of how her work positions itself at unexpected and sometimes uncomfortable perceptual angles.

Antin's feminist pieces avoided doctrinaire victimology as well as the lugubrious excess often marring feminist productions of that period, such as Judy Chicago's *Dinner Party* (1974–79), with its florid, vulval table settings. In contrast, how austere and scathingly forthright seems Antin's *Carving: A Traditional Sculpture* (1972), where she was both the sculptor "liberating" form from mass and the art object itself. It was an unsparing series of 148 black-and-white standing-nude photographs taken of her (from front, back, and sides) over five weeks as she lost ten pounds on a strict diet. This incremental chronicle, like a geometric mosaic, covered twenty feet of gallery wall. Its theme of the cultural pressures on women to conform to an ideal body image had also inspired her first video, *Representational Painting* (1971), where she ritually transformed herself with makeup (which she normally never wore), using herself as a canvas to manufacture the socially approved female mask. Both of these works of body art illustrated Antin's ruling concept of gender as performance, which she significantly developed from dynamic American precedents in avant-garde theater, film, and dance rather than from the verbose, labyrinthine French post-structuralist theory that later consumed academic feminism. In the 1970s, Antin adopted a cast of alter egos for performance on stage and off: the King of Solana Beach ("my male self"), a bearded cavalier modeled on the melancholy Charles I; a peppy, naive nurse, representing the class of "service professionals" shared by secretaries and stewardesses; and her favorite character, a black ballerina, Eleanora Antinova, a tempestuous diva battling the "white machine" of classical ballet.

Antin's most famous work, *100 Boots*, was incontrovertibly the most ambitious yet accessible project in the genre of mail art invented by Fluxus. At irregular intervals over two and a half years (1971–73), she mailed black-and-white picture postcards to a thousand people in arts, letters, and media. The photographs followed the adventures of fifty pairs of black rubber boots that she had bought at an army-navy surplus store. Later photos recorded the boots' arrival in Manhattan for their 1973 solo show at the Museum of Modern Art.

Much avant-garde art of the 1960s and 1970s has through familiarity lost its original high impact, but *100 Boots* still retains its mystery and surprise.

The idea came to Antin in a dream, re-created on her first postcard, *100 Boots Facing the Sea*, which shows the boots distantly lined up on a beach in a chilly light. The image recalls seaside paintings of unsettling stillness by Friedrich and Magritte. Who are these patient sentinels gazing at the elements? At a time when sleek, high-heeled boots with miniskirts were fashionable, Antin pointedly chose as her characters thick, functional boots worn by farmers and plumbers. Plain rubber was also an unorthodox material for art. Antin sometimes spoke of the boots as a single hybrid personality. Or she called them her "Beat heroes" whose restless travels were "out of Kerouac"; one photograph has the title of Kerouac's hitchhiking book, *On the Road*. Here is Antin's critical point of departure from Fluxus, which rejected both Beat literature and Abstract Expressionism because of their subjectivity and Romantic emotion. Her work has always been visceral, empathic, and dramatic. Among other things, she wanted to restore narrative ("one of my main passions") to contemporary art. She said *100 Boots* is a "picaresque novel" whose episodic format is modeled on the serial novels of Dickens and Dostoyevsky and a cliff-hanger classic of silent film, *The Perils of Pauline*.

As a work of Conceptual art, *100 Boots* consisted of temporary on-site sculptural installations documented by photographs (taken by Philip Steinmetz), which were sent uninvited to a distant, dispersed audience. The formal, squadron-like patterns assumed by the boots parody the frigid geometries then being made by male Minimalist sculptors. In their outdoor placement, the boots evoke traditional landscape painting as well as the new genre of land art, which was just emerging from Minimalism. Antin strategically varied the look of the cards so that "seductively beautiful" images were not the rule. Most of them have a bleak desolation reminiscent of existential European art films. Indeed, Antin saw the work as "a movie composed of still photos."

Like Pop Art, *100 Boots* appeals to children, but without the aid of Pop's bright colors. Its fairy-tale anthropomorphism recalls Mother Goose's dish that ran away with the spoon or Lewis Carroll's parading chess pieces and crabby plum pudding. That faceless, limbless rubber boots could be so amazingly expressive surely came from the staging skills Antin had acquired as a child compulsively playing with paper dolls in grandiose, improvised scenarios. At the Museum of Modern Art, she preserved and defended the fic-

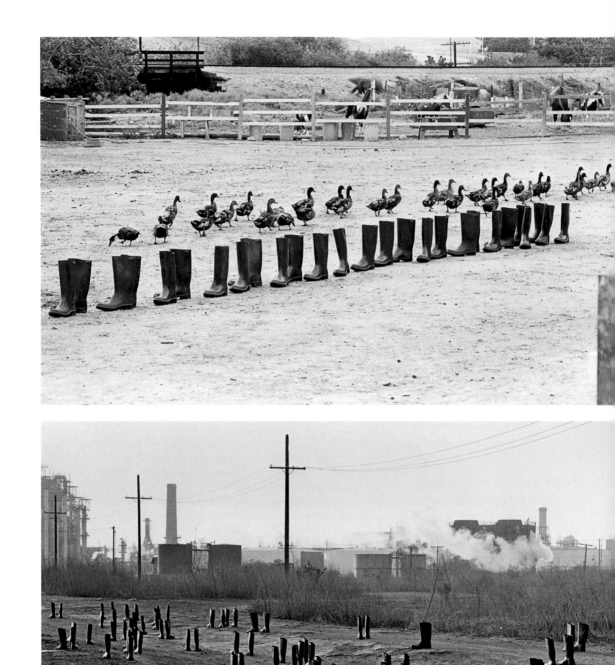

tive status of the real rubber boots by constructing a Beat "crash pad" for them—a spartan room with shabby mattresses, sleeping bags, and a radio blaring under a bare bulb, at which visitors could peek through a chain-locked apartment door. When the museum proposed selling five of the postcards in its shop, Antin rejected this as "an alien intrusion into the system"; it would have split the series and "made each image its own artwork." The cards were not for sale, she insisted: "They were biodegradable in their environment, the environment being the mailing list."

The boots begin their fabled journey in the suburbs, where they shop, stroll, go to church and the bank, and park at a drive-in movie. They trespass at a power station, have job troubles at an oil refinery and a circus, visit a ranch and a cemetery, play cards at a riverboat casino, take a dip in a pond, and make a shy call on a deserted dance studio, from which they glumly retreat. Drafted, they assault a hill and capture a burned-out house with an inciner-ated organ—recalling Fluxus's demolished pianos as well as Magritte's flam-ing tubas. This military sequence, mailed at a sped-up pace, was perceived as topical during the ongoing protests against the Vietnam War. In New York, the boots ride the ferry, cross deserted Herald Square, visit Central Park and the Brooklyn Bridge, and studiously scrutinize a belly dancer at the Egyptian Gardens nightclub.

Antin has said, "Comedy is at the heart of everything I do." But for all its bewitching humor, *100 Boots* also makes the viewer ponder profound issues of nature and culture. Few people appear in the photographs, even in the city. It's as if humanity has been vaporized, leaving the boots as proxies for all refugees and wanderers. The boots are partly Antin's alter egos: she said elsewhere, "I've always felt like an outsider. In a sense, I'm an exile, as a Jew." Her instinct for the archetypal gives universality to her saga, whose title might well be a carnival sign glimpsed in the background of one picture: "GHOST TRAIL." The boots mark the footsteps of vanished peoples, including Native Americans, who stood in the same marshes and crossed the same meadows and woods captured by these photos.

TOP: Eleanor Antin, *100 Boots Move On.* Sorrento Valley, California. June 24, 1972, 8:50 a.m. (mailed: December 9, 1972). BOTTOM: *100 Boots Out of a Job.* Terminal Island, California. February 15, 1972, 4:45 p.m. (mailed: September 18, 1972).

Often the boots' pantomime has a Chaplin-esque pathos. They suffer rebuffs and reverses but forge on with hopeful fortitude. They think, stare, huddle, hesitate, but always regroup. Though they sometimes seem to have different moods and tastes, there is no dissension within

their ranks. Animals (cows, ponies, a calico cat) ignore or stolidly accept their presence. But it is clear when they pass a row of ducks that the boots, like early man, are on a separate evolutionary path. By posture and attitude, the boots invite reflection on individualism and conformity, cooperation and solidarity, and the role of social bonding in civilization's advance from the nomadic age, when men had barely emerged from nature. When the boots gather at a town bank, it is ambiguous whether they plan to obey society or to rob it. Bedecked with government flags, the bank is a fortress of institutional and corporate power. The boots, like their creator, are outsiders, eternal migrants questing for knowledge and experience. The melancholy image of them straggling across a smoggy wasteland (the oil field at Terminal Island near Los Angeles) is a telescoping of history. This blasted patch is the vast arena of earthly life, through which Antin's boots warily thread their way.

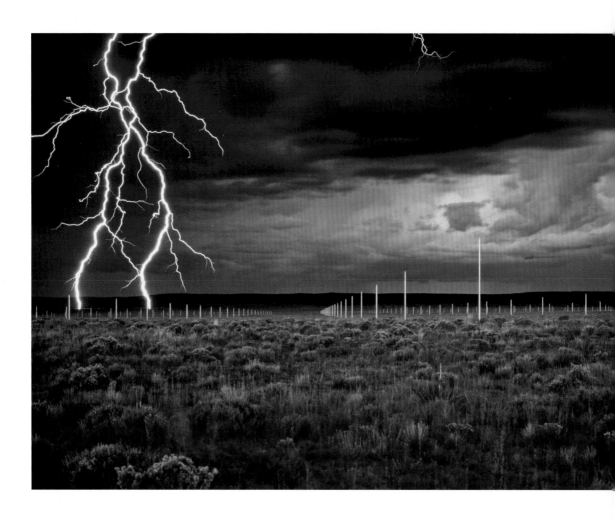

ELECTRIC
Walter De Maria, *The Lightning Field*

Minimalism was a movement in abstract sculpture that emerged from Conceptual art in New York in the mid-1960s. It had been prefigured in 1959 in Frank Stella's *Black Paintings*, executed with a housepainter's broad brush to achieve their smooth, impersonal surface. The twenty-three-year-old Stella, who was accused of "nihilism," was rejecting the emotional turbulence and theatrical brushstrokes of Abstract Expressionism. He insisted that his paint was just paint and his canvas was just canvas, with no implied meaning beyond them.

Minimalist sculpture was simple, spare, and geometric. Its severity represented a turn away from Abstract Expressionist bombast and Pop fun, while its density was a protest against the incorporeality of Conceptual art. If art could now be no more than an idea, the connection with the physical world had been cut. The Minimalist sculptor Carl Andre, who shared a studio with Stella, defiantly declared, "My work celebrates the properties of matter." Minimalist works foregrounded raw materials and insisted on their own concrete presence. The Minimalists took advantage of galleries that had recently been widened and heightened to show large-scale Abstract Expressionist paintings. The pedestal or block (plinth) that traditionally supported statues was discarded: Minimalist sculptures, placed on wall or floor, dominated both spectator and space.

The Minimalist sculptors' ties to Conceptual art lingered in how they sometimes generated an idea first and then handed it to an industrial foundry to execute, as if they were commercial contractors. Their work often looked machine made or engineered, with no trace of the artist's hand, personality, or inner life. Minimalist sculptures had an elegant purity—Tony Smith's black steel boxes; Anne Truitt's hov-

Walter De Maria, *The Lightning Field*. 1977. A permanent earth sculpture in Western New Mexico. 400 stainless steel poles arranged in a grid array measuring one mile by one kilometer. Average pole height 20 ft. 7 in. Courtesy of Dia Art Foundation, New York, New York, United States.

ering monoliths; John McCracken's leaning planks; Donald Judd's copper floor plates or protruding wall stacks; Robert Morris's squared columns alluding to Egyptian art. Some Minimalist works could be bafflingly chaotic, such as Barry Le Va's "floor array" of broken sheet glass or Andre's "scatter piece" of eight hundred small white plastic blocks spilled at random from a canvas bag. In 1976, there was a media storm in Great Britain over Andre's *Equivalent VIII,* acquired by the Tate Gallery: the bare rectangle of 120 identical gray bricks lined up on the floor was denounced as an insolent waste of public funds. Despite its initial controversy, Minimalist sculpture eventually won such widespread acceptance by museums and corporations that it was impugned from the Left as too establishment. It didn't help that the movement's 1966 breakthrough show in New York, *Primary Structures,* instantly inspired a glamorous fashion spread on the "minimal look" in *Harper's Bazaar* ("The New Dazzling Directness": "All lines clear; all edges clean").

Walter De Maria, a co-founder of Minimalism, attended college at Berkeley in the mid-1950s, when the San Francisco Bay Area was in Beat ferment. A musician as well as visual artist, he collaborated in happenings and theater with a fellow student, avant-garde composer La Monte Young. In 1960, the two moved together to New York, where De Maria's downtown loft became the scene of art events and concerts. Despite his appearance on the staff roster of a Fluxus prospectus, De Maria was always fiercely independent. It was partly his impatience with groups that triggered his departure from a brash New York rock band just before it became the Velvet Underground. (Maureen Tucker replaced him on drums.)

De Maria was the first artist to use plywood boxes as a format, adapted by Andy Warhol in his famed Brillo boxes. There was both formal concentration and taunting wit in De Maria's Minimalist sculptures of the 1960s. In *Move the Ball Slowly Down the Row,* a steel ball was shifted from one metal bin to the next at intervals that could be minutes, months, or years: it demonstrated, he said, how "time can be stretched." This kinetic, interactive piece subtly incorporated sound, a technique inspired by composer John Cage that De Maria used with a bang in *Ball Drop,* a plywood box inviting the viewer to push a grapefruit-sized wooden ball through a high hole. De Maria was drawn to Cage partly because of a shared interest in Zen Buddhism, which had permeated the San Francisco Beat scene.

De Maria designed a startling series of iconic symbols crafted in shiny aluminum—a cross, a swastika, a six-point star—whose inset rolling game

balls suggested the fictive, self-enclosed nature of religious and political systems. His *High Energy Bar* was a heavy, portable, stainless-steel ingot whose occult power had to be activated by a certificate endorsed by the artist-shaman. *Pyramid Chair* evoked Mayan step pyramids as well as Bernini's Chair of Saint Peter in its steep white staircase precariously topped by a black patent leather and steel chair. (De Maria, an Italian-American, said that the Catholic Church provided the "strongest and earliest sensations" of his childhood.) *Garbo Column* was a pagan memorial stele: a slim, gleaming metal pillar engraved with a chronological list of Greta Garbo's twenty-seven films. In *Silver Portrait of Dorian Gray*, De Maria played with metamorphic magic: behind a black-velvet curtain hung a burnished silver plate, a mirror destined to tarnish over time and corrode its owner's image.

But these ingenious works were overshadowed by De Maria's *Bed of Spikes*, which aroused "horrified wonder" in onlookers, according to a 1969 review in *Time* magazine headlined "High Priest of Danger." Its five large steel panels, resting on the floor, were studded with varying patterns of bright stainless-steel spikes, each an eleven-inch obelisk with a razor-sharp tip. This industrial fantasia on a Hindu fakir's bed of nails was potentially so lethal that visitors to the Dwan Gallery had to sign a release freeing it and the artist from liability for injury. De Maria said he was mixing "danger and beauty" to find a new synthesis for art. But even more important, *Bed of Spikes* was bursting the limits and genteel protocols of gallery space, from which artists would soon escape.

In the late 1960s, De Maria allied with another transplanted Northern Californian, Michael Heizer, with whom he would launch the new genre of land art. The concept was being simultaneously formulated in England by Richard Long, who made patterns in grassy fields simply by walking. De Maria had anticipated land art in a capricious 1960 Fluxus essay, "Art Yard," where he imagined a formally dressed audience of art lovers watching a parade of bulldozers and steam shovels dig a hole in the ground amid surreal "small explosions." By its very size and substance, land art could not be reduced to a collectible commodity. It also broke with what Heizer contemptuously called "the absolute city system of art": "Both art and museums are victims of the city." The land artist Robert Smithson, who loved ravaged, desolate places, called museums "asylums and jails": the galleries are "wards and cells" where the artwork "loses its charge."

In 1967, De Maria and Heizer took a road trip through the Southwest to

scout sites for future projects. The following year, they laid down *Mile Long Drawing* in California's Mojave Desert: two thin chalk lines running twelve feet apart for a mile. It was a blueprint for a never realized pair of forbiddingly high, mile-long concrete walls. The same year, De Maria created his first *Earth Room* by covering the floor of three rooms in a Munich gallery with soil, to be viewed like a precious artwork over a glass barrier. The poster proclaimed: "Pure Dirt/Pure Earth/Pure Land." Although De Maria's two German earth rooms no longer exist, a third version survives in a Wooster Street gallery in New York. Described by its custodian, the Dia Art Foundation, as "an interior earth sculpture," it consists of 280,000 pounds of dirt, peat, and bark at a depth of twenty-two inches.

The term "earthworks" came to be applied to any work of land art using soil as a primary material. Smithson called Frederick Law Olmsted, the nineteenth-century designer of New York's Central Park, "America's first 'earthwork artist.' " Modern British land art has always been more modest in scale and cost than its American counterpart. The open space in the United States offered a huge expanse upon which artists could impose conceptual patterns. Public reaction was mixed: for example, De Maria's shallow, mile-long bulldozer cuts for *Las Vegas Piece* in the Tula Desert were condemned as macho vandalism, despite their affinity with enigmatic prehistoric lines in Peru's Nazca Desert. Heizer's *Double Negative* was even more intrusive—two colossal cuts blasted out of Nevada's Mormon Mesa.

Land art could be delicate and ephemeral, like Robert Morris's *Steam Cloud,* a puff of vapor vanishing in thin air, or Andy Goldsworthy's exquisite melting ice sculptures in the forests and woodlands of Scotland. Sometimes it existed only as photographic documentation, as with Hamish Fulton's *Pilgrim's Way* (1971), which recorded his 120-mile walk down a worn ancient path crossing southern England from Winchester to Canterbury Cathedral. Land artists often invoked Native American precedents to signal their break with European high culture. In *Effigy Tumuli,* Heizer sculpted huge animal shapes in soil, imitating the Indian effigy mounds found by the thousands in the upper Midwest and also recalling the Mayan serpent motif at Chichén Itzá, which he had visited with his archaeologist father. Bill Vazan's *Ghostings,* outlined in white chalk on a big green lawn at Toronto's Harbourfront, was a collage of overlapping pictograms alluding to Indian longhouses and palisades as well as glacial grooves from the Ice Age. The land artist most known to the public is the Bulgaria-born Christo, who caused an uproar by

wrapping Berlin landmarks and Miami islands in plastic sheeting. Maya Lin's Vietnam Veterans Memorial Wall (1982) in Washington, D.C., is an earthwork: its somber trail, sinking into the ground past a Minimalist V-shaped black granite wall inscribed with fifty-eight thousand names of the dead, was denounced at first as a "black gash of shame." Nevertheless, the wall, with its dignified understatement, was soon embraced by the public and became one of the city's most popular monuments.

Some land art reconfigures the urban environment, but the most ambitious works have usually been situated in remote, inaccessible places. De Maria said, "Isolation is the essence of Land Art." Smithson's *Spiral Jetty*, a basalt rubble walkway, whirls out from the barren shore of Utah's Great Salt Lake. (Smithson was killed at age thirty-five in a 1973 plane crash while surveying a West Texas site.) In *Roden Crater* in Arizona, James Turrell remodeled the interior of a half-million-year-old extinct volcano into a celestial observatory. De Maria's *The Lightning Field* is a vast grid of metal rods standing in the high desert of New Mexico near the Continental Divide. Seeing it requires a lengthy trek from Albuquerque to a satellite office of the Dia Art Foundation in Quemado. Visitors must abandon their cameras and cars and be transported to the site, where they are left for a twenty-four-hour stay in a small cabin.

According to De Maria, *The Lightning Field* (1977) began as a note he had made after *Bed of Spikes*, whose form it resembles. But space has radically expanded, like an aeration of atoms. De Maria insisted, "The land is not the setting for the work but a part of the work." After searching by truck for five years throughout the Southwest for suitable sites with "high lightning activity," he constructed a small prototype (later removed) in Arizona. *The Lightning Field* is a sprawling Minimalist sculpture that cannot be viewed in its totality from any one point. Embedded within a rectangle measuring a mile by a kilometer are four hundred highly polished stainless-steel poles averaging twenty feet in height, adjusted by computer to conform to the rolling terrain. Positioned 220 feet from each other, they are anchored in carbon-steel pipes sheathed in concrete. De Maria claimed that "the plane of the tips would evenly support an imaginary sheet of glass"—a stunning poetic trope straight out of Conceptual art. An early visitor to *The Lightning Field* wrote, "The energy at the site is intensely felt." The poles, which flex in the wind, seem to vanish at midday but emerge when they redden at dawn and dusk or turn silver in the moonlight. Though lightning never arcs from pole to pole, the tips sometimes draw bouncing globes of Saint Elmo's fire.

ELECTRIC

De Maria once declared, "Every good work should have at least ten mean-
ings." Unlike so much other post-Pop art, with its cloistered urban ironies,
The Lightning Field has a metaphysical sweep, placing human artifacts in a
cosmic dimension. De Maria said his first works of land art were inspired by
"the whole field of vision in a desert." *The Lightning Field* too is a "field of
vision," whose assembled rods evoke golden wheat fields or glittering armies
on guard. The work is not so much about lightning as about waiting for
lightning—God's wrath or the flash of revelation, the thunderbolt of artis-
tic inspiration or love at first sight. The air is electric with anticipation and
suspense, as if the poles were antennas tuned to inaudible signals. They also
resemble missile-like spears: but are they aggressive or defensive? Is man des-
tined for alienation from or cooperation with nature? Like his nomadic ances-
tors, he remains helpless before the savage elements. When De Maria's metal
poles are nested in green ground cover and spring wildflowers, *The Lightning
Field* seems like one of Emily Dickinson's haunted landscapes where the dead
are frozen witnesses to eternity. The grid is the game, a playful mapping of
life's mysteries, which art accepts but science can never fully explain.

170

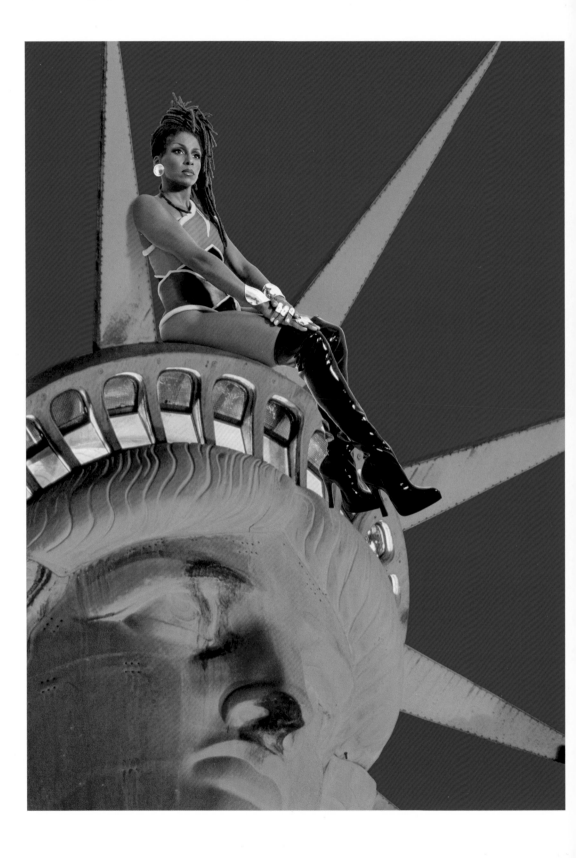

28

BLUE DAWN
Renée Cox, *Chillin' with Liberty*

Performance art emerged from Conceptual art in the late 1960s to become a dominant genre for the rest of the century. Performance is real-time activity centering on an artist's own voice or body. Though it may be documented by photography or film, performance art is often geared to a single moment and vanishes along with its live audience. Its ancestry can be traced to popular festivals, pageants, carnivals, and courtly masques. Some performance artists align themselves with commercial entertainment like music hall, vaudeville, and stand-up comedy, while others identify with the ancient sacred tradition of shamanism and prophecy.

Happenings, the crucible of performance art, were named by Allan Kaprow in the late 1950s in New York. A student of John Cage, Kaprow called his events "parlor anthropology" from his reading of Frazer's *The Golden Bough*. Audiences were small and the spaces unconventional—lofts, warehouses, storefronts. Happenings discarded both the words and narrative of conventional theater; they were episodic and disconnected, like a variety show. Happenings were sometimes described as "sculpture in action" or as a form of collage, juxtaposing spectators like props and multiplying their points of view, as in Cubism. The chaos or mess of many happenings was prankishly aimed at the tidy conformism and prudery of postwar American society.

The first happening may have been an evening diversion in 1952, organized by Cage at Black Mountain College, which mixed music with whimsical stunts. In the 1960s, a wave of political street theater emanated from civil rights sit-ins and antiwar protests. Mavericks who would shortly form the anarchic Yippies tried to levitate the Pentagon and then invaded Wall Street to scornfully rain dollar bills down on traders at the stock exchange. The Human Be-In, a giant happening held in San Francisco's Golden Gate Park in 1967, promoted hippie pacifism, environmentalism, and psychedelic drugs.

Renée Cox, *Chillin' with Liberty*.
1998. Ektachrome print. 5 × 4 ft.

173

Although happenings were commonly thought of as spontaneous madcap events merging performers with audience, Kaprow's two hundred happenings were strictly scripted and rehearsed. Sometimes they were simple installations or activities, such as filling a brick courtyard with rubber tires; planting a man wrapped with tin foil in a parked car; or playing a nineteen-part cascade of snapping lunch-box sounds. Others were more elaborate, as in *Fluids*, where Kaprow left twenty massive corrals of ice blocks to melt for three days in and near Los Angeles. His most complicated happening, *Gas*, unleashed on the Hamptons on Long Island, involved weather balloons, skydivers, oil drums, foam poured down a cliff, and a dozen uniformed nurses waving from hospital beds in the middle of a highway.

Many happenings violated taboos about public displays of sex or violence. In Yves Klein's *Painting Ceremony*, staged in Paris in 1960, a formally dressed audience watched three nude girls dip their torsos in electric-blue paint and make body prints against a white wall; meanwhile, an orchestra played a single sustained chord for twenty minutes. In Nice, Niki de Saint Phalle climbed a ladder to fire a rifle at glass objects and paint-filled balloons hung on a wall of junk. Viennese Actionism featured ritualistic tableaux of torture and mutilation, such as Hermann Nitsch's animal carcasses, red "splatter paintings," and a simulated crucifixion. In downtown New York, Carolee Schneemann's *Meat Joy* was presented by the Judson Dance Theater: as Top 40 pop hits blared, nude performers rolled around in a slippery orgy involving paint, hot dogs, raw beef hunks, and butchered chickens. Such Dionysian releases of repressed sexual energy were endorsed by the then-fashionable works of Wilhelm Reich and Herbert Marcuse.

Happenings sometimes took the form of total environments to engulf and disorient spectators, much like the Surrealist exhibitions of the 1930s. Perhaps the most influential of these immersive inventions was Hélio Oiticica's *Tropicália* (1967) at the Museum of Rio de Janeiro in Brazil. Inspired by Afro-Brazilian samba rhythms and street dance as well as by Oswald de Andrade's 1928 *Cannibal Manifesto*, Oiticica celebrated the vast racial and cultural diversity of Brazil, which was then under a military dictatorship following a 1964 coup d'état. His installation was a playful labyrinth of gravel paths, beach sand, straw mats, wicker screens, crude huts, and green plants, populated by live parrots. The layered soundscape included a loud TV and working-class music from the impoverished favelas. Oiticica's show triggered the epochal Tropicalismo movement in Brazilian music led by Caetano Veloso

and Gilberto Gil, avowed leftists who were arrested in 1969 and exiled for three years. Another Brazilian artist, Lygia Clark, devised environmental pieces requiring sensory interaction with the audience. Visitors were placed in body suits, plastic bags, masks, or spiced hoods; mirrored double goggles awkwardly bound two people together. Clark drew on motifs of political repression and psychological regression to evoke a sometimes uncomfortable hyper-awareness of the body.

Artists' use of their bodies as a material or medium for art had been anticipated after World War I by Marcel Duchamp, who tonsured his head in a Dadaist star. Performance artists from the 1970s on dabbled in exhibitionism, explored biological functions, and made the body an arena of extremity to test pain and endurance. Chris Burden had himself crucified to a Volkswagen roof; at another time, he had a friend shoot him in the arm in an art gallery (the bullet left "a smoking hole"). In her *Silueta* series, derived from Afro-Cuban Santeria, Ana Mendieta made an imprint of her naked body in earth, sand, or grass, then filled it with color or set it afire. Marina Abramović rapidly stabbed knives between her fingers, took catatonia-inducing pills, and let five large snakes crawl over her head and body. Tom Marioni and Linda Montano handcuffed themselves together for three days as they wandered the San Francisco streets or rested in a fake living room at a museum. Elsewhere, Marioni (as his persona Allan Fish) chugged beer for hours, then urinated from a ladder into a metal tub, whose tone changed as it filled. Stelarc, a Cypriot-American artist, suspended himself by eighteen flesh hooks over a New York street until the police stopped it; he later had a human ear surgically attached to the inside of his left arm. In *The Head of Medusa*, the French artist Orlan invited gallerygoers to examine her painted, menstruating genitals under a magnifying glass. She would undergo nine videotaped plastic surgeries to make her face a hybrid of perfect parts drawn from famous paintings: she called the operating room her "studio."

Performance strategies were widely adopted by the reawakened women's movement. At the 1968 Miss America pageant in Atlantic City, feminist protesters crowned a live sheep and tossed symbols of female servitude into a "Freedom Trash Can" on the boardwalk—girdles, brassieres, tweezers, hair curlers, women's magazines. (Despite legend, no bras were burned: a permit was denied by the fire department.) In Los Angeles, Suzanne Lacy and Leslie Labowitz presented a collaborative performance, visually designed to draw media coverage, to condemn sexist recording-industry billboards on Sunset

Boulevard; the immediate irritant was the male-domination cover of Kiss's *Love Gun.* In 1977, former governor Ronald Reagan scolded the California Arts Council for its seven-hundred-dollar grant to Mother Art, a collective of women artists, for *Laundry Works,* which aimed to bring art to the masses: art and poetry were hung on clotheslines inside Los Angeles laundromats; each performance was, in the artists' words, "timed to a wash and dry cycle." In the 1980s, the Guerrilla Girls donned gorilla masks to deliver satiric lectures challenging sexism and racism in the art world.

Many performance artists critiqued the new media technology then radically transforming society. Ant Farm, a San Francisco–based group, produced a video called *Media Burn,* where "artist-dummies" in astronaut suits drove a customized Cadillac at high speed through a flaming wall of TV sets. In Dallas, Ant Farm reenacted the assassination of John F. Kennedy in a performance (*The Eternal Frame*) based on the Zapruder film; it was repeated seventeen times when enthusiastic tourists mistook it for an official event. John Lennon and Yoko Ono courted voyeurism and ridicule when they invited the press to interview them as they sat nude at the Amsterdam Hilton in a weeklong "Bed-In" for peace. Gradually through the 1970s, collaborative happenings and dance theater evolved toward solo performance. This development had been prefigured in Japan in 1964 by Ono herself in *Cut Piece,* where audience volunteers scissored off the clothing of the humbly kneeling artist. At a Düsseldorf gallery the next year, Joseph Beuys sat in shamanistic makeup (gold leaf stuck to honey) while cradling a dead hare; as if in a psychotic trance, he tutored it about art.

Performance artists routinely invented alter egos to subvert gender roles or social class. Adrian Piper, a biracial philosophy student, donned a mustache, Afro wig, and motorcycle sunglasses to stroll the streets as the Mythic Being. In videos shot in her loft, Joan Jonas took the role of Organic Honey, an android fetish doll. David Bowie borrowed Kabuki makeup and the Dada spirit to refine campy Warhol drag motifs for his futuristic persona Ziggy Stardust. Lorraine O'Grady disrupted art openings as Mlle Bourgeoise Noire in a beauty queen's tiara and a gown made of 180 pairs of prim white gloves. Laurie Anderson used a vocoder to masculinize her voice in depicting a media-saturated universe. The Blue Man Group, robotic asexual clones splashing paint off outlandish fiberglass-pipe drum sets, started in downtown New York art clubs and attained global mainstream success. Transsexual self-portraiture was practiced by photographer Cindy Sherman

in her travesties of classic paintings and by "appropriation artist" Yasumasa Morimura in his somber drag re-creations of Hollywood glamour photos. In her one-woman show *Fires in the Mirror,* Anna Deavere Smith took both male and female roles to chronicle an urban racial conflict. Sitting for a parody interview video exhibited in *Every Part of Me's Bleeding,* Tracey Emin, one of a hip coterie of Young British Artists, split herself in two to confront and berate her louche public persona.

In the late 1980s, performance art became highly politicized again due to the AIDS crisis, which was ravaging the worlds of art, literature, and fashion. Several women performers gained passing prominence for a stage style of raging rant that conflated women and AIDS victims as martyrs of society. Over the next decade, there was also a series of bitter controversies over U.S. government funding of the arts because of works deemed pornographic or sacrilegious. In 2001, photographer Renée Cox became front-page news when New York mayor Rudolph Giuliani denounced one of her works, then on display at a Brooklyn Museum show, as "disgusting," "outrageous," and "anti-Catholic." It was a large, five-panel photograph, *Yo Mama's Last Supper,* a recasting of Leonardo da Vinci's *Last Supper* with black apostles (except for a white Judas) and Cox herself presiding as a nude, female Jesus. Yo Mama was an alter ego of black female power whom Cox had assumed in several widely praised prior pieces.

Born in Colgate, Jamaica, Cox was raised Catholic in what she calls "a privileged suburb" of New York. At age eight, she began taking pictures with a Brownie camera and was already making short films in grade school. By high school, with more sophisticated equipment, she was specializing in black-and-white portraits. Intending to be a filmmaker, she majored in film studies at Syracuse University. Her passion was cinematography, above all the art of lighting, which she feels contemporary movies have abandoned. The major artistic influence of her career was "very moody" European art films, which she describes as "a procession of stills." At a time when fashion magazines were under attack by mainstream feminism, Cox always respected them as a vibrant visual genre, and she later worked for many years as a fashion editor and fashion photographer in New York and Paris.

In the art photography that first brought her attention and acclaim in the 1990s, Cox used her own body as a performance medium. Seeking a prototype of the artist as mother (a persona missing from cultural history), she posed for a somber series of nude black-and-white photographs where she dis-

played her pregnant belly or embraced her young biracial sons. In *Hot-en-tot*, she dramatized nineteenth-century European concepts of African "primitivism" by modeling tie-on metal prostheses of inflated breasts and buttocks. Nudity remained a favorite tool in her work during the first decade of the new century. To protest the shooting of West African immigrant Amadou Diallo by New York police, she adopted the posture of Mantegna's Saint Sebastian, tied to a tree and torn by arrows (*41 Bullets at Green River*). Among the many large-scale photographs in *American Family*, Cox's monumental 2001 show at a New York gallery, were sardonic re-creations of classic paintings by Ingres and Manet with all-black characters (herself and family members). Also included were stunning close-ups of Cox's truncated torso in a black-leather corset, resembling abstract sculpture.

In a 1998 photomontage series, Cox created an Amazonian alter ego named Raje, a comic-strip avenger of racial injustice. She made her superheroine the granddaughter of Nubia, a forgotten character who had been introduced by DC Comics in 1973 as Wonder Woman's black twin sister. It was the period of low-budget blaxploitation films starring brassy spitfires like Pam Grier and Tamara Dobson. Armed with fiendishly sharp slasher-movie claws, Cox's Raje battles a burning cross and swastika, liberates Aunt Jemima and Uncle Ben from their desexed stereotypes, and swoops down on Times Square to punish a taxi for refusing black patrons.

As can be seen in *Chillin' with Liberty*, Cox as Raje wears a sleek, off-the-shoulder bodysuit trimmed in yellow cord; the four colors combine the Jamaican and Rastafarian flags. According to Cox, the suit began as "more Vegas showgirl" but was given its final form by designer Liz Goodrum. Cox found Raje's thigh-high, patent-leather dominatrix boots in a "trashy punk" shop featuring erotic fetish gear. Her finely molded silver rings, bracelets, and earrings were made by a leading art jeweler, Robert Lee Morris. Her hairdo of Jamaican dreadlocks piled on top of her head with ringlets cascading down one shoulder ironically invokes the festive ballroom style of white Southern belles during Reconstruction after the Civil War.

Cox says that her photography projects, with their complexities of casting, costume, and production, are like "making a mini-movie": everything must be "carefully mapped out" in advance. For the Raje series, she used a Mamiya 67 medium-format camera, which allowed her to blow up the images to great size while still retaining quality. *Chillin' with Liberty* began with her purchase of a stock photo of the Statue of Liberty (still available on the Web),

into which she dropped her own picture via Photoshop, the image-processing software first marketed by Adobe Systems in 1990. At the New York shoot, she was sitting in an elevated chair against a white background, while an assistant on a ladder worked the camera. She supervised the film processing in a commercial laboratory. It then took ninety-nine hours at the computer for her and an assistant to complete the digital editing of the photographs, including insertion of the iridescent Pop colors.

After her militant exploits, Raje has flown to the top of the Statue of Liberty to rest and commiserate with her. In African-American slang, "chillin' " means relaxing, but here it also suggests a cool reserve as Raje gazes across space and time. She is thinking about freedom, both granted and denied. Her mood is as blue as the steely sky, with its comic-book flatness. Cox's forceful cropping of Liberty's head in the original, noon-bright stock photo has produced a power angle of tremendous intensity. We see thoughts flaring from Raje's eyes, accentuated by the bladelike rays of Liberty's crown, spiky tropical fronds rotating like clock hands. It's time, Raje is saying. Her smoldering ferocity radiates from the reddened windows, like Liberty's internalized torch. The colossus's formidable copper face, weathered green, is partly shadowed, and Raje's shoulder too casts a shadow, as if lit by a fading moon or rising sun.

In a mission statement about her art, Cox once wrote that she strives "to unleash the bisexual duality of the human psyche." Raje is a masculine spirit in a female body. Her finger jewelry looks like a mobster's brass knuckles or a boxer's taped fist. But her elegant manner exudes the grace and glamour of French *Vogue* (for which Cox worked). Regal Raje exemplifies the new pro-sex feminism of the 1990s, uniting athleticism with beauty.

But Raje's glinting wrists and crossed hands also look shackled. She is subtly reenacting the horror of enslavement. In her 1992 black-and-white street photograph, *Liberty in the South Bronx,* Cox held up broken chains, wrapped around both wrists. She was alluding to Frédéric-Auguste Bartholdi's early model of the Statue of Liberty, who now tramples those chains, half-hidden by her robe, on her pedestal in New York Harbor. Raje's masklike face and penetrating eyes suggest she is contemplating and transcending centuries of atrocity and suffering. The crime of slavery remains America's incurable headache. Like a warrior born from the goddess's brow, Raje is welcoming the future but forgetting nothing.

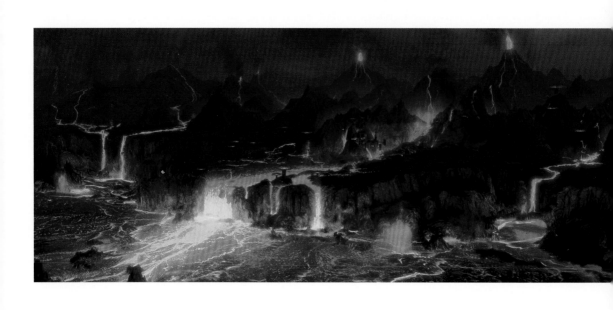

RED RIVER

George Lucas, *Revenge of the Sith*

W ho is the greatest artist of our time? Normally, we would look to literature and the fine arts to make that judgment. But Pop Art's happy marriage to commercial mass media marked the end of an era. The supreme artists of the half century following Jackson Pollock were not painters but innovators who had embraced technology—such as film director Ingmar Bergman and singer-songwriter Bob Dylan. During the decades bridging the twentieth and twenty-first centuries, as the fine arts steadily shrank in visibility and importance, only one cultural figure had the pioneering boldness and world impact that we associate with the early masters of avant-garde modernism: George Lucas, an epic filmmaker who turned dazzling new technology into an expressive personal genre.

The digital revolution was the latest phase in the rapid transformation of modern communications, a process that began with the invention of the camera and typewriter and the debut of mass-market newspapers and would produce the telegraph, telephone, motion pictures, phonograph, radio, television, desktop computer, and Internet. Except for Futurists and Surrealists, the art world was initially hostile or indifferent to this massive surge in popular culture. Industrial design, however, rooted in De Stijl and the Bauhaus, embraced mechanization and grew in sophistication and influence until it has now eclipsed the fine arts.

No one has closed the gap between art and technology more successfully than George Lucas. In his epochal six-film *Star Wars* saga, he fused ancient hero legends from East and West with futuristic science fiction and created characters who have entered the dream lives of millions. He constructed a vast, original, self-referential mythology like that of James Macpherson's pseudo-Celtic Ossian poems, which swept Europe in the late eighteenth

The volcano planet of Mustafar in the Outer Rim Territories. From *Star Wars: Episode III—Revenge of the Sith* (2005), directed by George Lucas. Courtesy of Lucasfilm, Ltd., San Francisco, California, United States.

century, or the Angria and Gondal story cycle spun by the Brontë children in their isolation in the Yorkshire moors. Lucas was a digital visionary who prophesied and helped shape a host of advances, such as computer-generated imagery; computerized film editing, sound mixing, and virtual set design; high-definition cinematography; fiber-optic transmission of dailies; digital movie duplication and distribution; theater and home-entertainment stereo surround sound; and refinements in video-game graphics, interactivity, and music.

Lucas was born and raised in the small town of Modesto in the flat farmland of the San Joaquin valley in Northern California. His father was an exacting owner of an office-supply store who expected his only son to inherit the family business. Small, shy, and socially maladroit, Lucas was a daydreamer who had trouble reading and writing at school and who gravitated toward mechanics and the visual arts, in which he showed early talent. "I was more picture-oriented," he said. He liked woodworking, tinkering, and taking photos, mostly of objects rather than people. He sculpted and did watercolors and ink drawings of landscapes and sports cars, some of which he sold. Comic books were a passion: he collected so many that his father built a shed for them; Lucas later called them his primary model for terse visual narrative. At the movies, he liked vintage Westerns and pirate swashbucklers, then declining genres; on TV, he never missed the old *Flash Gordon* serial, broadcast nightly. In his teens, cars as high-powered, girl-attracting status symbols were "all-consuming" to him. He entered races and won trophies at speedways around California. He already viewed hot rods (brightly painted customized cars with souped-up engines) as populist works of art—a theme he would recast in *Star Wars*' ingenious spacecraft and sleek land speeders, which are steered casually and repaired impromptu like cars.

Intrigued by TV commercials, with their febrile graphics, Lucas decided to become a commercial illustrator, but his father overruled it and refused to pay for art school. In college in Northern California, Lucas became interested in books for the first time; he read science fiction and dystopian classics by Jules Verne, Aldous Huxley, and George Orwell. Discovering European art films, he was attracted by Jean-Luc Godard's cinema verité technique and witty, jumpy editing. After transferring to the University of Southern California to study art and still photography, Lucas was bitten by the filmmaking bug, with documentaries his first focus. He said, "I started out as a cameraman and then became fascinated by editing"—a form of collage. He described his student films as "abstract visual tone poems," with special attention paid to sound

design. His fast edits impressed another Los Angeles film student, future director Steven Spielberg.

Lucas's first feature film, *THX 1138* (1971), shot in San Francisco and produced by his new friend Francis Ford Coppola, adapted his own story from a student film. It portrays a totalitarian future world of mind and body control where drugs are compulsory and sex is banned. Despite a sometimes clinical bleakness, its deft shuffle of cool, luminous images (edited by Lucas) often resembles minimalist scenarios of avant-garde dance, then flourishing in San Francisco. The film unexpectedly ends in a car chase, as a magnificent Lola T70 racer speeds through city tunnels, its supercharged whine a piercing machine music injected by Lucas into Lalo Schifrin's moody, ambient score.

But cerebral, European-style angst had narrow audience appeal. Lucas now turned to American youth culture: his low-budget *American Graffiti* (1973), with its high-school sock hop, hamburger drive-in, and drag racing, re-created his Modesto youth. It was a surprise box-office smash; its soundtrack album of Top 40 hits also made a fortune, rescuing Lucas and his wife from crippling debt. The film spawned a national nostalgia craze for the 1950s, as in the TV series *Happy Days*. Lucas wanted to film *Flash Gordon* next, but the rights had already been bought by Dino De Laurentiis for Federico Fellini, who never did the movie. Despite his aversion to writing, Lucas began painstakingly composing his own science-fiction story: it centered on the adventures of two bickering robots (the future R2-D2 and C-3PO), inspired by the comedy duo Laurel and Hardy as well as the clownish hobo peasants of Akira Kurosawa's *Hidden Fortress*. Science fiction, once a B-movie staple with ramshackle special effects for teenagers, was currently marginalized except on TV, where *Star Trek* had acquired a devoted fan base. Stanley Kubrick's majestic *2001: A Space Odyssey* had made an international sensation in 1968, but it took seven years to earn a profit. Thus no one, including Lucas, had high expectations for his project about "a long time ago in a galaxy far, far away" (*Star Wars*' opening crawl, a phrase from Lucas's earliest drafts).

The proposal for *Star Wars* was rejected by Universal Studios before finally being accepted by a skeptical 20th Century Fox. *Star Wars* "might never have been made," Lucas acknowledged, without Ralph McQuarrie's concept paintings, based on Lucas's instructions: the first picture showed the two robots against a desert landscape on a distant planet. To make *Star Wars* as he envisioned it, however, Lucas had to invent a whole new technology. In 1975, he founded his own laboratory, as feudal as a medieval guild: Industrial Light &

Magic (ILM), a subdivision of Lucasfilm hidden in an old warehouse in an industrial park outside Los Angeles. The young computer whizzes hired by Lucas's special-effects supervisor, John Dykstra, looked like hippies and brainstormed in the chaotic atmosphere of a commune. Out of ILM, which later moved north to Marin County, would come such wonders as the nimble, stampeding dinosaurs of *Jurassic Park* and the morphing, liquid-chrome killer robot in *Terminator 2*. ILM's Pixar Image Computer facilitated 3-D medical imaging and produced (after sale to Apple's Steve Jobs) the first digitally animated feature film, *Toy Story*.

Before writing the *Star Wars* screenplay, Lucas read extensively—fairy tales, mythology, and anthropology, including Frazer's *The Golden Bough*, Joseph Campbell's *Hero with a Thousand Faces*, and Carlos Castaneda's *The Teachings of Don Juan*. The robots receded while archetypal patterns emerged—mysterious births, quests for identity, father-son conflicts, rites of passage. Lucas calls much of his script "very personal": "There's more of me in *Star Wars* than I care to admit." His hero's name, Luke Skywalker, blatantly echoes his own. Lucas said that the Germanic name of the ruthless Darth Vader, Luke's shadowy father and antagonist, was "a combination Death Water and Dark Father." Chief enforcer of the Nazi-like evil Empire, Vader is the target for what Lucas calls his own "basic dislike of authority figures," rooted in childhood and surfacing in his skirmishes with Hollywood studios and unions.

The explosive action of *Star Wars*, which at its release in 1977 electrified a global audience starved for adventure movies, began as a vision of dance in Lucas's mind: "I wanted to see this incredible aerial ballet in outer space." He had used dance metaphors before: in the story treatment for *American Graffiti,* he wrote: "The dancing is created by cars performing a Fifties ritual called Cruising. . . . The passing chrome-flashing cars become a visual choreography." Before this, space battles had been stodgy encounters of behemoths zapping each other with lasers. Lucas gathered samples of zigzagging dogfights from World War II movies to give to his design staff. Special equipment had to be built. The computerized, motion-control Dykstraflex camera, based on factory production-line automated spray painting, swiveled, tracked, and panned around a stationary model: the darting spaceships of *Star Wars* never actually moved. Lucas's spectacular aerial battles, which became increasingly complex with each film, must be regarded as significant works of modern kinetic art whose ancestry is in Marcel Duchamp's readymades and Alexander

Calder's mobiles. The exhilarating eight-minute battle over Coruscant that opens *Revenge of the Sith* (2005), with its dense cloud of stately destroyers, swooping starfighters, and fiendish buzz droids, cuts optical pathways that are as graceful and abstract as the weightless skeins in a drip painting by Jackson Pollock. An ILM technician calls Lucas a "great master-weaver," guiding and gathering the fine stitching of his army of gifted fabricators.

Because of their enormously lucrative summer blockbusters, including their joint *Indiana Jones* series, both Lucas and Spielberg were accused of infantilizing the industry and driving out adult, character-driven films. They were punished at the Academy Awards, where for many years they were given Oscars only for technical achievement. But the first *Star Wars* movie was far more experimental than initially perceived. Lucas's novel methods baffled Fox executives and alienated the British crew at Elstree Studios, who assumed the film would be a flop. Lucas used two and sometimes three or four cameras: encouraging improvisation (there were no rehearsals), he reserved his options for postproduction. He called for naturalistic acting to anchor the space fantasy. He started in close, avoiding establishing shots; long shots were never held. He wanted a nostalgic "filtered look" but kept changing key lights for a "flashing, strobing" effect. He used a loose, "nervous" frame, as in newsreels. The dramatic center was displaced, deflecting the eye to background activity, which in later films would include poetically changing weather. This first film gradually turned darker, following a symbolic color scheme where organic brown and warm gold yielded to high-tech black, white, and steely gray.

For emotional resonance, Lucas commissioned a romantic 1930s Hollywood orchestral score from composer John Williams, who created a haunting constellation of operatic leitmotifs. For sound design, Lucas wanted real noises, not synthesized science-fiction twitters. Thus *Star Wars'* spacecraft doors open and sandcrawlers rumble with whooshes and clatter from the Philadelphia subway, recorded by soundman Ben Burtt. Burtt's very first sound effect for *Star Wars* was the hypnotic drone of the lightsaber, created by layering a TV-tube buzz over a projector-motor hum. Lucas's most avant-garde and much-imitated production concept was that of a rusty, junk-strewn "used universe." Costumes, weapons, vehicles, and sets were distressed for realism: robots and body armor were nicked and scuffed, walls smudged, and actors told to roll in the dirt.

Criticism of the *Star Wars* series has centered on its limited female roles and avoidance of sex; its paucity of black actors and its caricatured accents

perceived as racist; and its sometimes wooden dialogue. Lucas says, "My films are basically in the graphics": "Everything is visual." He views dialogue as merely "a sound effect, a rhythm, a vocal chorus in the overall soundtrack." In structure, *Star Wars* unfolds as dynamic action sequences alternating with grand panoramic tableaux, including breathtaking cityscapes stacked with traffic skylanes. Lucas declares, "I'm not really interested in plots." And elsewhere: "To me, the script is just a sketchbook, just a list of notes." Plot details (like the origin of a facial scar) are sometimes supplied from outside the films in the gargantuan cosmos of *Star Wars* serial cartoons, video games, novels, handbooks, action figures, plastic kits, and Web sites. Lucas's pictorial orientation as a director is unmistakable in his mission statement: "Movies are a mass of objects moving across a large surface." His main task, he says, is to decide where the viewer's eye should be and for how long. Lucas calls digital technology "a new color": "It's a whole different way of making movies. It's painting now; it's not photography anymore."

Lucas's massive product licensing and merchandising tie-ins, which he presciently negotiated with studio executives who saw little future in them, made him a billionaire, but his phenomenal success as a shrewd businessman has certainly slowed his recognition as a major artist. What has not been appreciated is the enormous contribution made by Lucasfilm to the visual education of children around the world. For example, its series of Incredible Cross-Sections books (subtitled *The Definitive Guide to the Craft of "Star Wars"*) is packed with stunning works of conceptual art: richly detailed diagrams and cutaways, including four-page foldouts, of imaginary spacecraft, weaponry, and alien species. The precise draftsmanship, mastery of perspective, and glorification of engineering in these superbly produced books have not been seen since modernist abstraction swept away the great tradition of architectural drawings of the neoclassic Beaux Arts school. In genre, the Cross-Sections books are anatomies, analogous to Leonardo da Vinci's notebooks, with their medical dissections, botanical studies, and military designs for artillery, catapults, tanks, and then-impossible submarines and flying machines.

While plot and dialogue may be de-emphasized, a simple yet cohesive philosophical system permeates all six films of *Star Wars*. Lucas's youthful liberalism (versus his father's rock-ribbed conservatism) was typical of the bohemian San Francisco Bay Area, a 1960s hotbed of radical politics and psychedelia. But Lucas is a straight arrow who does not smoke, drink, or use drugs and who had to curb even his chocolate habit because of diabetes.

Except for his custom-built rural enclaves in Marin County (he calls himself a "frustrated architect"), he lives frugally, plowing his profits back into film development. Environmentalism is implicit in *Star Wars*' lavish array of planetary ecosystems, fertile or ravaged; the color green always signifies good, as in the lizard-like skin of the ancient guru Yoda. Lucas professes a multicultural interest in world religions, with their diverse conceptions of God and spirit, and calls himself a "Buddhist Methodist." Divine power in *Star Wars* is the Force, an energy field around objects and living beings. As in 1960s occultism, gifted individuals, like the Jedi Knights with their samurai warrior code (Bushido), have a mystic power of telepathy and telekinesis. In its preoccupation with good and evil ("the dark side"), *Star Wars* often resembles 1950s Bible movie spectacles. Indeed, a poster of Cecil B. DeMille's *The Ten Commandments* hung in the main office of ILM, which rescued and retrofitted DeMille's wide-screen VistaVision cameras for *Star Wars*. Finally, *Star Wars* takes a cyclic view of history, seeing democracy defeated again and again by fascism and imperialism, from Caesar to Napoleon and Hitler.

Lucas's stature as an artist, as well as his relentlessness as an admitted "micromanager," is demonstrated by the tremendous climax of *Revenge of the Sith,* which he directed. The last of the six episodes filmed, this prequel takes the saga to its midpoint. *Sith* ends with the birth of the twins Luke and Leia, nineteen years before they appear as young adults in the original *Star Wars* movie. Crosscut with the babies' birth, during which their mother dies, is the tortured, cybernetic birth of Darth Vader, like Frankenstein's monster in his laboratory, now attended by pitiless surgical droids. Finally, after nearly thirty years, the mystery of Vader's origins as the mutilated and reconstructed Anakin Skywalker was revealed to the audience who had made him a legend.

Leading up to the interwoven birth scenes is one of the longest duels ever filmed, set against the apocalyptic backdrop of the sulfurous volcano planet of Mustafar. Lucas called this fierce fight between Anakin Skywalker and his Jedi master Obi-Wan Kenobi "the turning point of the whole series." Fire provides a sublime elemental poetry here, as water did on the storm-swept planet of Kamino in the prior film, *Attack of the Clones.* Lucas said he had long had a mental color image of the *Sith* finale, "monochromatic in its red and blackness." The seething reds and yellows of the great lava river and waterfalls (based on Niagara Falls) flood the eye. It is a vision of hell. As in Dante, there is an allegorical level: "I have the high ground," declares Obi-Wan when he springs to the top of a black sandy slope. Hell, as in Marlowe, Milton, and

Mineral-collection arms over the lava river at the industrial complex
on Mustafar. From *Revenge of the Sith*. Courtesy of Lucasfilm, Ltd.

Blake, is a psychological state—Anakin's self-destructive surrender to posses-
sive love and jealous hate.

Production of the Mustafar episode, which has three hundred special
effects, combined cutting-edge, high-definition digital cameras, lenses, and
editing techniques with old-fashioned artisanal model making. The phenom-
enally athletic lightsaber duel was shot against a green screen in Australia a
year before the background was filled in at ILM headquarters in California.
Computer animation of lava plumes and sprays and falling hot ash was ampli-
fied by real-life volcano footage when Mount Etna suddenly erupted in Sic-
ily: Lucas immediately sent a crew to film it. A miniature set (at $\frac{1}{132}$ scale) of
Mustafar's craggy black landscape was carved out of foam on a massive plat-
form, which was raised so that the forty-foot-long lava river (composed of fif-
teen thousand gallons of the translucent food additive methylcellulose, tinted
bright yellow) could be under-lighted to glow fiery red and burnt orange.
Then the entire platform was tilted so that the river, recycled by a pump sys-
tem, would flow. Clumps of ground cork simulated floating lava crust, while
real smoke was fanned overhead. The result was a collaborative triumph of
modern installation art.

The Mustafar duel, which took months of rehearsal, with fencing and saber

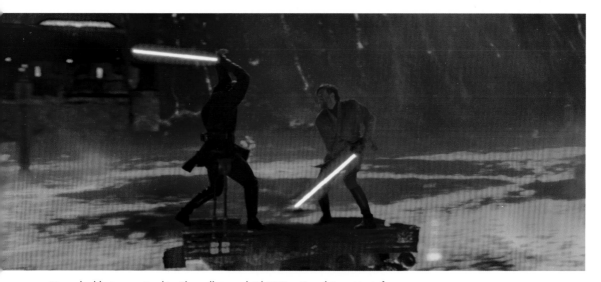

River duel between Anakin Skywalker and Obi-Wan Kenobi on Mustafar.
Hayden Christensen and Ewan McGregor in *Revenge of the Sith*. Courtesy of Lucasfilm, Ltd.

drills conducted by sword master Nick Gillard, was executed by Hayden
Christensen and Ewan McGregor at lightning speed. It is virtuosic dance the-
ater, a taut pas de deux between battling brothers, convulsed by attraction
and repulsion. Their thrusts, parries, and slashes are like passages of aggres-
sive speech. It is one of the most passionate scenes ever filmed between two
men, with McGregor close to weeping. The personal drama is staged against
a physical one: wrangling and wrestling, Anakin and Obi-Wan fall against the
control panels of a vast mineral-collection plant, which now starts to malfunc-
tion and fall to pieces. As the two men run and leap for their lives, girders, cat-
walks, and towers melt and collapse into the lava, demonstrating the fragility
of civilization confronted with nature's brute primal power. Lucas crosscuts
to the delirious destruction on Coruscant of the Great Rotunda of the Galac-
tic Senate, with its thousand round balconies in cool tonalities of gray and
black. This twinned ruination of industrial and political architecture is an epic
Romantic spectacle, like split parts of J. M. W. Turner's eyewitness painting of
the catastrophic burning of the British Houses of Parliament in 1834 (Cleve-
land Museum of Art). Williams's thunderous choral score, recorded with the
London Symphony Orchestra at Abbey Road Studios, has the implacable
charge of a Black Mass. The sound mix, overseen by Lucas, is unnerving: a

tempest of roars, hisses, sputters, clangs, and splashes goes shockingly blank and silent when Anakin's arm and legs are severed midair. He falls heavily to the ground, where he crawls like a serpent with demonic yellow eyes before he catches fire and is half-incinerated.

But all these horrors are transcended in the serene ending of *Revenge of the Sith*. The violent red river of primitive emotion is forgotten as the separated twins are delivered to their adoptive parents, at peace against idyllic open landscapes of mountains and desert across the galaxy. The exquisite tenderness with which strong men handle babies here surely reflects Lucas's own experience as a single parent who retired for two years to raise the first of his three adopted children. "Expand our universe!" Lucas commands his artists and technicians. He is a man of machines yet a lover of nature, his wily persona of genial blandness masking one of the most powerful and tenacious minds in contemporary culture.

Acknowledgments

My deepest thanks go to LuAnn Walther, who has been my editor at Random House since she acquired the paperback rights for my first book, *Sexual Personae*, from Yale University Press in 1990. Her unwavering support, astute advice, and amazing patience have been indispensable throughout this long five-year project. I am very grateful to Allison Zimmer, LuAnn's editorial assistant, for the command central role she played, with precision, persistence, and unfailing good humor, in tracking and monitoring the flood of files, documents, and proofs and also fielding queries as my trusty liaison to the many departments responsible for this complex book.

Many thanks for their formidable efficiency to managing editor Altie Karper and production editor Maria Massey and for her keen vigilance to copy editor Ingrid Sterner. I feel fortunate indeed to have had such wonderful designers working on my book: Andy Hughes, director of production at Knopf Doubleday; Roméo Enriquez, production manager; Kristen Bearse, inside design; and Peter Mendelsund, who designed the jacket and brilliant cover image. I am grateful to Michael Lionstar for his fortitude in producing a diverse portfolio of author photos. I am also indebted to the technical expertise of Dennis Bicksler at North Market Street Graphics.

Thanks are owed to Eleanor Antin and Renée Cox for granting telephone interviews for my chapters on their work. Professor Farha Ghannam of Swarthmore College kindly translated the Islamic medallion in Hagia Sophia. Laura Grutzeck, the Visual Resource Librarian at the University of the Arts, has been very generous with her time in creating the digital discs that I have used for my public lectures about art in the United States and abroad.

I am most appreciative for the many years of confidence and support from Lynn Nesbit, Tina Bennett, and Dorothy Vincent at Janklow & Nesbit Associates. Over the decades, I profited from conversations about art with Gunter Axt, Glenn Belverio, Robert Caserio, Kent Christensen, John DeWitt, James Fessenden, Herbert Golder, Kristoffer Jacobson, Stephen Jarratt, Kristen Lippincott, Alison Maddex, Diane Maddex, Lucien Maddex, Daniela Mercury, Lenora Paglia, Francesca Stanfill, and Helen Vermeychuk.

No research assistants were used for this or any other of my books. Whatever errors may appear are entirely my own.

Index

Page numbers in *italics* refer to illustrations.

Index

Index

Index

ILLUSTRATION CREDITS

Grateful acknowledgment is made to the following for permission to reprint images:

Nefertari Holding Hand of Isis. Photographed by Guillermo Aedena. © The J. Paul Getty Trust.

Man Standing in the Valley of the Kings below al-Qurn. © Kelly-Mooney Photography/Corbis.

Female figurine (Dokathismata variety). © Nicholas P. Goulandris Foundation, Museum of Cycladic Art, Athens. N. P. Goulandris Collection.

Charioteer of Delphi, three-quarter view. Archaeological Museum, Delphi, Greece. Marie Mauzy/Art Resource, N.Y.

Charioteer of Delphi, detail of head. Archaeological Museum, Delphi, Greece. Marie Mauzy/Art Resource, N.Y.

Caryatids at the Erechtheion, Acropolis, Athens, Greece. © Ocean/Corbis.

Caryatid from the Erechtheion. © The Trustees of the British Museum.

Greece, Attica, Athens, Acropolis. UNESCO. © René Mattes/Hemis/Corbis.

Laocoön and His Sons. Cortile del Belvedere, Museo Pio Clementio, Vatican Museums, Vatican City. Vanni/Art Resource, N.Y.

Hagia Sophia mosque © P Deliss/Godong/Corbis.

Hagia Sophia, UNESCO World Heritage Site, Istanbul, Turkey, Europe. © Yadid Levy/Robert Harding World Imagery/Corbis.

The Book of Kells. Courtesy of The Board of Trinity College Dublin.

Donatello. *Mary Magdalen*. Museo dell'Opera del Duomo, Florence, Italy. Erich Lessing/Art Resource, N.Y.

Donatello. *The Magdalen* (detail). Museo dell'Opera del Duomo, Florence, Italy. Scala/Art Resource, N.Y.

Titian. *Venus with a Mirror*. Andrew W. Mellon Collection. Courtesy of the National Gallery of Art, Washington D.C.

Agnolo Bronzino. *Portrait of Admiral Andrea Doria as Neptune*. Pinacoteca di Brera, Milan, Italy. Erich Lessing/Art Resource, N.Y.

Gian Lorenzo Bernini. Central nave toward the altar. St. Peter's Basilica, Vatican City. Scala/Art Resource, N.Y.

Gian Lorenzo Bernini. Cathedra of St. Peter. St. Peter's Basilica, Vatican City. Scala/Art Resource, N.Y.

Gian Lorenzo Bernini. Cathedra of Saint Peter, close up. Photo: Aurelio Amendola. St. Peter's Basilica, Vatican City. Alinari/Art Resource, N.Y.

Aerial view of St. Peter's Basilica and of St. Peter's Square © Alinari Archives/Corbis.

Anthony Van Dyck. *Lord John Stuart and His Brother, Lord Bernard Stuart.*

National Gallery, London, Great Britain. © National Gallery, London/Art Resource, N.Y.

Germain Boffrand. Salon of the Princess. Hôtel de Soubise, Paris, France. Scala/Art Resource, N.Y.

Eighteenth-century depiction of Hôtel de Soubise. © Leonard de Selva/Corbis.

Jacques Louis David. *The Death of Marat*. Musée d'Art ancien, Musées Royaux des Beaux-Arts, Brussels, Belgium. Erich Lessing/Art Resource, N.Y.

Caspar David Friedrich. *The Polar Sea* [*Das Eismeer*]. Hamburger Kunsthalle, Hamburg, Germany. bpk, Berlin/Art Resource, N.Y.

Édouard Manet. *At the Café*. Courtesy of the Walters Art Museum.

Claude Monet. *The Artist's Garden at Giverny*. Musée d'Orsay, Paris, France. Réunion des Musées Nationaux/Art Resource, N.Y.

Pablo Picasso. *Les Demoiselles d'Avignon*. Acquired through the Lillie P. Bliss Bequest. © 2012 Estate of Pablo Picasso/Artists Rights Society (ARS), New York. The Museum of Modern Art, New York, N.Y., U.S.A. Digital Image © The Museum of Modern Art/Licensed by Scala/Art Resource, N.Y.

George Grosz. *Freut Euch des Lebens!* (*Life Makes You Happy!*). Art © Estate of George Grosz/Licensed by VAGA, New York, N.Y.

Tamara de Lempicka, *Doctor Boucard*. © 2011 Tamara Art Heritage. Licensed by MMI NYC.

René Magritte. *Portrait (Le portrait)*. Gift of Kay Sage Tanguy. The Museum of Modern Art, New York, N.Y., U.S.A. Digital Image © The Museum of Modern Art/ Licensed by Scala/Art Resource, N.Y. © 2012 C. Herscovici, London/Artists Rights Society (ARS), New York.

Piet Mondrian. *Composition with Red, Blue, and Yellow*. Kunsthaus, Zurich, Switzerland. © HCR International. Erich Lessing/Art Resource, N.Y.

Xenia Goodloe by John Wesley Hardrick. © Derrick Joshua Beard.

Jackson Pollock. *Untitled (Green Silver)*. Solomon R. Guggenheim Museum, New York. Gift, Silvia and Joseph Slifka, 2004.

Andy Warhol. *Marilyn Diptych*. © 2011 The Andy Warhol Foundation for the Visual Arts/Artists Rights Society (ARS), New York. Tate Gallery, London, Great Britain. Tate, London/Art Resource, N.Y.

Eleanor Antin. *100 Boots at the Bank*. Courtesy Ronald Feldman Fine Arts, New York.

Eleanor Antin. *100 Boots Move On*. Courtesy Ronald Feldman Fine Arts, New York.

Eleanor Antin. *100 Boots Out of a Job*. Courtesy Ronald Feldman Fine Arts, New York.

Walter De Maria. *The Lightning Field*. Photo by John Cliett. © Dia Art Foundation.

Renée Cox. *Chillin' with Liberty*. © Renée Cox.

Three film stills from Mustafar. *Star Wars: Episode III—Revenge of the Sith*™ and © 2005 Lucasfilm Ltd. Used under authorization. Unauthorized duplication is a violation of applicable law. Courtesy of Lucasfilm Ltd.

A NOTE ON THE TYPE

The text of this book was set in Sabon, a typeface designed by Jan Tschichold (1902–1974), the well-known German typographer. Designed in 1966 and based on the original designs by Claude Garamond (ca. 1480–1561), Sabon was named for the punch cutter Jacques Sabon, who brought Garamond's matrices to Frankfurt.

Composed by North Market Street Graphics,
Lancaster, Pennsylvania

Printed and bound by Butler Tanner & Dennis,
Frome, Somerset, England

Designed by M. Kristen Bearse